MINIMALISM AND FASHION

MINIMALISM AND FASHION

Reduction in the Postmodern Era

ELYSSA DIMANT

Foreword by Francisco Costa

COLLINS DESIGN

An Imprint of HarperCollins Publishers

For Eyal

CONTENTS

FOREWORD

My journey as a designer has been a personal one that in many ways has been more about editing than restraint. When I arrived at Calvin Klein after holding positions at Oscar de la Renta, Balmain, and Gucci, I immediately felt consumed by the brand itself. I went through rigorous lessons in reduction; I learned to strip an idea down to its very essence and then have the discipline to look for more to refine. I call it being "Calvin-ized." I now view this evolution as an almost hypnotic quest for balance, perfection, and purity. Minimalism has become a loose synonym for simplicity, but to me that does not accurately acknowledge the achievement of the work. Within these walls, minimalism is about creating a perfect balance out of imbalance—about pairing shapes, fabrics, proportions, and colors that speak to the harmony of the whole.

Minimalism is about confidence and ease, but it is never easily cultivated. Its principles are rooted in accessibility, cleanliness, and progress. Minimalism is almost spiritual: it often relates to the basic elements of nature and creation. Since the term "minimal" was applied in the 1960s to great American artists such as Donald Judd, Robert Smithson, and Agnes Martin, it has also lived within the field of fashion, even as an abstract concept. Minimalism is often understood through modernity but can be found in various forms, from the juxtaposed shapes of primitive art to the sleek lines of 1920s Art Moderne. Dadaism, the Bauhaus, and Italian futurism have all contributed to the ways in which we view minimalism, and each of these movements has in turn influenced me. I often look to film, sculpture, photography, and architecture for inspiration and have found it in the unpretentious works of artists such as Brancusi, Madame Vionnet, Frank Stella, Man Ray, and John Pawson—my minimalist predecessors.

To be a true minimalist, one must be honest without inserting the ego or the past and must utilize this honesty to develop and enrich the work. Minimalism is about moving forward without nostalgia; it does not leave room for ambiguity or mediocrity. No artifice. Minimal styles do not need to be restrictive and should, in fact, be liberating. They should create an interest in the spaces of absence. The vocabulary of minimalism is similar to that of the architecture: "curvilinear," "monumental," "planar," "modular." The starkness of the minimal design is not a rejection but instead an opportunity to understand and celebrate the purity of form.

—**Francisco Costa**

INTRODUCTION

Contemporary art is at an extraordinary impasse: no longer delineated by formal classifications, new works are realized from the fusion of different mediums and incorporate developments in digital rendering and material technologies to enhance personal innovation. Evolved from critical lineages, they challenge the viewer to engage and therefore owe much to the pioneers of the mid-twentieth-century avant-garde, who democratized art and clarified the experience of viewing and interpreting as a vital component of their work.

Minimalism, which reached its academic apogee between 1960 and 1968, has played a crucial role in the construction of the extant aesthetic panorama. The movement's early proponents utilized the ambiguity of abstracted three-dimensional structures and the familiarity of reductive geometry to conceive objects that were astoundingly different from any sculptural or painterly forms that preceded them. Minimalism has since evolved to encompass a categorical artistic designation, a cultivated lifestyle, and an ephemeral sensibility in the realms of fine art, architecture, interiors, and fashion. In many ways, minimalism's transition from a 1960s high-art movement to a persistent force in the contemporary artistic vernacular is due to both its appropriation within the field of fashion and to the many fashion designers who have equated reduction and abstraction with beauty and progress. Fashion, positioned between utility and aesthetics, flat textile and sculpted garment, readily adapts the dictates of minimal art and espouses its legacies in the avant-garde and the ready-made niches of commodity culture.

This volume does not seek to identify all minimalist artists or designers, or to present minimalism as a formal discipline that has persevered in its original form to the present day. Rather, *Minimalism and Fashion* pinpoints key objects in various media that have catalyzed the longevity of a minimalist undercurrent that has alternately conveyed tenets of modernity, futurism, functionalism, or refinement over the last fifty years. Minimalism's prioritization of aesthetics over function as well as its anti-emotive dictates have been challenged and manipulated during this time, but its adherence to rigorous reduction and platonic composition has endured to become the characteristic goal shared by minimalist art and design in the postmodern era. This book seeks to examine the subtractive strategies of such works, the technical and frugal materials that they employ, and the barren or devoid environments in which they have been exhibited or presented in order to distinguish minimalism's persistent impact on contemporary artistic fabrication.

The structure of *Minimalism and Fashion* is somewhat chronological: chapter one, "Primary Structures," addresses key minimal artists in New York City as well as select proponents in Europe who, in the late 1950s and early 1960s, moved away from figurative composition and divested abstract expressionism of its implications and associations. Their works were identified by journalists such as Barbara Rose, Michael Fried, Irving Sandler, and Donald Judd, among others, as "ABC Art," "literalism," "Cool Art," or "Specific Objects," respectively.

This new art coincided with an influx of clean, streamlined shapes in fashion in tandem with the popularity of space-age imagery and propaganda. The resulting minimalist objects, produced mostly in an absentee white hue, serve as the prototypical structures of minimalist design.

Chapter two, "The Ready-Made," focuses on the commercial implications of minimalism, inherent in the movement's use of found objects and in the easy duplication of its basic shapes and anatomies. The discussion addresses the interconnectedness between minimalism and pop art in the mid-1960s: their joint promotion of banal symbols and products as a means toward broader cultural identification and their strategic use of serial composition. These techniques ultimately fused high and low in fine art and were also utilized by fashion in the production of sartorial ready-mades: the little black dress, the day suit, and the shift, among others, became pillars of reduction and mass manufacture that served as early templates for minimalist fashion in the late twentieth century.

The development of post-minimalism in the late 1960s and early 1970s loosened the strictures of minimalist abstraction to encompass emotive curves and figurative lines. Chapter three, "The Minimal Body," juxtaposes post-minimalist works with fashion objects from the 1980s and 1990s that presented the female body itself as an isolated primary form, akin to the cube or the sphere. This discussion highlights the innovations of designers Issey Miyake, Rei Kawakubo, and Yohji Yamamoto, who appropriated the modularity of traditional Japanese aesthetics in their configuration of garments that were constructively simple yet phenomenal in their impact.

Amanda Haskins's exposition on "decon-structures," or objects that reveal their construction in the service of the minimal creative process, examines deconstructive trends in fashion, sculpture, and installation throughout the late twentieth and early twenty-first centuries. Such works fulfill the minimalist aim to eliminate superfluous compositional elements, even to the point of omitting substantial portions of their foundations; in this way, they also inform the aesthetic of the minimalist void in which emptiness and abstraction replace decorousness and elaboration.

Chapter four, "Building 'Basics,'" maps the emergence of functional minimalism in late 1970s fashion and interiors, citing the rise of various American design icons as the catalysts for the global adoption of pared-down, disposable commodities. From the late 1970s to the mid-1990s sartorial minimalism championed the legacy of the formal movement in its strict reductions but rejected its antipurpose ethos to embrace function, comfort, and ease in the form of the working woman's wardrobe. In so doing, minimalism came to embody a certain androgyny: removed from any overt attempt to embellish herself beyond "the basics," the late twentieth-century minimalist figure was effectively degendered.

Much of minimalism's successful infiltration of consumer culture in the late 1980s and early 1990s is owed to the aesthetic of removal and abjection that surrounded the marketing of minimal objects. Chapter five, "Real-ism: Designing the White Cube," identifies key photographers in the stylistic veins of realism and deadpan, both of which helped to create a fashionable environment that abandoned ostentation and effusion for destitution, despondence, and sterility. These spaces denoted a complete withdrawal from traditional fashion promotion—a cleansing of all nonessentials in favor of the rigorous white of the minimal gallery.

In recent years, the austere, curvilinear constitutions of formal minimalism, once again freed from any functional or emotive associations, have resurfaced in high art and fashion fields to configure a new minimal aesthetic. Born from commodity fetishization and technological advancement, these works are engineered not for mass production but for visual appreciation, as the fruits of immaculate artistry. Chapter six, "The New Minimalism," recognizes the purveyors of this trend: fashion designers, digital illustrators, painters, industrial designers, architects, and sculptors who impose the austerity of minimalism upon the artistic object. Although many of their works require extreme technical knowledge and expertise, the results are both pristine and seemingly effortless. As artistic movements are often cyclical, it is no wonder that minimalism has come full circle to challenge our postmodern eye—poised to absorb the multinational romantic amalgam—to grasp a singular prophetic vision in which the most remarkable objects are also the most straightforward.

"MODERNITY BEGINS H
OF ELIMINATION: MIN
WEIGHT, MINIMAL CAR
MINIMALISM IS, I THIN

ERE, AS A PROCESS

MAL SEAMS, MINIMAL

E, MINIMAL DETAILS...

K, THE FUTURE."

—Geoffrey Beene, Interview with Grace Mirabella in *Geoffrey Beene Unbound*, 1994

1.

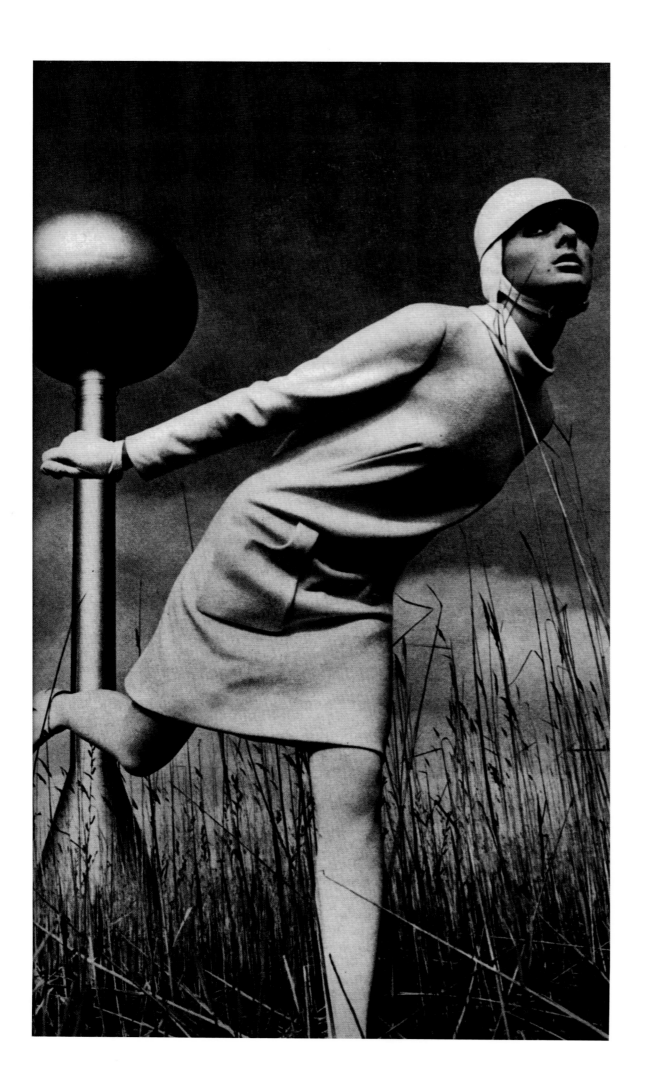

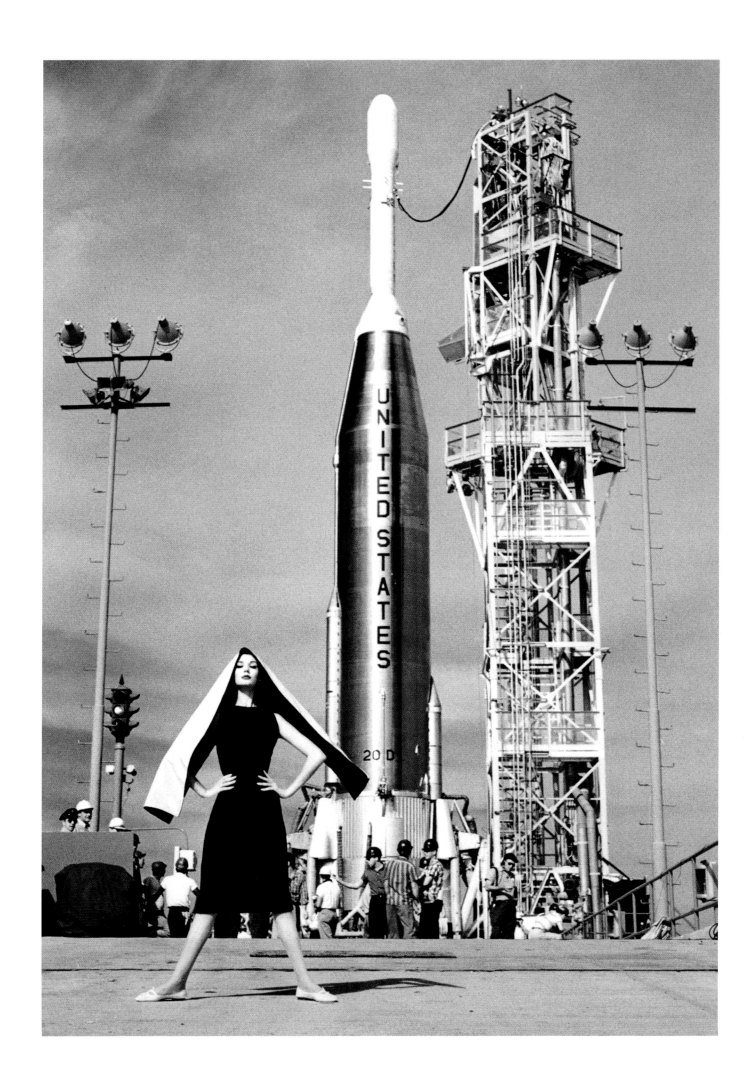

RICHARD AVEDON'S "CAPE CANAVERAL" PHOTOGRAPH FOR *HARPER'S BAZAAR*

of February 1960 presents the two most prominent forms of that decade, juxtaposed to emphasize their confluent flights: the American ready-made—legs spread in an impregnable stance, dressed in a black Pauline Trigère sheath as utilitarian as it was chic—and behind her the looming figure of a United States space shuttle, its metallic façade hardened and reflective. As this image found its way to coffee tables all over America, the country's citizens sat poised, waiting to witness the first successful human launch into space, enlivened by the ambitions of a youthful administration. Global microcosms of art, design, and fashion churned out orbit-worthy commodities, distinctive in their curvilinear shapes and untarnished white surfaces, as if to signify a homogenous societal dedication to progress. American Airlines offered Coty-designed jet-age fashions nationwide at Gimbels, while *Harper's Bazaar* affirmed that Yves Saint Laurent's "wavy navy chevron stripes have really launched something—a zig zag trail to ignite the Milky Way." In fact, space-age design, with its distinctive aesthetic, provided the perfect guise for the tropes of modern fashion: bold, platonic structures and monochromatic color systems.

The "White-on-White" idea, as labeled by *Vogue* in July 1964, was omnipresent in the visual culture of the era and seemed to represent a clear break from the overly fettered, feminine New Look silhouettes of the previous decade. In *Concepts of Cleanliness: Changing Attitudes in France since the Middle Ages* (1988), Georges Vigarello argued the link between white clothing and historical notions of hygiene. The absence of color came to signify purity and newness, even serving as a fresh layer of "skin." In the 1960s fashion image, these implications were magnified by the lenses of aeronautical progress and futurism. As models leapt across pages in white sheaths topped smartly by pristine white helmets—over captions celebrating "Super Fashion!" and "Lunar Whites"—the white-clad mobile woman became a metaphor for a new modern era.

Molly Parkin, the fashion editor of *Nova,* a British magazine popular throughout the 1960s, recounted her own fascination for the clean white surface in explicit instructions to her staff: "White on white—white skinned models with bleached blonde hair flown in from Scandinavia, preferably albinos, wearing all-white clothes. . . . We'll fly them to the Alps and photograph them against the snow, just before dawn when the light is pure white." These bleached spreads were emphasized by the spare, graphic style of the photographers Hiro and Jeanloup Sieff, who used intense polarizing light to focus the eye on the silhouette of the model, clarifying her in immediate relief and positioning the garment as either unremarkable or "basic." In *White Walls, Designer Dresses* (1996), architectural theorist Mark Wigley stated, "The look of modernity is that of utility perfected, function without excess, the smooth object cleansed of all representational texture."

The whitewashed dress was also reductive in its A-line frame, angular seaming, and squared hems. Simple shifts and molded wool overcoats, though exemplified by the collections of the French designers André Courrèges and Pierre Cardin, were mass-produced both in the United States and abroad, and ultimately became tabula-rasa uniforms—blank slates akin to the rigid white structures of modern architecture. Cardin noted his good fortune to be "part of the post-war period when everything had to be redone."

Page 17: Photograph, Gösta Peterson, "Lunar Whites," *Harper's Bazaar*, August 1966; dress by Georgia Bullock and hat by Mr. John. Opposite: Photograph, Richard Avedon, Dovima, dress by Pauline Trigère, Cape Canaveral, Florida, November 1959. © 2010 The Richard Avedon Foundation.

When applied to the saturated colors and basic shapes of early 1960s ready-to-wear, the words of the modern architect Le Corbusier's "Letter to William Ritter from Pisa" (1911) become poignant: "In their crazy course, red, blue, and yellow have become white. I am crazy about the color white, the cube, the sphere, the cylinder and the pyramid and the disc all united and the great empty expanse."

By 1964 this "great empty expanse" was crystallized in a fusion of art and fashion in the pages of *Vogue*. "Fascinating this Minute," a six-page spread of models fitted in columnar gowns and positioned in front of works by Ellsworth Kelly, Frank Stella, Robert Morris, and Tony Smith, was an homage to the recently mounted exhibition at the Wadsworth Atheneum in Hartford, Connecticut, entitled *Black, White, and Gray*. The spread served to elucidate the interactivity of the visual arts at the time but also identified new movements in the art world for a larger consumer public. The curator, Samuel Wagstaff, cited the homogeneity of his inclusions, noting their "sparse aesthetic" and bland palette, which might prevent the viewer from becoming biased by "the emotionalism of color." When *Black, White, and Gray* opened in January 1964, Wagstaff explained that the works had "no subject, no emotion (showing), no handwriting, brushwork, space, or attempt to please or ingratiate." While many of the works in the show were flat canvases, just two years later this "sparse aesthetic" had evolved to wholly embrace a broader range of sculptural and relief forms more similar structurally to those celebrated in fashion. Curated by Kynaston McShine, the exhibition *Primary Structures: Younger American and British Sculpture* was mounted at the Jewish Museum in New York in 1966; the show surveyed a group of "new" works that the critic Richard Wollheim had first referred to as "minimal" in 1965.

The explicit linguistic reference to minimalism appeared in fashion shortly thereafter: in conjunction with the close of *Primary Structures,* the editors at *Harper's Bazaar* identified a "minimal look" and raved about "the new dazzling directness, pure form fashions conveying chic with minimal statement for maximal response. All lines clear; all edges clean." In *Minimalism: Art and Polemics in the Sixties* (2001), the art critic and historian James Meyer stated, "The 'minimal look' expressed a futurist ethos, sixties style that was utterly in sync with the bright-hued, machine-made aesthetic lionized by '*Primary Structures*.'" Diverging from the emotionally wrought canvases of Pollock's abstract expressionism, the bare, sculptural forms of Donald Judd, Robert Morris, and Carl Andre strove to omit both artist's imprint and message, beckoning the viewer with only the familiarity of their common anatomies—cube, pyramid, or rectangle. They relied on visual reductivity to convey a straightforward, machinist phenomenalism, intentionally both elementary and highly imitable. Minimalism is, in many ways, a movement forever entangled with the history of modernism, absorbing and resuscitating its ideals of unfettered lines, basic shapes, streamlined design, and, ultimately, social progress.

While the minimalists carved out a distinct niche in the New York art world from 1960 to 1966, exhibiting at trendy galleries such as Leo Castelli and Sidney Janis, their sensibility had been accrued osmotically via the historical precedents of geometric abstraction and the contemporary trends toward hard-edged design. Meyer noted the near blindness of minimalists such as Judd and Stella to any preceding avant-garde artistic contingents, yet the unmitigated planes and color-block composition of their works certainly owed

a great deal to the revolutionary-era suprematist canvases of Russians Kasimir Malevich and Liubov Popova. Suprematist art focused on fundamental geometric forms in order to signify a "new beginning," and the works of the minimalists similarly strove to break from classical Western traditions in painting and sculpture in order to configure a futurist vocabulary from which all aesthetics could be cast. The minimalist legacy inevitably relies on the trajectory of geometric abstraction that can be traced back to the modern avant-garde movements of early twentieth-century Europe and Russia. In particular, the aesthetics of the 1960s were unarguably derived from the streamlined forms of the 1920s: the hard edges, severe lines, and platonic constructions of both the 1920s and the 1960s reinforced a linear modernist sartorial dialogue that was somewhat absent from the fashion imagery of the three decades in between.

The look of the mid-century minimal movement, both in art and in fashion, emerged in its early years as an inadvertent homage to the abstract traditions of the suprematists, the constructivists, and the De Stijl movement, in effect drawing from various factions of the modernist lexicon. The repetitive and simplistic employ of the circle and the square as foundation structures of suprematism informed the minimalist goals of geometric abstraction and nonfigurative composition. Margarita Tupitsyn, the editor of the Tate Gallery's 2009 exhibition catalogue *Rodchenko & Popova: Defining Constructivism*, explained, "Popova's tireless experiments with the tenacious symmetry of grids and linear configurations, at times as minimal as technical drawings, and her insistence on flat material definitions of colour, provide a new historical background against which we may read a formal vocabulary of 1960s American abstraction, including the early steps of the Minimalists."

Popova, along with Varvara Stepanova, was one of the few successful female artists in Russia during the early decades of the twentieth century, having been given every opportunity to utilize the vast foreign education in art and history provided by her affluent background. Employing the draftsman's tools, she created textile designs alongside her drawings, ultimately adhering to the constructivist's agenda of geometricizing everyday life. Although her garments were never produced en masse as she had hoped, Popova's textile sketches and fashion collage work were frequently identified in constructivist and artistic literature, and ultimately graced the cover of Vladimir Mayakovsky's productivist magazine *Lef* in 1924.

Popova's administration of interleaving flat panes of color to create a layered, abstracted whole positioned the garment on an equal plane with the figure and elucidated what Dadaist Max Ernst once described as "a gesture of rebellion against the relationships, the functions, and the hierarchical scale between objects." In a window-display collage from 1924, Popova juxtaposes Western-style dress, simplified by linear patterning and generous lengths of frictionless fabric, with the automobile, effectively allowing them comparable physical proportions and equal gravity as twin symbols of a pervading capitalist consumer environment made possible by Russia's New Economic Policy of 1921. The 1960s image-maker Guy Bourdin cleverly toyed with the same parallels in a fashion photograph for French *Vogue* some forty years later.

The boxy hard-edged suits and straight shifts Bourdin captured two-dimensionally were modernized forms of the sack dresses and sailor styles of Popova's 1920s. These 1920s shapes were recalled regularly in 1960s cinema, both in the Givenchy-designed wardrobes of Audrey Hepburn and in French New Wave

Above: Collage design
for a window display, Liubov
Popova, Summer 1924.
Opposite: Photograph,
Guy Bourdin, French
Vogue, July 1966.

films such as François Truffaut's *Jules et Jim* (1962). Where the automobile was the consumer machine par excellence of the 1920s, the formidable towers of modern architecture embodied 1960s industrial progress. The Pan Am Building (now the MetLife Building), designed by Emery Roth & Sons with the help of Walter Gropius and Pietro Belluschi, was built in 1963 and exemplified the iron grid of architectural modernism. Set as a background neither obscured nor diminished by the models' forms, the building becomes another flattened shape in Bourdin's collagist jumble of unyielding planes.

Whereas the textile and clothing designs of the constructivists retained the collapsed, two-dimensional qualities of their canvases, the 1920s sartorialists of Paris began to form interlocking geometries to cloak an actual body. Sonia Delaunay, who designed rugs, screens, textiles, and ultimately fashions by the mid-1920s, opened a fashion atelier in 1924 with the designer Jacques Heim. Married to the painter Robert Delaunay, Sonia clearly was inspired by his representational, fragmented forms. Yet whereas Robert's creations were impressionistic and figurative, informed by frenetic cubo-futurist planar cutting, Sonia's textiles were straightforward geometries built from honest lines and even shapes. Her fabrics were embroidered with concentric squares and triangles that wound their way around the female body.

In *New York Fashion* (1989), historian Caroline Rennolds Milbank deciphered the broad trend of linear patterning and abutting planar juxtapositions in 1960s textiles, which owed their decorations to the geometric formations of the 1920s garment. Milbank stated, "Donald Brooks and other designers used black and white in gigantic stripes, chevrons, ziggurats, and checkerboards. . . . To them, the more graphic a pattern, the better it was." These angular compositions stimulated the otherwise basic shapes of 1960s ready-to-wear, providing a dynamic interplay that not only enlivened the broad canvases of midi skirts and straight-cut shifts but also became the visual focus of the ensemble. The designer Rudi Gernreich, famous for his "total look" ensembles of tunics, body stockings, boots, and even hoods printed with matching animal markings, utilized the geometric print as a mask for the dimensionality of the garments themselves. Gernreich's prints were duotone and found more commonality with the constructivist canvas than the fettered gowns of predecessors Christian Dior or Pierre Balmain.

Fashionable façades built from hard-edged shapes and marked black lines spoke as well to the frenzied

pace of modern life for the 1960s woman. An August 1966 *Harper's Bazaar* editorial featured a Gernreich-esque ensemble of zigzagging lines by Robert Sloan, complete with a helmet by Paco Rabanne. The spread, entitled "High Gear," was annotated with the caption "Rush hour. Colors, beeping bright. Lines, road-divider bold. Zigzags like frenzied traffic patterns. Black and white darting zigzags." Confluent with the larger op art trend, such textiles provided no organization for the viewer's eye but instead championed a composition inherently flat in its uniform rhythms. Although not strictly minimal in decoration, these frenetic patterns did interject the minimalist conceit of anticompositionality via an indeterminate visual organization. Fashion photographers echoed the haphazard quality of these zigzags, polka dots, and curvilinear repeats in off-kilter or asymmetrical compositions within the frame of the magazine page. In the "High Gear" image, photographer James Moore obscures the divisions between planes of fabric, offering only a face, leg, and forearm to discern the corporeal cocoon of abutting zigzags, but in a spread entitled "See Paris," meant to convey the trends of the Spring 1966 season, he uses groups of models to affect his uneven layouts. With one body teetering over another, each ensemble a permutation of the last, the structure of each photograph is itself asymmetrical. In the image of Yves Saint Laurent's designs, formerly organized planes of zigzagging

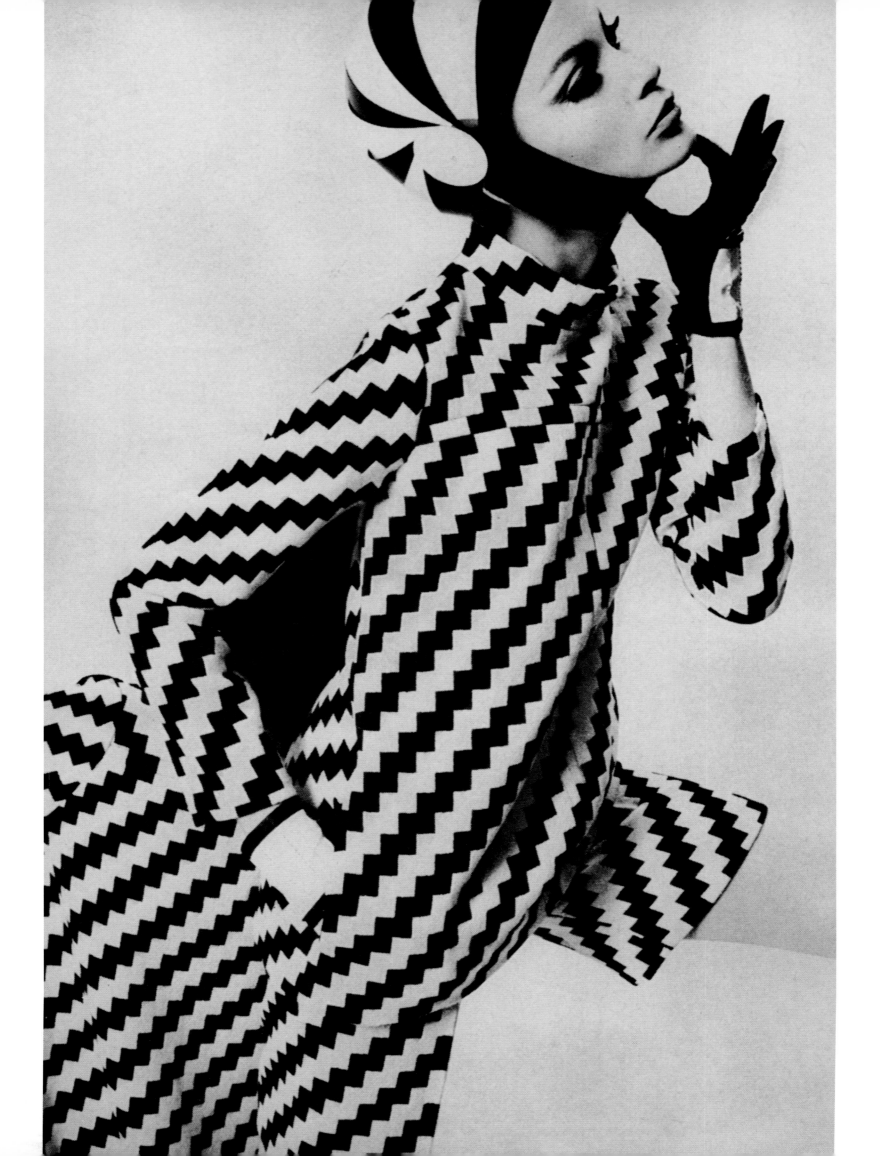

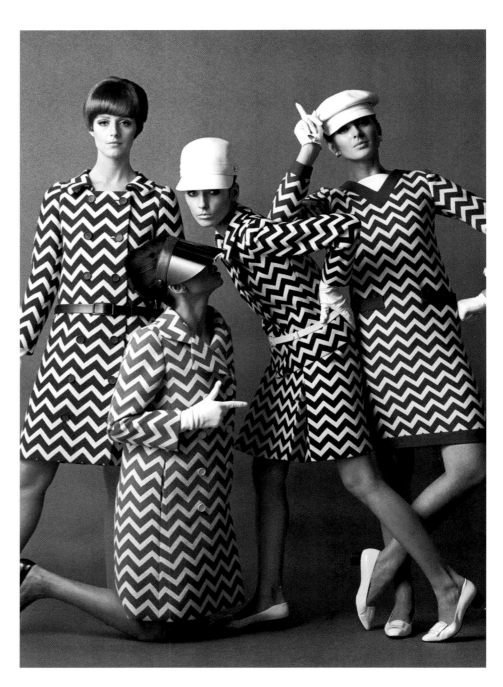

Top: Photograph, James Moore, "See Paris," *Harper's Bazaar*, March 1966; ensembles by Yves Saint Laurent. Bottom: Sol LeWitt, *Wall Drawing*, 1960.

lines are muddled by the crease of a skirt pleat or shoulder seam, becoming ultimately unreadable as rigid platonic shapes. Moore utilizes the same spoilers as those found in Sol LeWitt's *Wall Drawing* (1960). At the Museum of Modern Art in New York, LeWitt, a famed minimalist, created abstract reliefs such as *Wall Structure, White*, and *Wall Structure, Black* but became best known for his modular building blocks of the mid- to late 1960s. In *Wall Drawing* his crescent arcs seem at first glance to move in rolling diagonal waves across the canvas, though upon closer inspection, the broken, intersecting, and fading lines remove any discernible compositional consistency.

De Stijl artists such as Piet Mondrian celebrated the chaos and disorder of the anticompositional canvas as well. In *Art Yearbook 4* (1961), Charmion Wiegand recounted a "story about Mondrian in New York dancing to his beloved boogie-woogie, when in midstream the band switches to another kind of jazz. 'Let's sit down,' Mondrian said to his partner, 'I hear melody.'" Saint Laurent's 1965 "Mondrian" dress, a basic shift with the surface markings of the famed painter's signature canvases, materialized the decade's persistent referencing of early twentieth-century avant-gardism and fused its geometric principles with the tangible pared-down minimalist shape. Unlike Mondrian or Malevich, however, his minimal aversion to formal composition was based more on the desire to extract any expressivity or emotion than on a need to create balance or momentum out of asymmetry. The minimalists strictly rejected premeditated composition, which was construed as a measure to convey meaning and was therefore an irrelevant factor in the movement toward complete reductivity. Meyer cited Donald Judd's explicit dismissal of such formal composition: "Judd held that linguistically construed 'ideas' were an unneeded supplement, if not a hindrance, in the experience of visual art."

Transforming his painted works of the late 1950s into his *Line* drawings of 1960–61 and ultimately into benchmark minimal objects that would come to illuminate the movement throughout the 1960s, Donald Judd was credited as an early champion of minimal art. His simultaneous roles as a critic for *ArtNews* (beginning in 1959), *Arts Magazine*, and *Art International* as well as the author of the seminal minimalist manifesto "Specific Objects" (1965) provided him a multitude of platforms from which to create a public discourse for the works that are now known as minimal and, ultimately, to establish their tenets.

Above: Frank Stella,
Tuxedo Park, Black
Series II, 1967. Opposite:
Photograph, David Bailey,
Queen, February 1964
(unpublished).

If Judd was minimalism's spokesperson, then Frank Stella was its muse. Stella's unapologetic lines of graphic geometry, executed as early as 1952, had by the end of the 1950s become templates for monochromatic flatness and—with their hardened enamel surfaces—purveyors of a machinist sensibility. Stella's *Black Paintings* were particularly coveted for their emotional negation and, programmed by the shapes of their blackened compositional geometries, came to embody a directness that would be associated with American art and, eventually, minimalism throughout the 1960s. Stella's personal statement, written by peer Carl Andre for the Museum of Modern Art's 1959 *Sixteen Americans* exhibition catalogue, served not only to outline the artist's own intentions but also to elaborate the aims of a particular sector of the New York avant-garde at the time:

> Preface to Stripe Painting
> Art excludes the unnecessary.
> Frank Stella has found it necessary to paint stripes.
> There is nothing else in his painting.
> Frank Stella is not interested in expression or sensitivity.
> He is interested in the necessities of painting.
> Symbols are counters passed among people.
> Frank Stella's painting is not symbolic. His stripes are the paths of brush on canvas. These paths lead only to painting.
> —Carl Andre

Tuxedo Park exemplifies the artist's strategy of simultaneously challenging and delineating the limits of the framed canvas. According to Robert Rosenblum of *Artforum,* Stella's designs, as ceaseless interchanges between geometric arrangements of stark black stripes, reiterated "the simple perpendicular and parallel relationships of the frame. No forms overlapped. None seemed secondary. Instead, the entirety of the rectangular field was recognized as being of one importance. The picture could no longer be reduced to major and minor components, but had to be accepted as a whole, as a flat and irreducible object." In David Bailey's 1964 photograph of muse Jean Shrimpton for *Queen* magazine, the frame fails to contain Shrimpton's full silhouette, cropping her torso and editing out her limbs. The image's borders effectively abstract the human body on which the sartorial covering relies, thereby making the garment unreadable as a coat. Through Bailey's lens, focused on blurred vertical lines, the covering becomes an autonomous object akin to Stella's geometric canvas and is similarly unwilling to define the body beneath it.

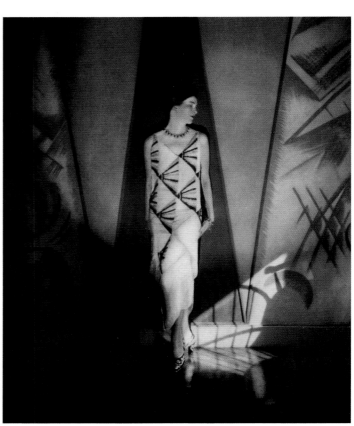

The early minimalist dialogue between flat geometry and sculptural form is particularly relevant to fashion's relationship between textile and garment. The basic forms of 1960s clothing—the cube, the cylinder, the conical sheath—were the perfect reductive shapes to champion either graphic print or uninterrupted monotone, but their platonic constructions would not have been possible without the historical precedents created by the couturiers Madeleine Vionnet and Paul Poiret. Harold Koda and Andrew Bolton, curators at the Metropolitan Museum of Art's Costume Institute, assessed the latter's unique sartorial methodology in the exhibition catalogue *Poiret: King of Fashion* (2007). They explained, "Poiret advocated fashions cut along straight lines and constructed of rectangles. Such an emphasis on flatness and planarity required a complete reversal of the optical effects of fashion. The cylindrical wardrobe replaced the statuesque, turning three-dimensional representation into two-dimensional abstraction. It was a strategy that dethroned the primacy and destabilized the paradigm of Western fashion. Poiret's process of design through draping is the source of fashion's modern forms."

Although less informed by drapery than additive construction, Vionnet's sartorial blueprints also influenced the monumental geometric forms of mid-century modernity, freed as they were from the two-dimensional decree of "front" and "back." In Edward Steichen's photograph, which appeared in *Vogue*'s June 1925 issue, the photographer positions a silk crepe de chine Vionnet sheath, its triangular insets elaborated by embroidered panels of gold, black, and silver bugle-bead embroidery, in front of a painted wall. The somewhat illusory shapes of the studio set are flattened by the enigmatic dimensionality of the gown itself. Vionnet's fan embroideries, both painterly and sculptural as they curve around side seaming, anticipate the visual manipulations of Frank Stella's and Ellsworth Kelly's paintings of the late 1950s and early 1960s. *Artforum* critic Henry Geldzahler noted, "Ellsworth Kelly's work is an advance in presentation and construction. The colors are fewer, the forms more simple and repetitive than would seem possible in a rich and rewarding work of art. Yet the effect is compelling and complex. Even in terms of Kelly's own history of minimal forms and shapes and colors, the new work does exactly enough with astonishingly little." In *Untitled* (1960) Kelly zigzags a broad black band across the canvas, carrying its line off the edge. This allowance, "exactly enough," ultimately defines the plane of the painting, affording a continuous reading of negative space and wall as the ground for the fore shape.

The notion of objecthood was used to define the parameters of a work physically and conceptually for the minimalists and offers the most compelling explanation for a critical reading of high fashion, positioned as it is between utility and art, sculpture and shelter. In "Specific Objects," Donald Judd explained that the minimal work must reject the monikers of both "painting" and "sculpture," as these terms would be forever entangled with traditional art-historical concepts and presuppositions. Although generally unwilling to identify precursors to minimal thought, especially those from Europe (with all the various implications of Old World formalism still somewhat intact), Judd did cite the work of Yves Klein and Enrico Castellani as inspirations. The Italian artist Castellani founded the journal *Azimuth* in 1959 with Piero Manzoni and dedicated its content to the fundamental goals of modern representation. Castellani's own works, like Stella's, sought to be self-expressing entities and intimated the exquisite capabilities of Vionnet's

Opposite, left: Ellsworth Kelly, *Untitled*, 1960. Opposite, right: Photograph, Edward Steichen, *Vogue*, June 1, 1925; dress by Madeleine Vionnet.

and Poiret's oeuvres. By removing themselves from any a priori classification, Vionnet and Poiret flirted with the interstitial spaces between dimensions. This blurring of distinctions between sculpture, clothing, and even architecture was reinforced by the undercurrent of futurist thought that had been present since the dawn of the modern era. The Italian illustrator Fortunato Depero, a proclaimed futurist, envisioned the hard edges of the 1920s visage, a prophecy of mid-century minimalism, as an unbroken line between body, garment, and building. Judd realized this vision with his first three-dimensional objects in 1962—these stacked boxes or cubes derived directly from his painted squares and seemed as if they had literally crawled off the canvas and onto the floor. These works adhered fairly conservatively to the principles of minimal work illuminated in *Primary Structures*, guidelines that Judd, along with the show's curators and fellow minimal artist LeWitt, had helped to establish. Judd's minimalist structures, grounded by preexistent tectonic formations, echoed the larger visual tendency of the 1960s to reduce. Now positioned on the gallery floor as opposed to a platform or pedestal, minimal works were defined neither by traditional scale nor figurative composition. They effectively became so reductive that in 1966 Charlotte Willard of the *New York Post* allied their foremost concerns with those of modern architecture: "space, volume, movement, and light."

Broadly disinterested in traditional craftsmanship, minimal art and fashion objects utilized sleek, architectural materials to purge their façades of idiosyncrasies. While vinyl and leather superseded silk crepe or nubby wool in the more avant-garde or explorative fashions, Judd, like Lewitt, turned to specialized workshops to execute his basic shapes in the synthetic mediums of postindustrialist production. *Untitled (DSS#41)* was part of Judd's Cadmium Red series, which utilized a color that would delineate the contours and hard edges of his work and thereby articulate its presence. Judd's attention to the "edge" in determining the physical boundaries of an object was reinforced by Gilles Deleuze, an influential philosopher in the 1960s and 1970s. Deleuze described the edge as the authoritative divider of inside and outside in constructed form. Judd's plenary application of cadmium red served the dual purpose of providing an un-nuanced surface. Where white was too "pure" and black too "expressionistic," cadmium red held no prior symology for the onlooker. By 1964 cubes and slabs of Formica, rolled steel, and Plexiglas replaced Judd's early wood prototypes, thereby allowing the viewer to perceive an object devoid of visual distractions.

Where Judd used steel, couturier Cristóbal Balenciaga worked with duchesse and stiffened gazar silks to create architectural clothing that was neither bolstered by a corset infrastructure nor adherent to the human body's natural shape. David Bailey photographed the designer's "Bride" dress for a spread entitled "Marvels of Form" for *Vogue*'s July 1967 issue. The images attested to the impressive restraint of Balenciaga's designs. The conical "Bride" gown was molded from only three seams connecting two extraordinary lengths of gazar: one at each shoulder and one down the center back line. Bailey's blank backdrop and dramatic lighting showcase the sculptural qualities of the garment as well as its kinship with decorative objects such as Grete Jalk's 1963 laminated oak chair for Paul Jeppesen or Vernor Panton's eponymous chair. Such furniture was generally more organic in line and, in Panton's case in particular, more figurative than the era's minimal objects. Yet in many ways Panton's chair prophesized the evolution of minimal shapes, which for LeWitt had been transformed from "lines, angles, and cubes" to "ziggurats, irregular pyramids, and polygonal solids" by the following decade.

Opposite: Donald Judd,
Untitled (DSS#41), 1963.

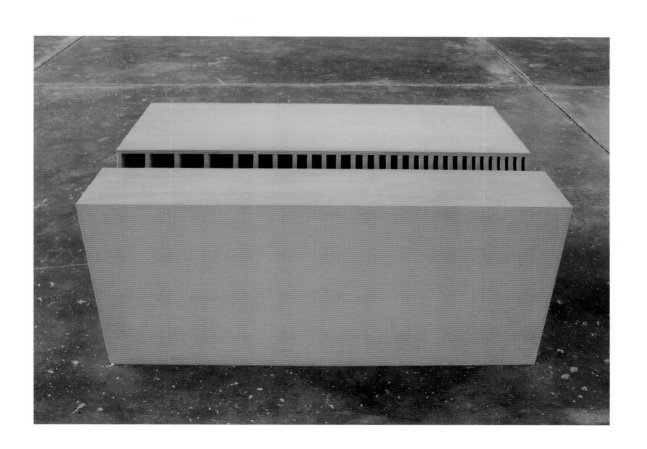

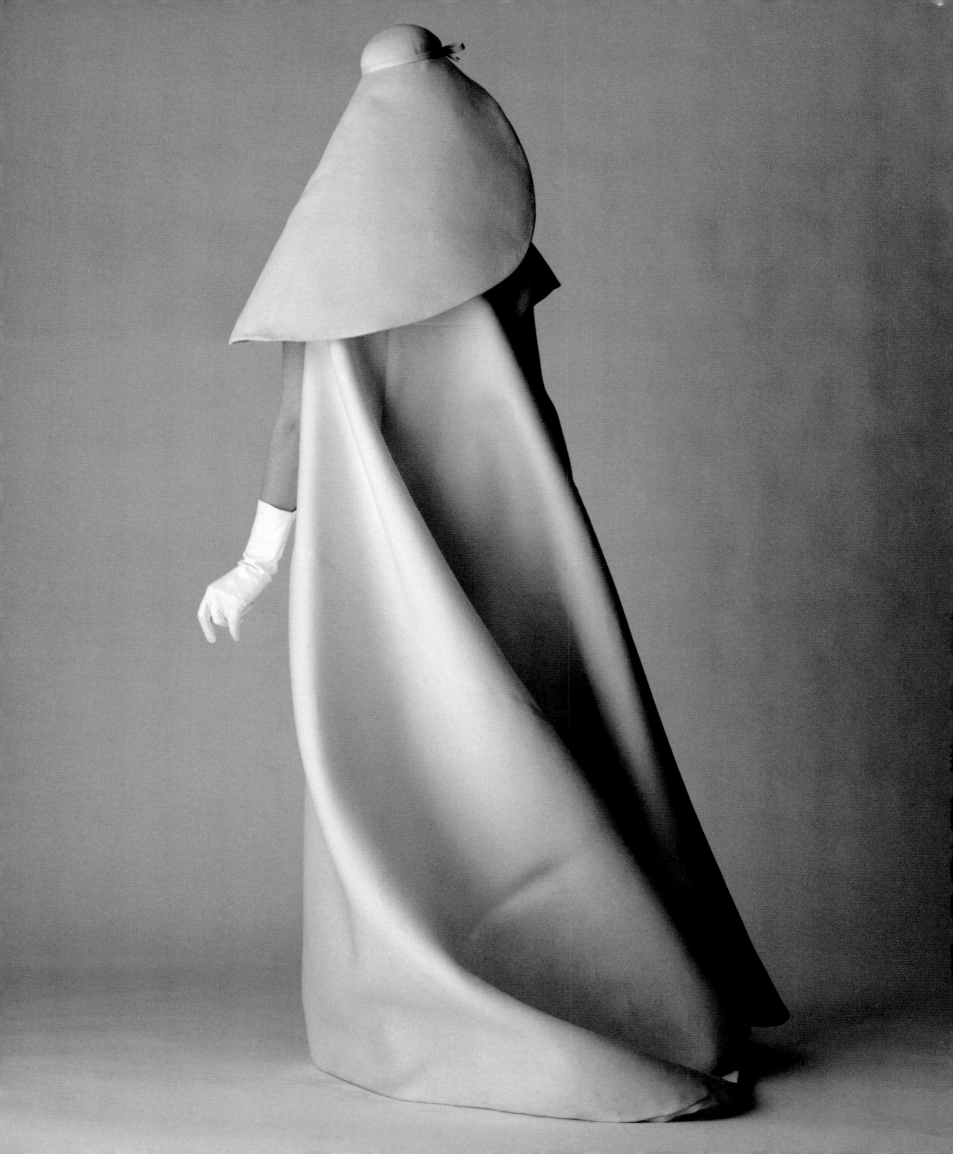

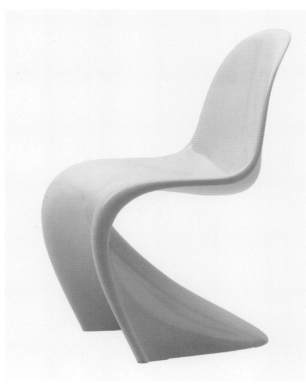

Opposite: David Bailey,
"Marvels of Form," *Vogue*,
July 1967; "Bride" gown
by Cristóbal Balenciaga.
Top: Sol LeWitt, *Complex
Form #46*, 1989. Bottom:
Vernor Panton, *Panton
Chair*, 1960.

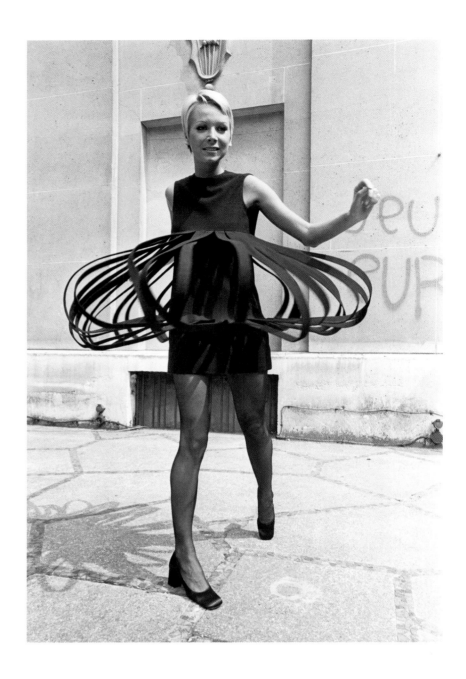

Above: Dress, Pierre
Cardin, 1969. Opposite:
Cover, James Moore,
Harper's Bazaar, May 1964.

Irrespective of the uniform architectural aesthetic of 1960s, or perhaps because of it, the creative fields of fashion and art would also coalesce within the minimalist discourse on the basis of what critic Rosalind Krauss called the "lived perspective." While Judd embraced the literal qualities of his structures in order to emphasize their physical presence as respective autonomous forms, the sculptor Robert Morris developed his own caveat to minimalist doctrine, which included the gestalt psychology of perception. Meyer stated, "What distinguished Morris's sculpture for many observers was its installational character . . . it sought to reveal the room in which it was placed." Morris felt that the pared-down, even bare nature of minimalist works was waiting for the viewer's digestion. His perspective precedes the declaration of French literary theorist Roland Barthes that "the death of the author" is "the birth of the reader."

In the *Harper's Bazaar* cover for May 1964, James Moore captured a woman encased in a fragile white dome cape, itself reliant on her frame to inflate its globelike structure. Neither the naked body nor the cape is autocratic: as equally reductive components to the image, set against a white ground, they rely upon each other for an accurate representational reading. Just as Morris's shapes and unitary forms required a reader to move around, under, and even through them, so too did the platonic sartorial discs and rectangles

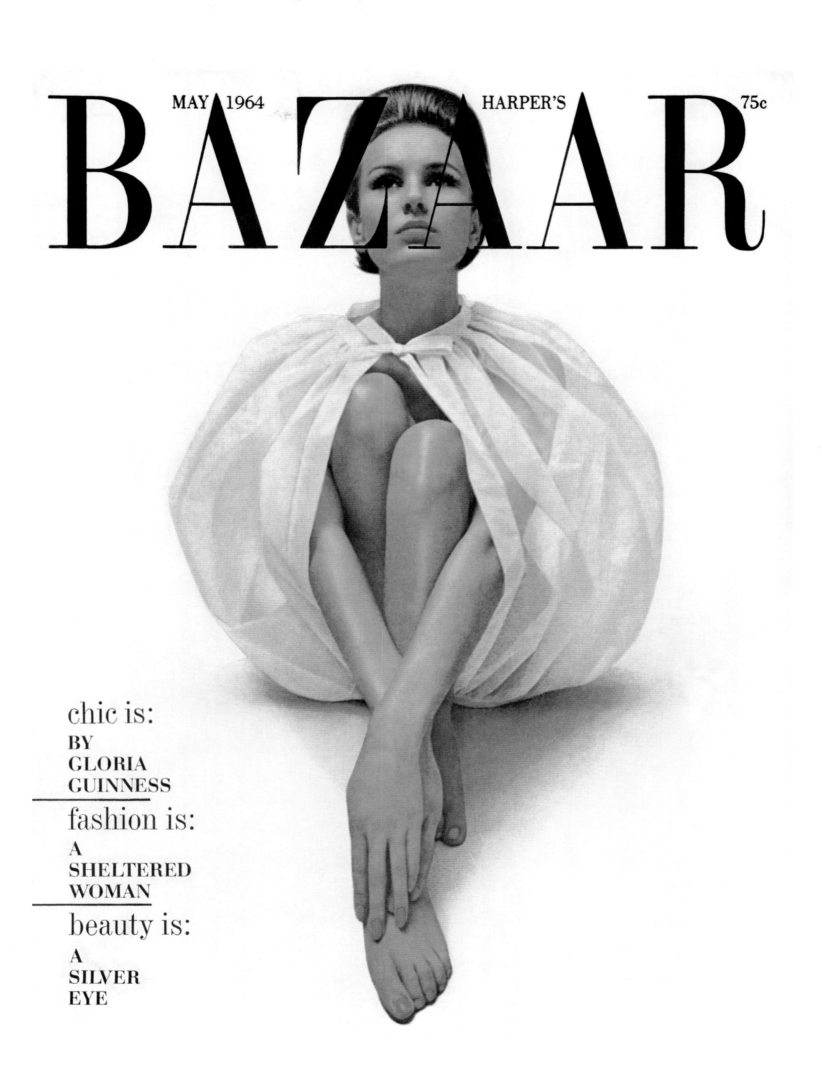

MAY 1964 HARPER'S 75c

BAZAAR

chic is:
**BY
GLORIA
GUINNESS**

fashion is:
**A
SHELTERED
WOMAN**

beauty is:
**A
SILVER
EYE**

Photographs, Gösta
Peterson, "One Minute
from Now," *Harper's
Bazaar*, May 1966.
Left: Dress by Oscar
de la Renta. Right:
Dress by John Moore.

configured by Poiret, Vionnet, Courrèges, and Cardin require a wearer to clarify their objecthood. A photograph of Pierre Cardin's 1969 car wash dress demonstrates the same transformation: as a blackened column with applied band loops, the design is "seen" only through the mobile body's lived perspective. Cardin acknowledged the relationship between the body and its exterior casing when he explained, "The dress is a vase which the body follows. My clothes are like modules in which bodies move."

The photographer Christian Simonpietri's street shot of Cardin's dress alludes to the ready-made quality of minimal fashion and art during the 1960s, but the more formal fashion photographs of the era generally placed the model in a location-less environment, distinctive only for its relationship to the futurist compositional entity of empty space or the geometry championed by the clothing itself. In *Individuals: A Selected History of Contemporary Art, 1945–1986,* Hal Foster explained the compelling minimalist strategy: "In short, with minimalism, 'sculpture' . . . is repositioned among objects and redefined in terms of place. In this transformation, the viewer, refused the safe, sovereign space of formal art, is cast back on the here and now; and rather than scan the surface of a work for a topographical mapping of the properties of its medium, he or she is prompted to explore the perceptual consequences of a particular intervention in a given site." Aligned with Morris's environmental reading of the minimal aesthetic, the editorial "One Minute from Now" by Gösta Peterson for *Harper's Bazaar* (May 1966) features two dresses configured from interpenetrating dark and light panels, echoed both by the dividing lines of the studio backdrop and the angular positing of the models' limbs. The spread utilizes the minimalist vernacular, incorporating various analogous components to affect a total minimal experience: the garments themselves are authorless interpretations of common shapes, built from rigid materials and contextualized within a larger composition of spare forms and hard edges.

When *Primary Structures* opened in 1966, the markings of Stella and Kelly had already influenced the graphic prints of Rudi Gernreich and Donald Brooks. The forms of Judd, Andre, LeWitt, and Morris grew from and informed the creations of Courrèges, Cardin, and countless others. Minimalism was everywhere—from sculpture to jewelry, from furniture to fashion. Photographer Brian Duffy's "bust" of actress Ursula Andress in a James Wedge–designed white and green acetate helmet composed simply of dome crown and

Above: Suit, Yves
Saint Laurent, 1967.
Opposite: Photograph,
Brian Duffy, British
Vogue, April 1966
(unpublished); Ursula
Andress in a hat
by James Wedge.

crescent visor coincided with her role in the James Bond parody *Casino Royale,* directed by John Huston in 1967. Having starred in the first Bond movie, *Dr. No,* in 1962, Andress was the perfect icon to spoof. Her persona was further stylized by the simplicity of the circle and square as minimal forms. Duffy's image, a paradigm of the early minimal look, was conversely a caricature of the era's shiny plastics and monochromatic sterility—a snapshot of a futurist pastiche.

Although the proto-futurist machinations of the 1960s were outmoded by the decade's close, the geometric composition, disciplined reductivity, monochromism, and pedestrian accessibility of the style would endure as the mainstays of a minimalist undercurrent in sculpture, architecture, decorative arts, and, of course, fashion. The ongoing presence of this aesthetic owes much to its democratic nature; the appropriation of the minimal look was facilitated by the ease with which one could identify and absorb a straightforward visual vocabulary of primary shapes, or as Frank Stella famously stated: "What you see is what you see."

In 1967, Yves Saint Laurent decorated his iconic Le Smoking with the stripes of the minimal canvas—in this case, Stella's—to configure a suit as modern as it was adherent to traditional menswear. The ensemble was simple, approachable, and, most importantly, imitable enough to be copied by department stores and specialty boutiques. Alongside the platonic sculpture or the geometric painting, the restraint of the 1960s tailored suit illuminated an innovative aesthetic of reduction. With the media of art, fashion, photography, and film aligned in their common exploit of minimal imagery, the status of the minimal object as a commodity, and moreover as a modernist currency, was clarified.

"IF ARTISTS WERE IN HE
ARE IN BUSINESS."

LL IN 1946, NOW THEY

—Alan Kaprow, *Essays on the Blurring of Art and Life*, 1993

2.

The Ready-Made

IF THE HISTORY OF MODERNITY IS RELIANT ON THE TRIUMVIRATE RELATIONSHIP

between women, glamour, and commodity, as Peter Bailey, Stephen Gundle, and, most recently, Caroline Evans have argued, then the 1960s was a critical juncture in this history, specifically with regard to fashion. The growing ready-to-wear market, coupled with the eventual emergence of the prêt-a-porter, facilitated the new consumer's desire for a pared-down, easily reproducible style. As fashion, design, and even art consumption became less dependent on the trickle-down effect and more attentive to democratization and universal socioeconomic promotion, minimalism created a vocabulary of easy dressing that would come to define modern fashionability.

In *POPism: The Warhol Sixties* (2006), Andy Warhol and Pat Hackett asserted, "The idea that anybody had the right to be anywhere and do anything no matter who they were and how they were dressed, was a big thing in the sixties." The girl on the street, as both consumer and influencer, echoed and enriched the welcoming experiential environments of the minimalist gallery and the fashion boutique. Architect Hans Hollein's design for the Austrian CM boutique, an exemplar of modularity both enhanced and sterilized by white Formica shelving and silver leather furniture, was reiterated ad infinitum in the store's mirrored walls. In a 1968 series of promotional images for CM, fashion model Katharina Sarnitz becomes the "every girl": her isolated posturing clarified alternate roles, as inorganic commodity and beguiling consumer.

The boutique culture of the 1960s worked in tandem with New York's art galleries, including Tibor de Nagy, Betty Parsons, Green, Leo Castelli, Sidney Janis, and André Emmerich, among others, to expedite the consumption and recognition of the minimal object and the canonization of minimal artists and designers. As minimalism became a more approachable and commercially viable aesthetic in the late 1960s and early 1970s, an outcropping of European dealers such as Konrad Fisher and Rudolph Zwirner as well as middle-American vendors like Ronald Greenberg and the Locksley Shea Gallery in Minneapolis became avid collectors. In *Blam! Explosion of Pop, Minimalism and Performance: 1958–1964* (1985), Barbara Haskell remarked on the increased efficiency of artistic commerce by the mid-1960s: "Works of art were heralded almost as soon as they were produced; artists achieved renown and financial success at remarkably young ages."

Circumventing the gallery promotion of minimalism, *Vogue* and *Harper's Bazaar* printed quotations from artists Dan Flavin, Robert Smithson, Carl Andre, and others as a way to acclimate middle-class taste to the aesthetics of minimalism by pointedly fusing the dictates of minimal art and minimal fashion. James Meyer identified this merging strategy as pulling "the highbrow into congress with the middlebrow, blurring the distinction between those spheres; it lent the authority of fine art to design while conferring the glamour and publicity of fashion to fine art." Although minimalism began as a high-art movement, conceptually— and even aesthetically—incomprehensible to the average consumer, the massive mechanisms of popular fashion, conditioned as they were by the pre-minimalist forms of modern dress, transformed the trend into a consumable and covetable culture-sell. In *Adorned in Dreams: Fashion and Modernity* (2003), Elizabeth Wilson affirmed fashion's capacity to disseminate the minimal lifestyle, identifying "the peculiar role

Page 45 and opposite: Model Katharina Sarnitz in the CM Boutique by architect Hans Hollein, 1968.

played by fashion in acting as a kind of hinge between the elitist and the popular."

Another vehicle for the translation of minimalism during this era was the persona of the progressive female herself. This ideal was particularly noticeable in the pages of *Nova*, as the magazine's editors noted: "The whole magazine, both visually and editorially, was creating a running portrait, a definition of the 'new' woman." The emergence of New Wave photography in fashion magazines, advertisements, cinematic posters, and nearly every other promotional surface of 1960s commodity culture served to liberate the decade's "Single Girl" from the spurious matriarchal and sedentary environment of the studio and place her instead on the streets, in the dance clubs, and traveling the world. Located on any given urban block, the New Woman became part of an infinite system in which the expanse of streets, sidewalks, and buildings always extended beyond the frame.

The photographic historian Polly Devlin explained, "For the first time fashion and clothes began to come from the streets up," in large part due to "the photographic partnership of David Bailey and Jean Shrimpton." Perhaps the duo's most iconic images, the "Young Idea Goes West" series featured in *Vogue* in April 1962 represented a turning point not just in fashion photography but in the purpose of the fashion editorial as well. Suddenly, the constructive details of clothing were all but indecipherable. Bailey helped to actualize fashion's intent to sell a lifestyle that was at once covetable and accessible, built from an endless rotation of interchangeable separates reliant neither on the embroiderer's needle nor the luxury loom. These minimalist garments were valued instead for their fresh, young cuts and simple, curvilinear shapes. The label, alternately derived from either the couture atelier or the department store, had become nearly the only distinction in the minimalist lexicon of the modern wardrobe, as the shapes and raw materials were essentially similar. The "It" commodity was not this jacket or that dress but instead the persona of the youthful, minimally clad fashionista. Recognizing the popularity of his 1960s images, Bailey tellingly quipped, "I never cared for fashion much, amusing little seams and witty little pleats: it was the girls I liked."

Motion and the angular, anxious permutations that it produced were central to Bailey's imagery and to that of his contemporaries, and the automobile, though previously employed in advertisements of the 1920s to embody newfound mobility, was easily recast as the backdrop for the 1960s fashion editorial. Paco Rabanne's

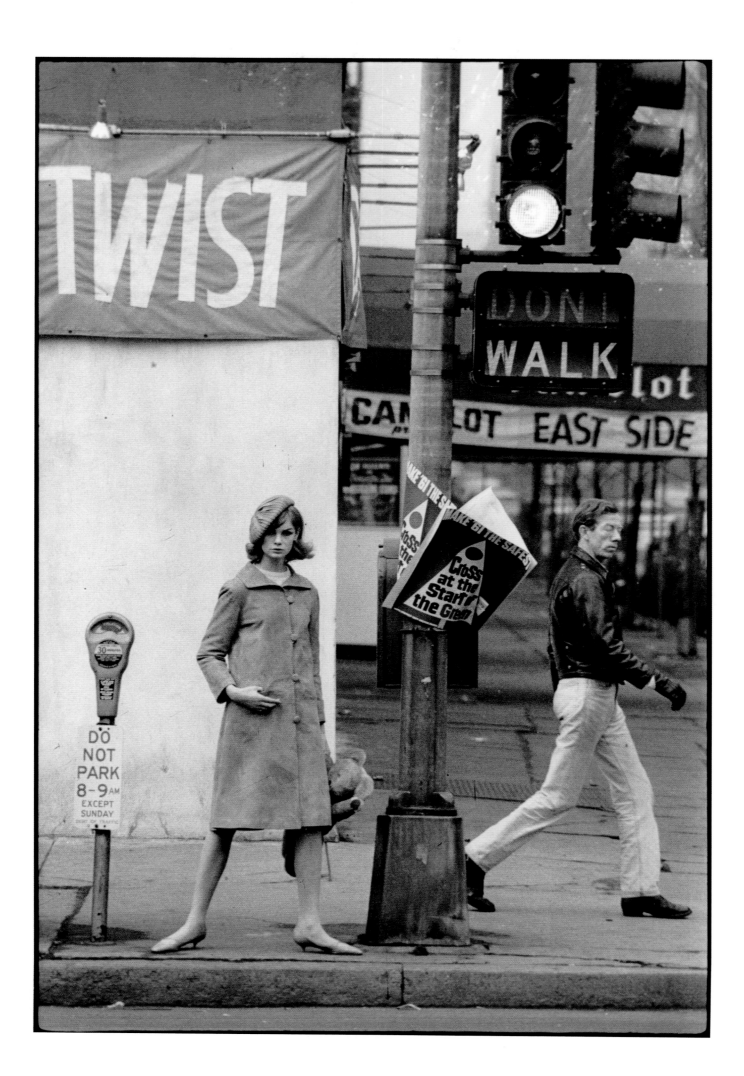

1969 collection of PVC and vinyl trench coats was featured on models wearing matching hoods and motorist's goggles staggered across the hood of a car. Gabriele Mentges, professor at the Institute of the Cultural History of Textiles at Germany's Dortmund University, referenced the juxtaposition of women and cars in popular imagery: "In many advertisements, the female silhouette was adapted to that of the cars, and in this way a geometric vision of the female body was constructed." Inspired by Jacques Henri Lartigue's turn-of-the-century images of women at automobile races, Jerry Schatzberg's photograph of Peggy Moffitt wearing a grid-patterned camel wool driving ensemble and perching on the grille of a Rolls Royce configures this vision. The angled limbs of Gernreich's celebrated muse are emphasized by the perpendicular markings of her sartorial grid. Her suit, designed by Gernreich and supplemented with a black suede balaclava by Leon Bennett and pumps by Capezio, was featured in *Vogue*'s September 1, 1964, issue with the caption: "For the future: Gernreich's designs already look prepared for the next century." The statement is evidenced by Moffitt's gaze upward to the stars, as if to indicate the infinite nature of this new modern sphere. The art critic Rosalind Krauss dubbed the grid "an 'emblem of originary purity' endlessly repeated." This structure was employed consistently in 1960s minimalist art, particularly in the graphite line drawings of Agnes Martin. Krauss cited Rodchenko's *Grid,* from the exhibition catalogue *5×5 = 25* (1919), as the original reference for this formation in fine art. Elaborating Krauss's citation in *On Abstract Art* (1997), critic Briony Fer explained, "By emphasizing the grid in this last exhibition of Constructivist painting, Rodchenko positioned it, along with the line, as the emblematic structures of modernity, signs of 'materialism, science and logic.'"

In the context of the early twentieth-century avant-garde, both the grid and the slanted line would signify what the Italian futurist Umberto Boccioni categorized as the "dynamic force-line" in his 1912 manifesto. Boccioni's force extended the tension of a composition toward infinity. In his 1965 photograph *Cape Courrèges*, David Bailey posited the model, mid-vertical leap and cloaked in her immaculate designer striped coat, as a dynamic force-line of fashion, her white leather boots and neatly coiffed head bookending the elongated corporeal column to lead the eye out of the frame. Bailey's imagery was intended for easy digestion and immediate impression in order to effectively attract the consumer's attention. As the photographic historian Martin Harrison pointed out, "Working specifically

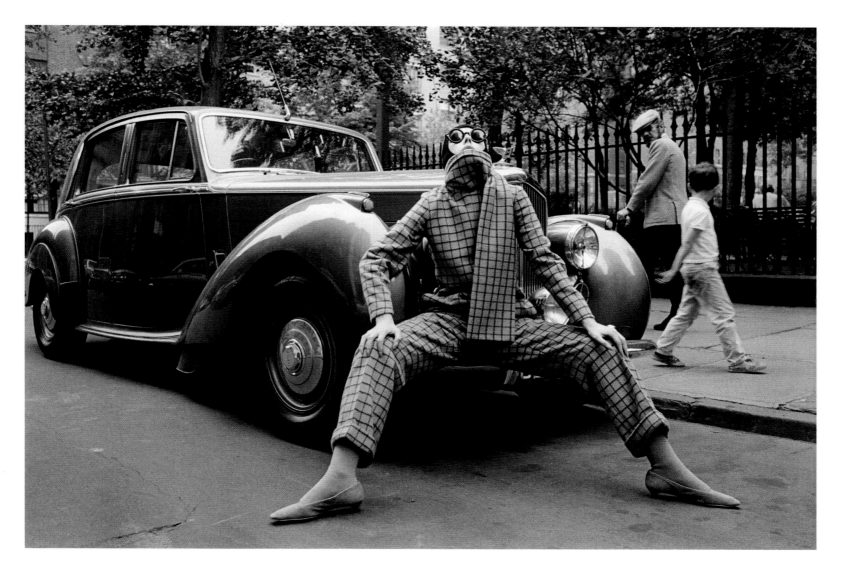

Ensemble, Rudi Gernreich,
worn by Peggy Moffitt,
Fall 1964.

towards the magazine page, Bailey's close cropping within the image rectangle aimed to achieve maximum impact in reproduction."

The singular energy and force of *Cape Courrèges* anticipated the work of Carl Andre, who demonstrated the pertinence of this composition to the mid-century minimal discourse in his seminal work *Lever,* first exhibited at *Primary Structures* in 1966. Designed specifically for the environment of the Jewish Museum gallery, *Lever* was composed of 137 firebricks laid side-by-side from one doorway to the other, so that the viewer would have a unique perspective on the object, depending on the door from which he or she entered. Andre insisted, "All I'm doing is putting Brancusi's *Endless Column* on the ground instead of the sky." The artist's fondness for pre-existing regimented units lent easily to his configuration of standardized modular structures throughout the 1960s and 1970s, including *Fall* (1968), which was comprised of twenty-one slats of hot-rolled steel applied seamlessly to the gallery floor and adjoining wall. Such works are implicit in their reference to infinite repetition and ultimately their advocacy of commercial reproduction.

A 1965 image of an Emanuel Ungaro coat exploits the infinite compositional fixtures of both the grid and the line. Ungaro commissioned Sonja Knapp to produce fabrics of double thickness to fortify his stiff, angular shapes, exemplified by a checked trapeze coat. The model, who is balanced on one foot and seemingly poised to leap, foregrounds a dingy bowling alley, its lanes of severe black lines fading into the expanse of the frame. These compositional lines, whether within the fashion object or the larger image, are duplicated ad infinitum. By forcing the tension of composition outward, these channels effectively posit the observer/consumer as a transposition of the model or form at the work's center.

William Klein, who was enamored of the moving image and composed a great deal of his fashion prints according to the fragmented repetitions of cinematic film, became well known for his 1960 work with Louis Malle on the full-length feature *Zazie dans le Métro* and later directed the cult favorite *Qui Êtes-Vous, Polly Magoo?* (1966). His fashion photography emphasized the fashion consumer as a purchasing participant rather than simply a viewer. Hilary Radner observed, "The human is not recuperated in the work of Klein. Rather the aesthetic formal qualities of the model's face transformed through the camera render her beautiful as an art object, an 'objet d'art' but an object nonetheless that works hard in the service of consumerism." As a figure, the model is the everywoman and becomes a blank template upon which the viewer can transpose her own visage. The

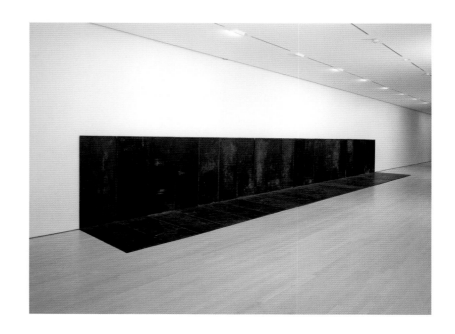

Opposite: Photograph, David Bailey, "Cape Courrèges," *Vogue,* March 1965; ensemble by André Courrèges, Spring 1965. Above: Carl Andre, *Fall,* 1968.

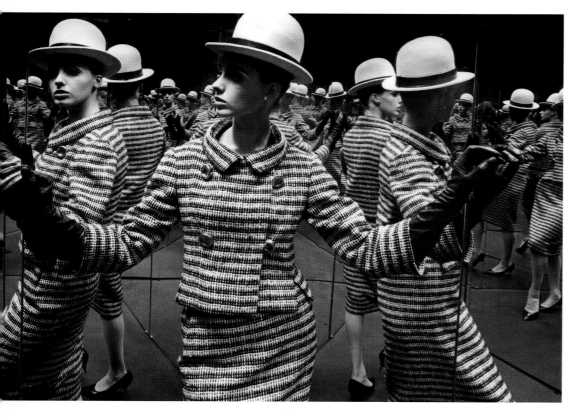

Above, left: Photograph, William Klein, *Vogue*, March 1963; suit by Pierre Balmain, Spring 1963. Above, right: Dress, Balenciaga, 1962, worn by Jennifer Connelly for French *Vogue*, Spring/ Summer 2006. Opposite: Reconstitution of the 1926 "Ford" dress by Chanel.

clothes within Klein's lens, like Bailey's, become somewhat obscured within the broader representational image: the fashionable style becomes more about abstract shapes than the pointed sartorial details of a given ensemble. In Klein's 1963 snapshot of a model fitted in a Balmain suit and placed cleverly in a multimirrored chamber, the fashion design is actually marginalized, reproduced ad nauseam to indicate the commodity's accessibility rather than employ the haute-couture conceit of enviable exclusivity.

Gabrielle "Coco" Chanel used the multifaceted mirror as the winding wall of her atelier staircase in order to effectively assail her patrons with the look of the house. Chanel was her own muse: the perpetual reflection of the couturière—a stark figure in her reductive uniform of white blouse, boxy jacket, and straight skirt—mutates and even deforms these components but still manages to convey the essential elements that configure the Chanel label to this day. Chanel's easily adaptable components are the sartorial counterparts of minimal art's primary shapes: basic building blocks that appealed intrinsically to a larger audience than the one drawn to overly ornate designs. Chanel, unlike her peer Paul Poiret, was not concerned with the mass copy of her creations and even encouraged the reproduction of her aesthetic in order to perpetuate a more plenary saturation of the Chanel style at every economic level of consumer fashion. Her boxy suit related, in its strict geometries and restrained palette, to her sling-back pump, her quilted bag, and, of course, her little black dress.

Of all Chanel's innovations, her little black dress would emerge as a conceptual ready-made that conveyed discreet, refined chic no matter the price tag. The couturière's first "LBD" is typically dated to a 1926 dress model of wool crepe and silk satin, which *Vogue* dubbed a "Ford signed Chanel." The reference instantly allied the French designer's reductive black shift with principles of automated American Fordist

production: mass appeal and paramount accessibility. Chanel's modernist uniforms, figures cut in black and white, seemed built to utilize the industrious American fashion industry, a bulwark of efficient reproduction and standardization based solely on simple shapes and digestible styles. In *Couture Culture* (2004), the fashion theorist Nancy J. Troy likened Chanel's creations to the buildings of Le Corbusier, explaining that both "extolled the beauty of simple, functional design" as a means to configure a saleable modern lifestyle. In fact, Chanel's dress provided a ready-made template for boutiques, specialty shops, and Seventh Avenue retailers alike—a single clothing item that could be adapted for an evening at the prom, a collegiate function, a day at the office, or a cocktail party. The little black dress is a standard and an original, a design that can be reinterpreted by nearly any designer or manufacturer and still retain its inherent value as the champion of progressive fashionable dressing. With regard to the minimalist discourse, this ready-made speaks to the major criticism of minimalism itself: in its simplicity, accessibility, and translation to mass production, is the minimal object enough "art"?

The venerable art critic Barbara Rose bolstered the skepticism surrounding minimalism in her 1965 *Artforum* review "Looking at American Sculpture," where she stated, "The new sculpture, like the new painting, seems involved with finding out how little one can do and still make art." Although the minimal object has been a permanent fixture in the modernist gallery since the mid-1960s, its ready-made status has often brought its value, and certainly its craftsmanship, into question. In this way, minimalism has long been allied with Dadaism, though the former is far less concerned with conceptual interpretation.

In the early decades of the twentieth century, Marcel Duchamp, widely recognized as the father of Dadism, created his famed ready-mades, including his 1914 Underwood typewriter, which was reissued in twelve copies in the mid-1960s. These ready-mades incited criticism similar to that received by mid-century minimalist works; the objects were perceived to have required minimal effort, thereby repositioning their worth from the productive to the imaginative. Whether utilitarian (Dada) or painstakingly basic (minimal), the ready-mades were removed from their prior context and function and elevated to the status of art objects. Their ready-made capacity also omitted any associations of authenticity or originality, effectively nullifying the exclusivity and elusiveness of fine art. In "Apropos of

'Readymades'" (1966), Duchamp explained, "Nearly every one of the 'ready-mades' existing today is not an original in the conventional sense."

Duchamp praised the employ of the found object and encouraged the use of new media such as photography and film to further disavow the relevance of traditional fine art. As such, he was undoubtedly a major influence on minimalist Dan Flavin. Flavin's works primarily featured the common lamp, first as a domestic light bulb and, later, in compositions of sequential fluorescent tubes. Although Flavin's structures have various arrangements, his goal has been consistent: to take a commonplace object and make it "strikingly unfamiliar." Judd perceived Flavin's works as self-contained phenomena, intended to elicit a visceral reaction in the viewer.

Regarding *Icon V (Coran's Broadway Flesh)*, Flavin declared, "I had to start from that blank, almost featureless square face which could become my standard yet variable emblem—the 'icon.'" Affixed with dirtied fasteners and store-bought bulbs, *Icon V* presents a collage of found objects, an equivocal relationship between canvas and light that requires the onlooker to experience the work as part of its environment rather than as a "singular, discrete object." The lightbulb, as Flavin's medium of choice, associated the artist with the "junk" tradition typically ascribed to the works of Robert Rauschenberg, Jasper Johns, Lee Bontecou, and Arman, among others. The era's increasing systems of mass production in fashion and consumer goods lent credibility to "junk" as the art form of an emergent disposable culture.

The experimental designs of 1960s fashion boutiques adapted the found object as well. Hiro's 1966 photograph of a shoe made of corrugated cardboard and neon paint for the "Look" section of *Harper's Bazaar* forecast the looming popularity of exotic imagery in 1970s fashion, but it also revealed the validity of cheap, industrial materials as components of contemporary clothing. Caroline Rennolds Milbank recalled a plethora of such found-object frocks as "skirts fashioned from counterfeit dollar bills; do-it-yourself dresses of plastic and metal rings; paper and Mylar minis, jumpsuits, and underwear." The niche would reach its apogee with the punk styles of the late 1970s, which utilized safety pins, clothes pegs, and razor blades as (un)fashionable decorations. Ultimately, such designs were the province of the modern avant-garde, the newest iterations in a tradition of "making strange" by removing the common object from its utilitarian context in the service of artistic representation.

This tradition is exemplified by the work of Claes Oldenburg, who repositioned household commodities such as the toilet, the ice cream cone, and the hot water bottle, to name a few, from the domestic realm to the gallery. This strategy served to reinterpret products as objects instead and divest them of their primary functions. Oldenburg's bas-relief wall hangings of various clothing articles, most notably represented by *The White Slip*, sometimes called *Braselette*, toyed with the boundaries between form and image and ultimately embodied Donald Judd's delineation of the "specific object." These painted plaster reliefs were sold at The Store, Oldenburg's Lower East Side mercantile property, and as such were heavily criticized for blurring the distinction between artwork and commercial product. Logically, it follows that many art historians have cited Duchamp's ready-mades, the Underwood typewriter in particular, as points of departure for Oldenburg's creations. But while Duchamp's ready-mades were often translated to fine art by virtue of a nearly instantaneous

Opposite, top: Dan Flavin, *Icon V (Coran's Broadway Flesh)*, 1962. Opposite, bottom: Photograph, Hiro, "Look" extracted from *Harper's Bazaar*, April 1966.

Above, left: Ensemble,
Helmut Lang, Spring/
Summer 2004. Above,
right: Dress ensemble,
Rei Kawakubo for Comme
des Garçons, Spring/
Summer 2008. Opposite:
Claes Oldenburg,
Braselette, 1961.

process lacking any intermediate artistic handling, Oldenburg actually rebuilt the ordinary to embrace
an alternate physical and theoretical reality. In 1965 Oldenburg told radio host Bruce Glaser, "If I make an
image that looks very much like a commercial image, I only do it to emphasize my art and the arbitrary act of
the artist who can bring it into relief somehow. The original image is no longer functional. None of my things
have ever been functional. You can't eat my food. You can't go out in my clothes. You can't sit in my chairs."

These words ally Oldenburg's work with the minimalist repression of artistic meaning or purpose. In
Helmut Lang's Spring/Summer 2004 ensemble, the formal classifications of clothing are similarly turned
on their heads: cropped and collared jackets are tacked on as skirts, sleeves dangling awkwardly, as if to
illustrate a known sartorial entity made strange.

Rei Kawakubo for Comme des Garçons has long been known for warping the traditional shapes of
fashion and employing atypical fabrics to produce work often more artistic than sartorially viable. Kawakubo
distorted the form of a simple short-sleeved dress in runway variants for her Spring/Summer 2008 collection
by affixing the entirety of the dress as a flattened shape atop a base garment, nullifying the protective capabilities
of the outer layer. By inverting the light-against-dark palette of Oldenburg's *Braselette* and flattening the
dress into a two-dimensional casing, Kawakubo presented a true minimal object, made "strange" and

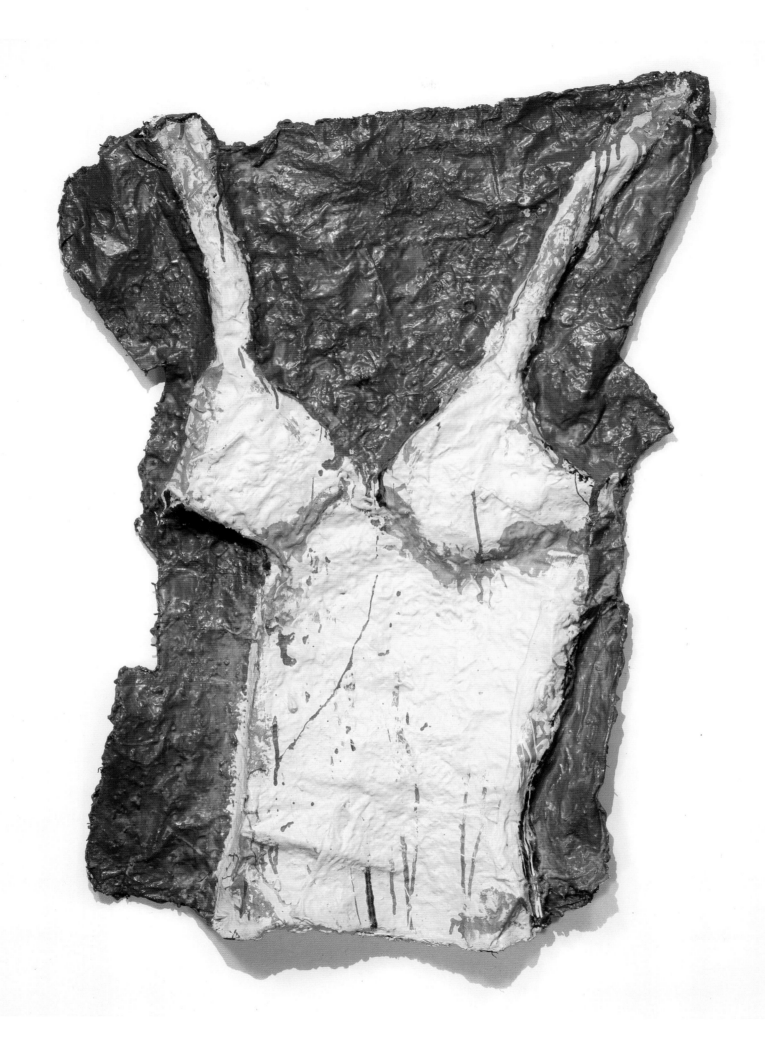

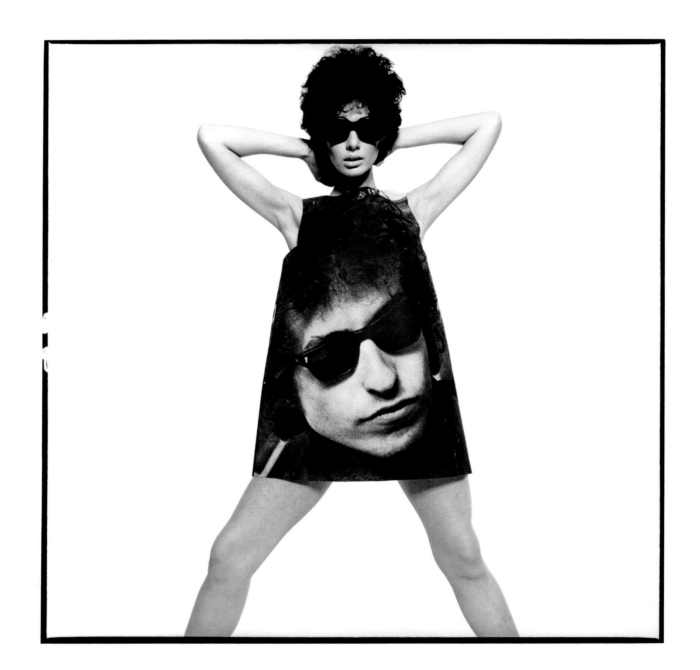

"specific." The fashion journalist Kate Betts has noted Kawakubo's typical rejection of traditional materials in favor of those "found," specifically in the 1998 Comme des Garçons perfume Odeur 53, which "had notes of nail polish and burnt rubber." The designer's Spring/Summer 2008 garment evokes the 1960s paper dress, a hallmark of the do-it-yourself (DIY) and found-object movements.

A 1969 David Bailey photograph captured a model sporting a Dylan-esque afro and sunglasses and wearing a paper dress printed with an image of Bob Dylan. The garment's simple A-line frame, commonplace materials, and popular-culture reference served to fuse the structural dictates of minimalism with the explosive markings of pop art. Pop mapped a trajectory confluent to that of minimalism and was similarly implicit in the emerging relationship between art and commerce. Both groups were quick to repudiate the titles of "pop" and "minimalism" in favor of broader recognition as the mid-century avant-garde; Carl Andre asserted, "My art is that of the culture of my origins . . . 20th century North American capitalist culture." Yet as eager as the minimalists were to reject pop art's "low" for the "high" of their artwork, the confluent departure points of the two movements were undeniable. Where the minimalists employed the found object, pop artists advanced the acceptance of the found image as art.

The dawn of the silver age of comic books in the late 1950s and the broadcast of the first episode of *The Flintstones* in 1960 heralded a new aesthetic era in which simplified, saturated forms were paramount to artistic representation. Of the paper-dress trend, Bailey concluded, "It does sum up the whole superficial Sixties thing." Bailey's "thing" was a phenomenon that was initiated in large part by Andy Warhol's prints and photographs and by Roy Lichtenstein's paintings— works that exposed the quotidian motifs of pop culture. *Glamour*'s art director Miki Denhof first introduced Bailey to Warhol in 1963. Bailey recognized, "I liked the idea that Andy was interested in objects that had been considered banal and turned them into art." Warhol would mine imagery from sources as broad as the corporate logos of Campbell's Soup and Brillo to the local catastrophe. His aptly named *Tuna Fish Disaster* depicts an actual newspaper page announcing the deaths of two women poisoned by canned tuna. Warhol disavowed any notion that the images were symbolic or meaningful. In a 1964 interview, accompanied by his dear friend Oldenburg, he described the haphazard process of selecting his source material: this photograph or that

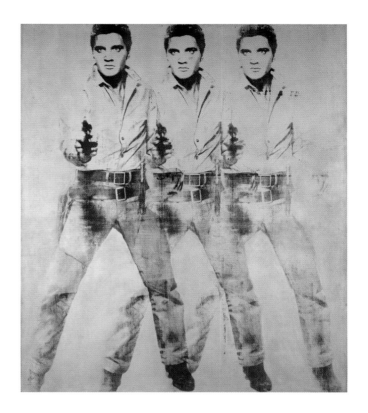

Opposite: Paper dress with Bob Dylan print, 1969. Above: Andy Warhol, *Triple Elvis*, 1962.

one "just caught my eye." Of course, his most celebrated works are the repeat-format prints of icons Marilyn Monroe, Jacqueline Kennedy, and Che Guevara, to name a few, which most likely evolved from the rigorous serial compositions and graphic contrasts of his 1950s commercial newspaper illustrations.

Warhol's serial imagery, often extending to multiple rows and columns, forms an abstract grid. In *Andy Warhol: A Retrospective* (1989), the curator and author Kynaston McShine highlighted the impact of the early minimalists on Warhol's sequential imagery: "By the mid-fifties the serial-grid composition had regained the prominence it enjoyed in the twenties: Ellsworth Kelly's serial arrangements of monochrome display panels such as *Colors for A Large Wall,* 1951, and Johns's *Gray Alphabets,* 1956, for example, prefigure the central strategy of Warhol's compositional principle." In fact, serial repetition emerged regularly in minimalism and would remain a mainstay strategy of the minimal movement; the repetition of a single image catalyzed geometric abstraction and also provided a subtext of easy reproduction.

Warhol, like many pop figures, strived for the smoothness and "cool"-ness of the industrial object that minimalism embraced early on, beginning with his adoption of the silkscreen process in 1962 as a means to more efficient mass production. His works became increasingly sharp-edged and untextured as the decade wore on, but *Triple Elvis,* one of Warhol's early silkscreen prints on aluminum paint on canvas, reveals the unintentional presence of the handmade via the uneven application of paint to the screen or pressure to the canvas. Although Warhol's famous desire may have been to "be a machine" and he eventually labeled his studio The Factory, it was actually Donald Judd who first succeeded in fashioning a mechanical aesthetic by outsourcing the production of his Plexiglas, galvanized iron, and anodized aluminum designs to specialized industrial workshops.

Like Warhol's familiar images, the primary shapes employed by Judd and Robert Morris were configured in serial repetition to extract any figurative composition or emotion from proverbial forms. The installation of "one thing after another" voided the viewer's capacity to dissect and reflect upon the singular unit. Judd's stacks, which he created in 1965 and continued to produce well into the 1990s, championed glossy veneers and rigorous uniformity, thereby integrating the nonaesthetic or machinist lexicon into the realm of high art as the means to achieve impeccable results. The stacks could also expand or retract in number depending on the mounted space that they occupied, which indicated a compositional capability to infinity. Although Morris's serial works, such as *Nine Fiberglass Sleeves,* often insinuated the presence of handcraftsmanship via scuffs or discolorations, they were still attacked for their lack of genuine "work." The critic Hal Foster elucidated, "Minimalism appears as a historical crux in which the formalist autonomy of art is at once achieved and broken up, in which the ideal of pure art becomes the reality of just another specific object among serial others."

The presence of serial repetition in the visual culture of New York in the mid-1960s was so pronounced that "Stella's stripe paintings, Warhol's Soup Cans, and Judd's *Record Cabinet*" prompted the art critic Peter Schjeldahl to dub 1966 "The Year of the System." By this time, the impact of minimalism and pop art, specifically with regard to serial repetition and the glamorization of commodity culture, could be felt in Middle America as well as the country's urban hubs. The Graham's Homes for America project, published in *Arts* magazine in 1966, depicted "prefabricated housing developments," which even followed a spliced

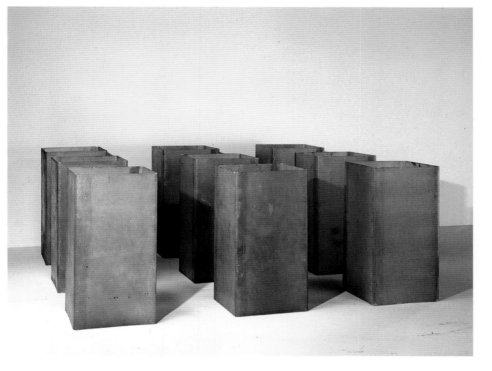
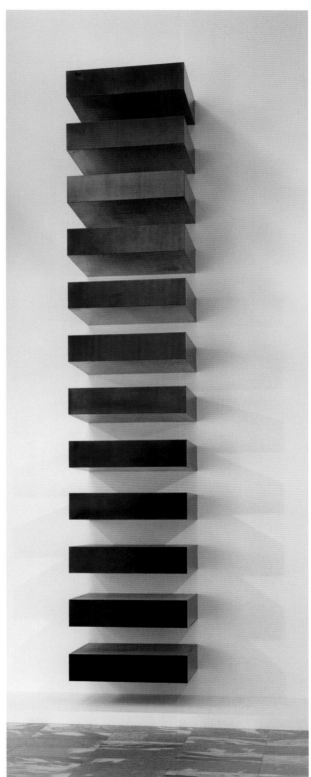

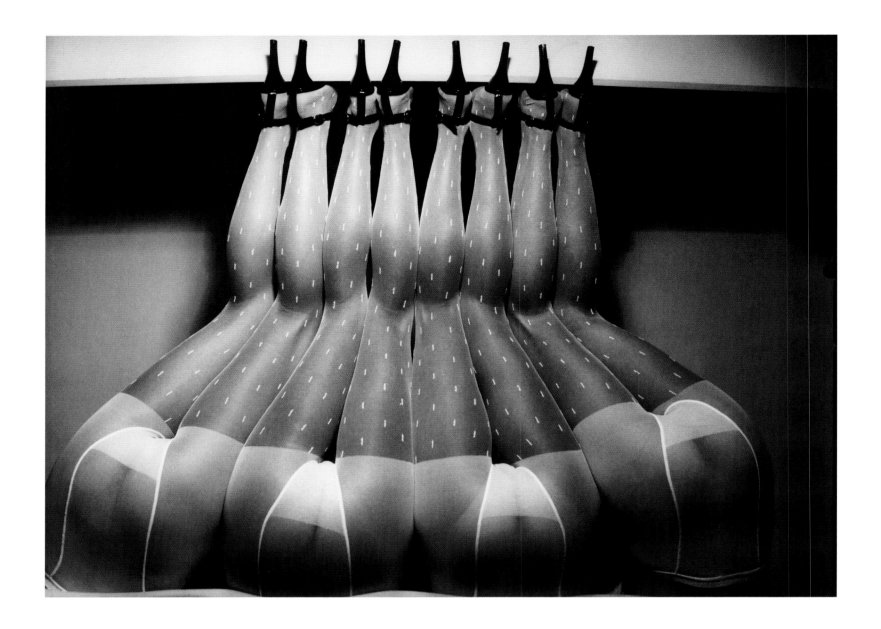

Above: Photograph,
Guy Bourdin, mid-1960s
(unpublished). Opposite,
left: Dancers from the
musical *The Dairymaids*,
1906. Opposite, right:
Advertising image,
Costume National,
Spring/Summer 1988.

provincial nomenclature that included such variations as "Pleasantside" or "Pleasantville." The subdivision, a developmental exemplar of the serial system, a self-contained sequence on par with the minimal work, was parodied in Tim Burton's period film *Edward Scissorhands* (1990), in which each mid-century house, lawn, and car was a carbon copy of the one beside it. The *Scissorhands* set, like the Warhol print or the Judd box, glorified commonplace commodities, imbuing them simultaneously with artistic merit and consumer appeal. Guy Bourdin employed serial formation in a mid-1960s shot of upside-down hosiery-clad females, their black-patent stiletto heels the anchoring roots of an inverted leggy bouquet. This was likely an advertisement for Charles Jourdan shoes, but hosiery, as one of the most successful ready-to-wear items of the twentieth century, became a more poignant focus.

The ready-to-wear fashion industry as a whole, particularly with its integral promotional vehicles of the catalogue and the dressed store window, has long relied on serial repetition to identify a fashionable silhouette. Because shapes or colors are reproduced ad infinitum, the consumer is no longer required to make choices to suit her own body but rather need only service and sculpt the (seasonally reliant) fashionable body that is duplicated endlessly before her. Caroline Evans has cited the film theorist Siegfried Kracauer's association between the 1930s chorus line and the assembly line as synchronized systems of component repetition that

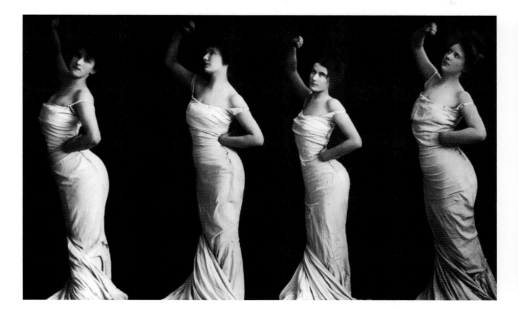 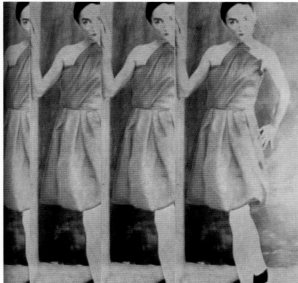

ultimately exist only to configure a single image, an independent commodity. The theatrical costume of the early twentieth century was a natural breeding ground for endless repetition, particularly in the fashioning of the turn-of-the-century Gibson Girl shape, whose generous convex curves of bustle and puffed bombastic chest naturally stacked horizontally to formulate one extended *S*. The essential minimalist goal of making the already-seen appear was achieved in both art, via Warhol, Judd, and Morris, among others, and fashion, through the repetition of the house mannequin (real or inanimate) as either a sameness or a nearly indistinguishable variant.

In *Fashion and Modernity* (2005), Evans linked the origins of the fashion show with the serial composition of photography and film, juxtaposing the "early mannequin parade" with the 1880s series-driven photographs of Eadweard Muybridge. A 1988 advertisement by the Italian fashion firm Costume National simultaneously channeled the serial framing of the cinematic contact sheet, the romantic strokes of the nineteenth-century theatrical or chorus poster, and the fragmented components of the atelier mirror. Fusing the serial traditions of art, photography, and fashion, the features of the model and even those sartorial details crucial to the identity of the singular commodity are obscured within the abstract image of a fragmented form.

When Hussein Chalayan outfitted his Panoramic runway in mirrors for the Fall/Winter 1998–99 presentation, he elicited the reflective surface to eradicate the boundaries of his environment, effectively providing for each dress model to be repeated endlessly. In *The Fashion of Architecture* (2004), Bradley Quinn described Chalayan's models: "Distorted into generic shapes and unified by architectural proportions; cones were fixed to the top of the head to elongate the body's shape, while faces and bodies were swathed in black to create a non-distinct cultural/ethnic identity." With the characteristics of individual bodies and personalities repressed, Chalayan capably codified the runway models as mechanical variants, moving, one after the other, through his modernist vision of fragmentation and mass production.

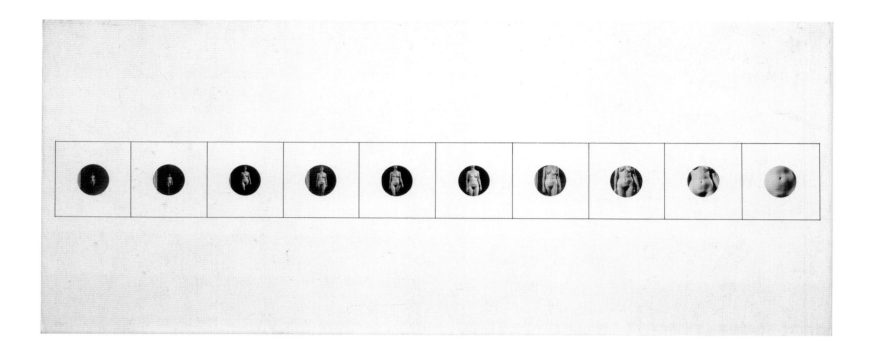

Pages 66–67: Runway image, Hussein Chalayan, Panoramic collection, Fall/Winter 1998–99. Above: Sol LeWitt, *Muybridge I*, 1964. Opposite: Eleanor Antin, *Carving: A Traditional Sculpture*, 1973.

In Chalayan's presentation, as in the Muybridge series, the body is rejected in order to advance an abstract pattern. While Chalayan's models disappeared and reappeared anonymously from a mirrored environment, Muybridge's fractured, frame-by-frame explorations obscured both subject and location in lieu of recording a specific moment in time, from start to finish. In the trajectory of mapping this evolution, of capturing a distinct movement, Muybridge's studies comprised a self-contained sequence—an appealing entity for Sol LeWitt, who had built a career out of modular repetition. In *Muybridge I*, LeWitt's sequential reference is the process of seeing, from various vantage points, the realities of the nude female form. Ironically, the work succeeds primarily in abstracting the subject's corporeal details via a pointed interplay between shadow and light, figure and ground. As Meyer pointed out, "LeWitt transformed the scientific precision of Muybridgian optics into a language game, rendering the normative relationships of words and images incommensurate, absurd."

Nearly a decade after *Muybridge I*, the celebrated post-minimalist Eleanor Antin created the photographic collage *Carving: A Traditional Sculpture* over the course of forty-five days, during which the artist adhered to a strict diet and documented her weight loss with four photographs daily. *Carving* was exhibited in sequential order, with the images aligned in a format akin to Muybridge's compositions. Antin's work, with its clear commentary on the societal fixation with female weight loss, fit squarely into the niche of feminist performance art that saturated the 1970s market, with the minimalist sector being no exception. Although the act of "carving" the body, as intuited by the work's title, infuses Antin's content with a violent undercurrent, it adversely enacts a theoretical removal of corporeal vulnerability for adaptability, replacing flesh with the traditional sculptural materials of wood or stone. The social and theoretical implications of the work move it from the minimalist to the post-minimalist realm, but its serial repetition and accessible content still allow for its contributions to the minimalist dialogue. Antin actually adhered to a minimalist-oriented serial organization fairly conservatively: by mapping her grid according to chronological time, the artist eliminated the possibility of her own premeditated, rational, or emotive input into the composition.

The minimalist employ of ready-made objects and images in serial repetition united the avant-garde movements of the twentieth century, both in art and fashion, emphasizing their confluent aims to translate high art to the democratic masses and to clarify the physical and tactile properties of the new work. Ironically, as minimalism initially rejected the figurative so vehemently, the female body would be transformed by late twentieth-century artistic and sartorial purveyors of the movement from an emotive subject into a recognized product and, eventually, into an abstract form. Again addressing the triumvirate relationship between women, glamour, and commodity, the minimal reading of the female body as both a foundation for basic, reproducible structures and a site, like so many others, is reinterpreted and reimagined.

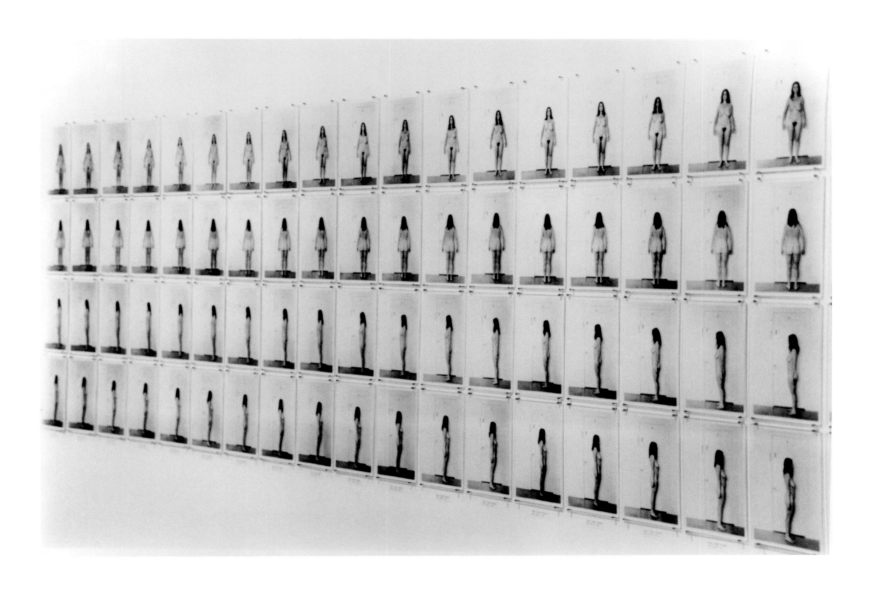

"THE GARMENT REFLE
DREAM OF 'SEAMLESS
GARMENT ENVELOPS
THE MIRACLE PRECIS
CAN ENTER IT WITHOU
OF DOING SO?"

CTS THE OLD MYSTICAL

NESS'; SINCE THE

THE BODY, IS NOT

ELY THAT THE BODY

T LEAVING A TRACE

—Roland Barthes, *Système de la mode*, 1967

3.

The Minimal Body

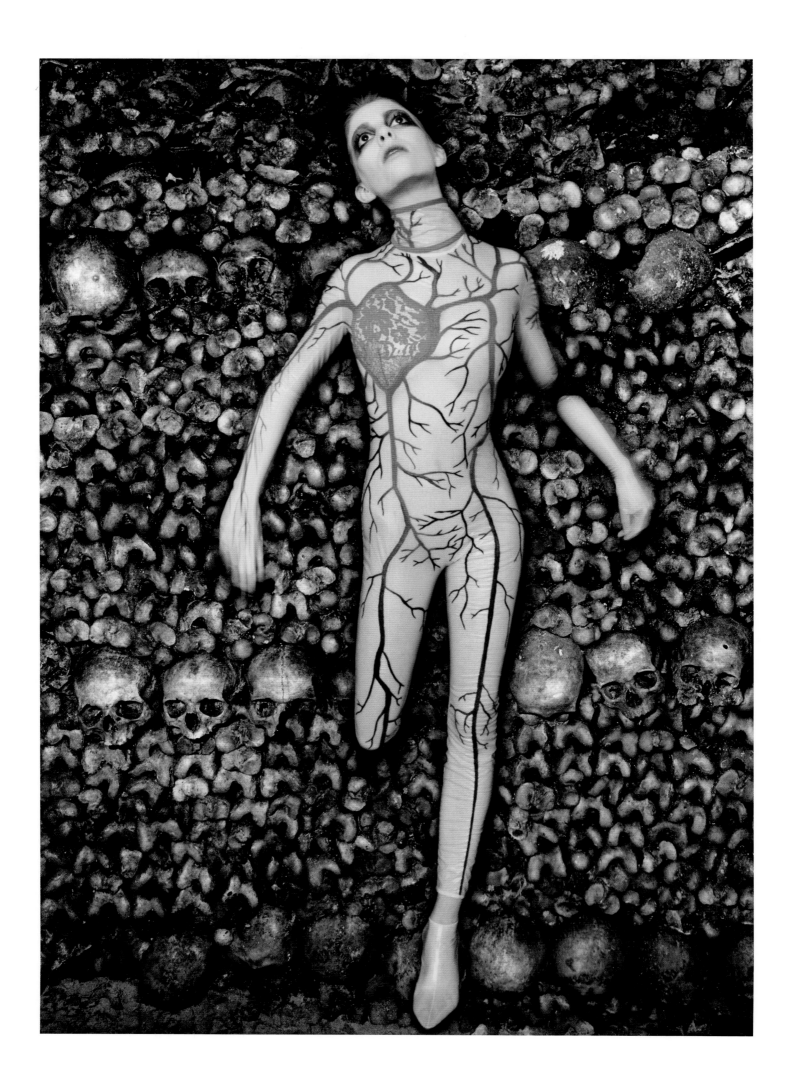

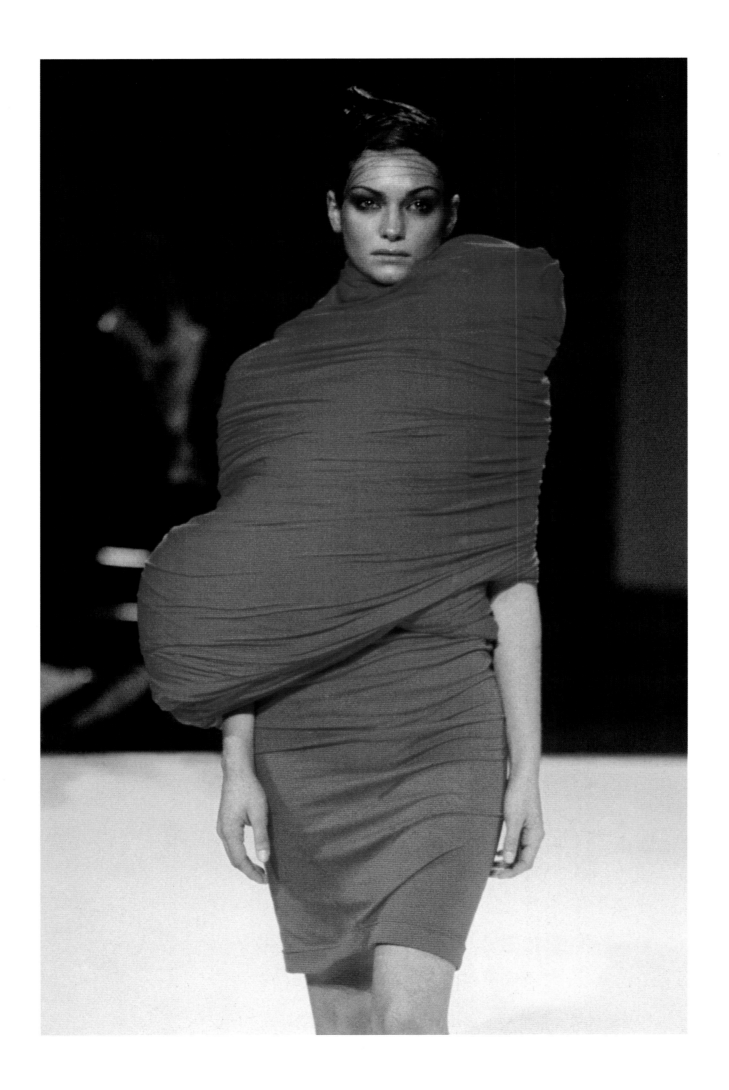

FOR HIS SPRING/SUMMER 1998 COLLECTION PRESENTATION, THE BELGIAN DESIGNER

Martin Margiela replaced professional models with "fashion technicians": men in clinical white lab coats similar to those worn by the mid-century couturiers Balenciaga and Balmain while at work in their ateliers. Each technician carried a Margiela creation around on a hanger, pointing out compelling details to the surrounding audience. Just a year later, Margiela outfitted ordinary people with sandwich boards bearing the image of each design in his Spring/Summer 1999 collection. Fashion has always been reliant on a corporeal ideal, embodied by the physiques of each era's models. By removing this ideal from the runway—the stage where fashion is introduced—Margiela begged this question: how crucial is the body to the design itself?

After the brief era of 1960s formal minimalism, with its explicit aims of non-emotiveness, rigorous reduction, and anti-figurative focus, the minimal movement marched on in the following decades to encompass the more expressionistic work of Fred Sandback, Terry Winters, and Robert Therrien, among many others. These artists distorted primary structures and alluded to known objects, whether found or, in some cases, figurative. In 1968 Robert Pincus-Witten first categorized their works as post-minimal, a label that, according to James Meyer, "was meant to suggest an expansion of formal possibilities opened up by minimalism rather than its critique."

Simultaneously, the Japanese fashion pioneers Issey Miyake, Rei Kawakubo, and Yohji Yamamoto mined their own form of sartorial minimalism, heavily reliant on the abstraction and rejection of the traditional female body. In the context of their creations, the body served as an armature for oversized sculpted garments and was even incorporated into the designs themselves as an abstract representation. The textiles employed by these fashions were a crucial focus of their streamlined, molded, and knit constructions. A survey of these post-minimalist works reveals each designer's intention to integrate the human experience with the work of art—a minimal instinct—by isolating the human figure as yet another primary form. Barbara Vinken identified the "post-fashion" period of the late twentieth century, when haute couture had long since celebrated its one-hundredth anniversary and emerging designers began to deconstruct the female body that had for so long been distorted and hidden by fashion's structures. Vinken in fact pinpointed the transparency of these fashions, intent as they were on exposing their own constitutions along with those of the body itself. She explained, "Where fashion used to disguise its art, it now exhibits its artificiality."

Rudi Gernreich pasted triangles, circles, and squares all over the arms, legs, and torsos of his models for a September 1966 fashion presentation and in so doing foreshadowed the all-in-one bodysuit that Issey Miyake would create just over a decade later. Miyake crystallized his vision of the "Tattoo Body" for his Fall/Winter 1989–90 collection in a seamless covering of hand-painted, knit, stretch-synthetic textiles. Mimicking the traditional tattoo designs of Japan and Africa, Miyake's bodysuits strove to re-create the marked human flesh itself, fusing body and fabric into one cohesive structure. In his Fall/Winter 1998–99 collection, Olivier

Page 73: Body suit, Olivier Theyskens, Fall/Winter 1998–99. Opposite: Ensemble, Rei Kawakubo for Comme des Garçons, Spring/Summer 1997.

Theyskens reinterpreted Miyake's "Body," forgoing the decorations of the tattoo for those of the human circulatory system, complete with an oversize blood-red heart. In *Diary of a Film* (1950), Jean Cocteau remarked, "The soul of a dress is a body," but in Theyskens's imagination, the dress itself is a body, and the work presents plainly, if stylistically, the constituents that our epidermis seeks to hide. Like Deleuze's edge, the skin provides the border between inside (form) and outside (non-form). Theyskens configured a minimalist sheath that occupies its role as a boundary but simultaneously attempts to expose its essential ingredients as aesthetic components.

In her 1987 sculptural piece *Vanitas—Flesh Dress for an Albino Anorectic,* Jana Sterbak took Theyskens's inversion to the next level, winding actual salted flank steak around wire to build her garment. The work has ironic undertones, as flank is often referred to as "skirt steak," and the artist is a Canadian from the primary beef-exporting province of Alberta. All jokes aside, the dress provides an effective transposition of natural body and fashioned frock. With its installational spirit and somewhat gruesome implications, *Vanitas* recalls Claes Oldenburg's oversize cheeseburger, its "meat" and "bun" glazed over to enhance an alternate tactility and, according to some theorists, transform the nonhuman into "fleshlike" material. Sterbak's piecemeal construction also forms a connection with the work of the French artist Saint Orlan (her stage name), whose performances have comprised multiple facial plastic surgeries to appropriate the features of various beauties from historical works of Western art. Orlan's assistants, who accompany the artist into surgery, often adorn their clothing with the phrase "The body is but a costume." Taking this slogan of sorts at face value, the human body may be perceived not as a predetermined object but as a mutable one, able to be reworked and redefined. In a 1994 interview Orlan stated, "We're changing . . . we'll change even more with genetic manipulation. The body is obsolete." This quality of obsolescence distances the body from the representational identity it has had in traditional fine art, reframing it instead as a viable minimalist entity.

When Rei Kawakubo presented her Spring/Summer 1997 series of Quasimodo dresses, tautly stretched nylon replaced skin and oversize goose-down pads were placed strategically in the convex areas of the body to transform the human musculature into a tumor-ridden alternate corpse. The collection's press release delineated each figure's evolution: "Body meets dress, body becomes dress, dress becomes body." These "lumps and bumps" moved in congress with the model's gait, clarifying the clothing and the underlying

Above: *Plastic Body*,
Issey Miyake, Body Series,
Fall/Winter, 1980–81.
Opposite: Dress,
Alexander McQueen,
Spring/Summer 2007.

figure as a single unpredictable shape. With no demarcation in their constitutions for natural breasts, hips, or buttocks, the new bodies that emerged were not readable as female and were logically readapted as gender-neutral costumes for Merce Cunningham's "Scenario" dance sequence that year. In an interview for *Vogue Nippon* in 2001, Kawakubo reflected on the collection: "I was keenly aware of the difficulty of expressing something using garments alone. And that is how I arrived at the concept of designing the body."

Kawakubo's creations were critically attacked by the fashion press for diverging from typical Western ideals of beauty, but they did more than that: they reinforced an androgynous, anti-hourglass silhouette by diverting the usual strategies of revealing and concealing. Just as the work of Saint Orlan unweaves the fabric of the body, so too did Kawakubo's "bumps" nullify and off-set the erogenous zones of the dress, presenting a shoulder protrusion instead of a bust, a cantilevered tube instead of a waistband. In Terry Winter's *Untitled* (1989), a set of two striated musclelike structures seems to float within the anticompositional space of a plain white background. They serve to expose the texture associated with human flesh but immediately reject the natural habitat in which such tissue is normally found. Yohji Yamamoto similarly displaced the human bone structure in an ensemble from his Fall/Winter 2006–7 collection: an exposed ribcage of black wool crepe jutted out from an otherwise tailored bodice, providing an armorlike breastplate rather than an internal foundation. Vinken observed, "The technical distinction of Yamamoto's fashion stems from researches into the relation of body and garment, and from a remarkable feeling for space." In the external shank ensemble, the skeleton is revealed as an aesthetic object, and its reductive bands designate a reductive linear pattern.

Yamamoto's bodice recalls Miyake's early 1980s Bodyworks series, which was exhibited worldwide and seemed to present the designer's interpretation of clothing as neither garment nor monument but a sculptural object in between. The Issey Miyake Bodyworks exhibition was comprised of designs built from traditional and modern materials that included rattan, bamboo, and polyurethane, and highlighted Miyake's ongoing attentiveness to the relationship between outer shell and underlying body. After founding his design studio in 1970, Miyake prioritized textile innovation, which would be instrumental to the development of

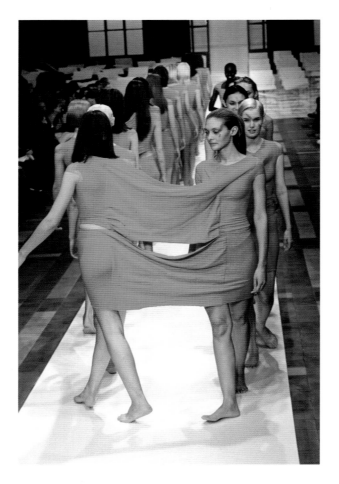
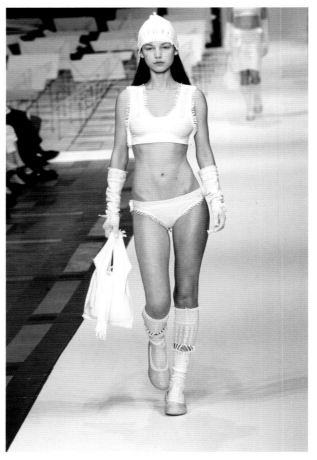

his unique creations. He and his in-house textile designer, Makiko Minagawa, collaborated early on with cutting-edge establishments such as Toray Industries, which invented Ultrasuede, and the Asahi Chemical Company. These partnerships, like those of Judd's with specialized industrial workshops in the 1960s, emphasized Miyake's commitment to employing new forms of technology in the creation of his work. One bustier from the Body Series was cast from red fiberglass and pursued the role of clothing as a second skin. The designer explained, "Without the human body, I can't make clothes." Yet even with the natural corporeal structure as its muse, Miyake's *Plastic Body* configures a dermis that is neither soft nor adaptable like human flesh. The curved ridges along the bottom of the cast imply the draped folds of fabric, but on such an immutable object, these "soft" furrows seem to mock typical sartorial drape.

Alexander McQueen created a similar carapace for his Spring/Summer 2007 collection. A dress of bone-hued leather was molded to reflect the human stomach muscles and trace the swell of the bosom, but McQueen's hipline, widened to the point of absurdity, removed the naturalistic associations with the organic hourglass form and replaced them with the visual isolation and stylization of the sculptural object on display. The leather, left jagged and hanging at the hemline, revealed the object's natural tactility but, like Miyake's bustier, reframed the design independently of the live model as the superseding body.

Miyake's textile explorations have provided some of the most compelling sartorial iterations of the last half-century. In 1997, the invention of A-POC, an acronym for "A Piece of Cloth," affirmed the designer's dedication to the processes of clothing construction. The early A-POC creations required no stitching, and were comprised of extended tubes of machine-knit jersey with delineated pattern lines along which the wearer could cut to customize each ensemble's components. Akiko Fukai, director and chief curator of the Kyoto Costume Institute, observed, "A-POC deconstructed the human body into arms, legs, and torso, then recomposed these parts into garments."

In fact, during Miyake's Spring/Summer 1999 presentation, A-POC *King and Queen* ensembles were actually cut apart on the runway, evoking the staged "happenings" of the 1960s, in which the clarification of process and the performer's (or wearer's) integration into this process became the central components of the artwork. For the show's finale, a parade of models marched down the runway and back with the movement of an apportioned caterpillar, clothed in A-POC *Le Feu* tops and bottoms that had not yet been cut from the tube. This presentation of the A-POC technique championed Miyake's ability to use minimal construction to maximum effect. Though A-POC later evolved to explore additional constructive strategies via weaving, stitching, braiding, and non-woven production as well as the knitting machine, these early tubular creations seemed correlated to each limb and zone of the wearer's body as independent shapes that configured a human whole. When considered in the context of their presentation, these designs inadvertently championed the convenience of mix-and-match dressing. With each ensemble only slightly varied from its runway leader and follower, the 1999 collection can be viewed as a basic serial system.

In *The Cutting Edge: Fashion from Japan* (2005), the contributor Bonnie English relayed the reflections of Arata Isozaki, "Miyake's close friend," who compares A-POC to "the hollow, seamless, sacred garments woven for the gods—which were the prototype of clothing: "It becomes an archetypal dress, a universal, circular form.'" In A-POC's beginnings, Issey Miyake unwittingly created such "universal, circular forms" as exemplars of customization and mass production, and in doing so embodied minimalism's democratic spirit.

Opposite, left: A-POC *Le Feu*, runway finale of Issey Miyake Paris Collection, Spring/Summer 1999.
Opposite, right: A-POC *King and Queen*, Issey Miyake Paris Collection, Spring/Summer 1999.

The Tunisian-born Alaïa, now immortalized for his similarly prototypical knitwear structures, presented his first ready-to-wear collection in Paris in 1980 and earned the moniker "The King of Cling" shortly thereafter. His designs, generally sleek and short, emphasized the newly toned curves of the 1980s woman and were promoted by a long list of celebrity clients, which included Grace Jones, Cindy Crawford, Tina Turner, Stephanie Seymour, and Naomi Campbell, among others. Alaïa utilized stretch synthetics such as Lycra and various poly-blends to sculpt his shapes. Often constructed from more than forty different bands, his dresses still achieved an astoundingly simple silhouette. In a collage for the *Sunday Times,* the artist Michael Roberts channeled the exotic and primitive elements of Alaïa's "Sphinx" dress when he depicted its strategically placed bands against a flattened African body type, the fabric strips providing just enough coverage to allow keyhole glimpses of the underlying skin. In Alasdair McLellan's 2009 photographs of model Sessilee Lopez in Alaïa, the designer's persistent brand of reductive classicism was exemplified by a platonic leather gladiator brasselette and winding rib-knit bodysuit ensemble. Alaïa's designs, which retained their shapes even on the hanger, melded the natural female physique into a continuous curvilinear shape.

Fashion's minimal bodies require simple or even invisible closures so that their integrity trumps the complex structures of disparate yet intermingling components from which they were configured. Geoffrey Beene has been celebrated for his ability to juxtapose textiles of different weights and weaves and still manifest an uninterrupted liquid drape. His columnar gowns, jumpsuits, and shirt dresses of silk and wool jersey, which employed few seams and little to no surface ornamentation, effectively demonstrated his minimalist restraint. In 1988 he told *Vogue,* "The more you learn about clothes, the more you realize what has to be left out." His sumptuous fabrics were less stiff and architectural than wispy and supple and allowed for a silhouette that seemed effortless, save for the fabric's impeccable fall. Beene's closures were always well hidden: an invisible zipper fitted along a winding seam; a row of hook-and-eyes set farther in so as to gently yet firmly abut two textile planes. The results of such an exacting sartorial methodology are evident in a Guzman photograph of a Fall/Winter 1991–92 jumpsuit and "harness": Beene's streamlined geometries neither constrict nor obscure the natural female body but seem to reduce it instead to a severe, platonic structure. His rigorous reduction and elimination of even the surplus seam speak to the Japanese notion of *shibui,* derived

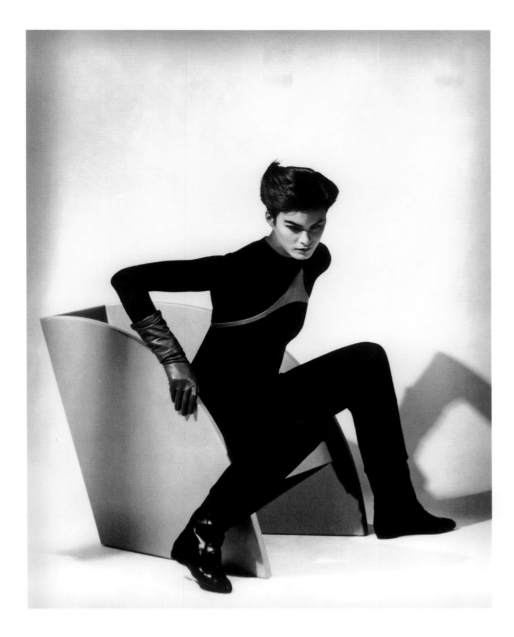

Opposite, top: Collage, Michael Roberts, *Sunday Times*, March 1990; "Sphinx" dress by Azzedine Alaïa, 1988. Opposite, bottom: Bra, Azzedine Alaïa, Fall/Winter 2009–10. Left: Jumpsuit with "harness," Geoffrey Beene, Fall/Winter 1990–1. Below: Richard Serra, *House of Cards (One Ton Prop)*, 1969.

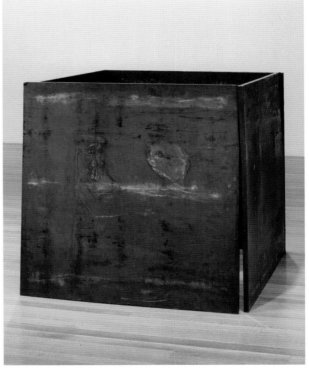

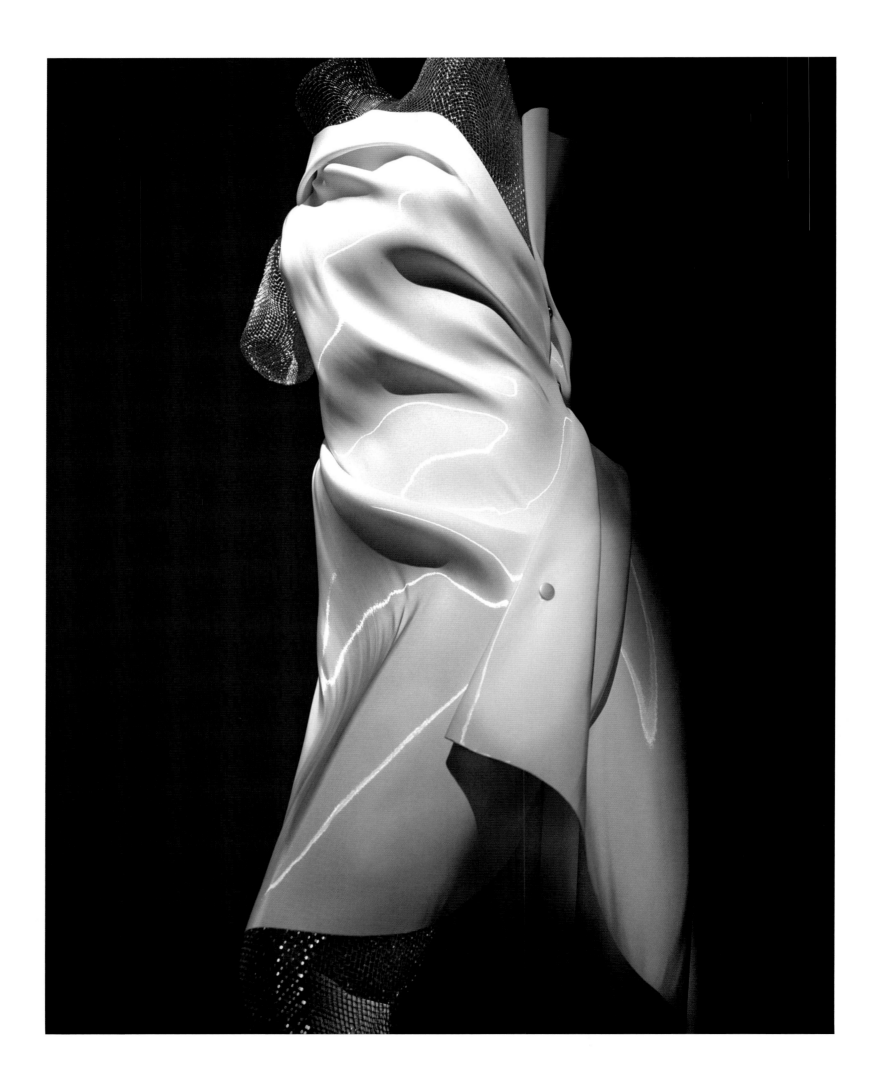

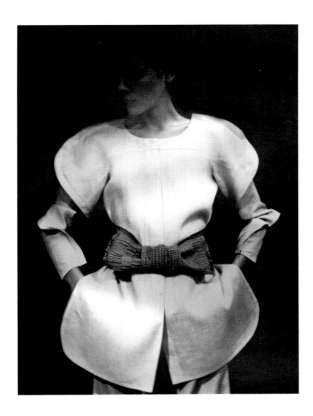

Pages 84–85: "Colombe"
Dress (flat and assembled),
Issey Miyake, Spring/
Summer 1991. Above:
Ensemble, Ronaldus
Shamask, Spring/Summer
1981. Opposite: Dress,
Issey Miyake, modeled by
Grace Jones, 1994.

from the Zen Buddhist ideal of "astringency in taste."
Shibui celebrates a spiritual minimalist restraint,
distinguished solely by the decoration inherent in
an object's material properties, such as the grain of
the wood or, in this case, the interlocked threads
of the knit.

The tenacious works of Richard Serra have
embraced *shibui* tactility, composed as they are from
rolls and slats of metal that the sculptor designs to sag
with time into both an advanced shape and a rusted
patina. His famous 1969 *House of Cards (One Ton Prop)*
features four such slats pitched perpendicularly into an
open-top cube. The work, with its off-kilter balance and
evident construction, is an exemplar of the minimal
movement, but is also derived from traditional
Japanese asymmetrical wrapping.

Miyake's strategy of wrapping as a means to
develop and fortify an independent, sculptural garment
culminated in the production of the *Colombe* dress of
Spring/Summer 1991, which the designer described as
a "simple square of fabric cut under heat transforms,
without any needle or thread, into a wrap which folds
round and envelops the body, constantly changing its
shape according to the positions adopted." Miyake's
seamless garments, independent or irrespective of
a foundation or base, often mimic the standardized
minimal template of the Japanese kimono.

Although the Japanese robe—overlapped at front,
secured with a sizable sash, and supported by multiple
under robes—has existed in the lexicon of traditional
dress for many centuries, the kimono, designated as
such during the Meiji period (1868–1912) as an identifier
for Western visitors, was imported along with Indian
pajamas and Chinese porcelain in the seventeenth
century on the ships of the East India Company. As a
static column produced in only one size, the kimono
is wrapped around a human frame, whether rotund
or diminutive, and creates an interstitial space that
eliminates the gender distinctions of male and female
and similarly negates the sexuality frequently imbued
in Western clothing. Depicted as a dressing gown in
the portraits of James Abbott McNeill Whistler and
Edouard Manet in the nineteenth century, the kimono
also served as a consistent inspiration for twentieth-
century fashion.

Certainly Rudi Gernreich's 1963 *Kabuki* collection,
named for the Japanese theater, was among the first to
stylize and homage the kimono in a decidedly Western
fashion via mini tube skirts, modified empire tops, and
built-in obi sashes. Madame "Alix" Grès also created

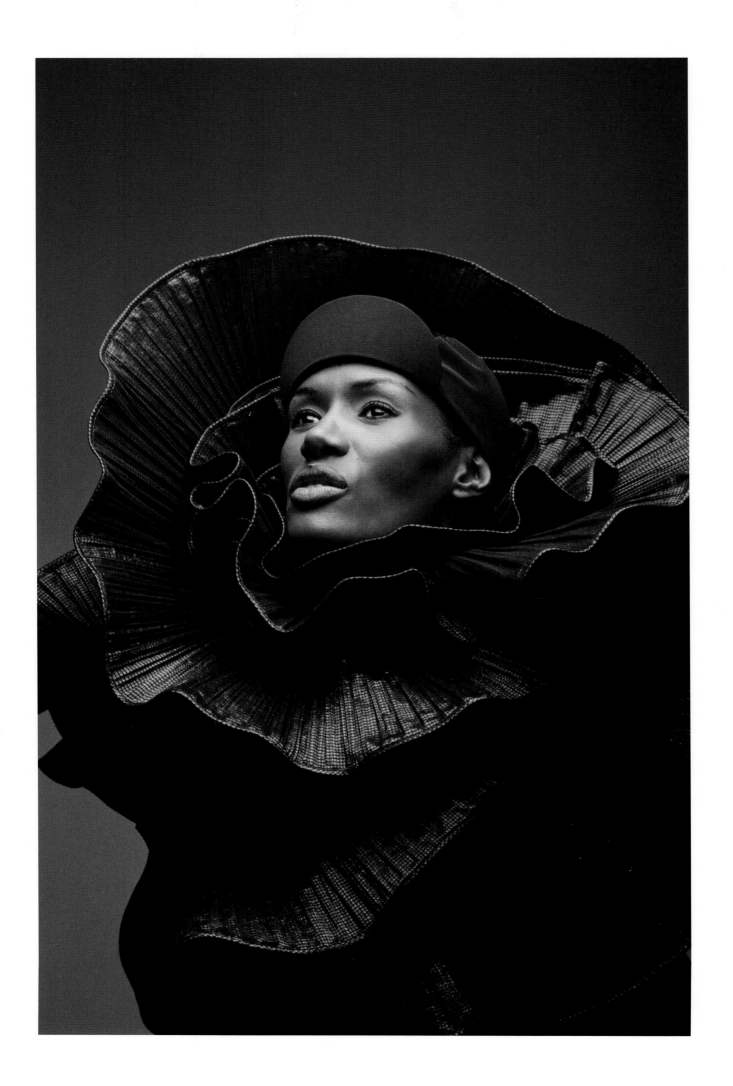

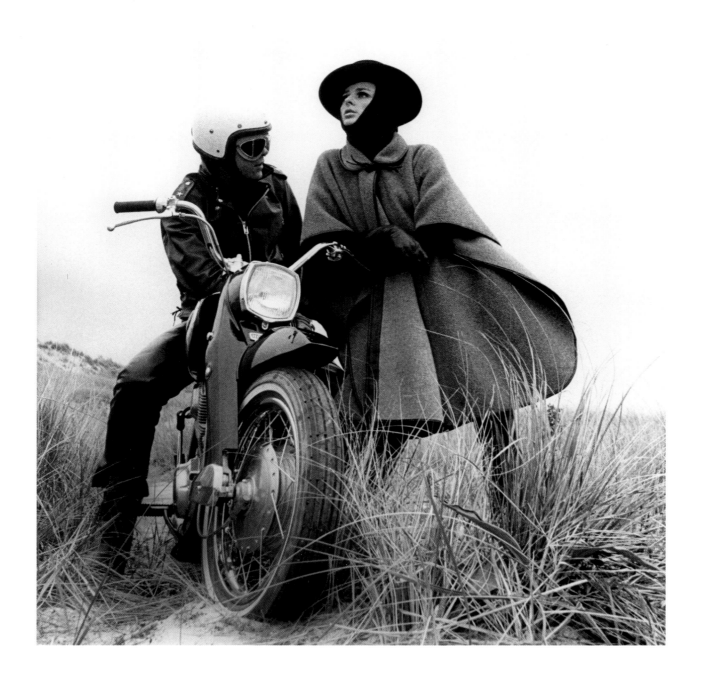

gowns and jumpsuits in the mid-1960s that employed the wrapped closure and voluminous folds of the kimono within amorphous shapes where the body was, unlike in her signature pleated gowns, somewhat lost.

The girth and sway of the kimono interacted seamlessly with the minimal object's grand proportions: a grossly increased size was crucial to Donald Judd's 1960s identification of the "single"—a sole object whose space could not be accurately categorized or codified. The Art Deco illustrations of the 1920s and the fashion editorial photography of the 1960s stressed the monumental presentation of fashion's expansive planes. In particular, a 1920 *Gazette du bon ton* fashion plate entitled "L'heure du thé" by Eduardo Garcia Benito delineated a tiny, abstracted model's head and body enveloped by gargantuan tiers of fabric, a silhouette that was reiterated in Francesco Scavullo's photograph of a Bonnie Cashin full circular poncho for *Harper's Bazaar* in August 1966. The latter was accompanied by a caption that read: "Volumes of gray double-faced wool chinchilla—leather bound in black—to swagger about in the sudden brisk air." This pointed emphasis on proportion, which both informed the "singles" of minimal art and relied on the inflated platonic structure of the traditional kimono, naturally helped to birth the pervading capacious shapes of the 1970s.

According to Bernadine Morris of the *New York Times*, the oversize look emerged in part due to the pioneering efforts of Kenzo Takada, who produced dramatic, aggrandized shapes for his 1973 Paris collection that migrated west by the following year. The American designer Ronaldus Shamask moderated the oversize silhouette into a kimono configuration more literal than Gernreich's kitsch; he adapted the garment's platonic architecture and sculptural fabrics. Shamask's 1981 "Cello" jacket explored the way that the shoulder seam could dictate an exaggerated sleeve shape. The waxed beige linen of "Cello" provided the stiffness needed to configure a shell effectively removed from the surface of the skin. Shamask anchored his voluminous shapes with a decorative obi-style sash, a clear nod to the traditional kimono.

Issey Miyake exploited the abundance of the kimono rather than its origami-esque folds in his early 1980s garments. June Weir, a *New York Times* columnist who reported consistently during this period on the influence of the Japanese aesthetic, described one of Miyake's billowing shapes as "a sack of potatoes." This reference insinuated a shapeless quality but also highlighted Miyake's hyperbolic volumes. These over-size looks, along with the tendency to wrap and layer, were, even after appropriation by the European and American design communities, intrinsically linked to Japanese style. Noting the launch of a two-thousand-square-foot Yohji Yamamoto boutique at the New York shop Charivari the following year, Weir interviewed a

Opposite: Cape, Bonnie Cashin, Fall 1966; Photograph, Francesco Scavullo, *Harper's Bazaar*, August 1966 (unpublished). Above: Fashion plate, Eduardo Garcia Benito, "L'heure du thé," *La Gazette du bon ton*, 1920.

89

theater director and Charivari customer, who explained, "Japanese clothes are not for everyone. They're very comfortable, but I feel lost in them. I'm attracted to them because they're like works of art. But I'm not able to wear them."

The designs of Miyake, Yamamoto, and Kawakubo have all invoked the kimono as a universal form, a minimal prototype that can define sartorial proportion, segmentation, and space as it relates to a genderless, ageless, weightless body. In a 1988 interview with *Connoisseur* magazine, Miyake clarified, "I learned about space between the body and the fabric from the traditional kimono . . . not the style, but the space." A Miyake advertisement the following year positioned a model against a white background, clothed in a striped pleated ensemble that seemed to take its rectilinear shapes from the traditional garments of the *kosode* and the *hakama* pant. The ad was striking for the sculptural beauty of the garment itself but even more so for the disparate spaces evident between its stiffened frame and the organic silhouette of the underlying leg.

When Naoki Takizawa took over as creative director of the Issey Miyake label in 2000, he managed to retain many of the design hallmarks Miyake himself had established since the founding of the house. Takizawa's capable attention to the treatment of space within the fashion object produced men's suits with inflatable muscle components and hemlines as well as dresses of parachute nylon for the Fall/Winter 2000–2001 collection that were inflated manually through plastic intertube nozzles. In the latter, the natural female form was completely obscured by a ballooning bodice and skirt, respectively, where the trapped air manifested a palpable tension between inside and outside, organic and geometric.

The Groninger Museum's exhibition catalogue *Hussein Chalayan: 10 Years' Work* (2005) identified the Cypriot-born British designer as the creator of "micro-geographies" between cloth and body: "an extra large 'personal space,' as extra protection against external influences whilst carrying one's environment from one place to another." This transportable dwelling embodies the minimalist goal of the "lived perspective" but also presents a Cartesian dualism in which the "mind"—here, the garment—is a distinct entity, separate from the ambiguous natural "body" within. These micro-geographies were most pronounced in Chalayan's Before Minus Now collection of Spring/Summer 2000 in which overblown, irregular geometric panels were constructed outwardly from the natural body. One dress presented dozens of micro-geographies

within its condensed layers of tulle that could potentially expand and contract with movement. Chalayan's designs often function more as individual architectural structures than clothing, thus bringing the model into focus as the primordial foundation.

In a 1964 B. H. Wragge advertisement, the model appears in prodigious scale and becomes a looming architectonic figure as she looks down and away from the Lilliputian viewer. Her hair is hidden by a white scarf, which in turn is covered by a domical wide-brimmed hat, a near-awning to shade her white-on-white ensemble. Her blouse is untextured save for machine-cut circular "windows" that run down the length of the bodice, leading the eye to the caption below: "Why do architects marry Wragge girls?" The Wragge girl is merely the core for a self-sustaining outer casing that possesses all the structural integrity of both the minimal object and the modern building. Quinn explained, "Both [fashion and architecture] trace their roots back to archaic textile panels; those adapted for us on the body became clothing, while those fastened to fixed frameworks became buildings." As such, the body becomes an impregnable infrastructure, a dehumanized support for a reductive, streamlined exterior.

As fashion photography evolved to embrace more artistic strategies over the latter half of the twentieth century, clothes themselves were often left out of the frame and the actual skin of the model was manipulated

Opposite, top: Ensemble, Naoki Takizawa for Issey Miyake, Fall/Winter 2000–1. Opposite, bottom: Dress, Hussein Chalayan, Before Minus Now collection, Spring/Summer 2000. Above: Advertising image, B. H. Wragge, Spring 1964.

to reflect artificiality rather than naturalism. In a 1996 photograph entitled *Georgina, Back View*, Herb Ritts captures a model, posed still amid finely trimmed topiaries and caked with white to affect the texture of an antique statue's marble. The image finds likeness with one taken by Louise Dahl-Wolfe in 1939 in which a model in a sleek bathing suit is situated at the far end of a wading pool in a classical stance juxtaposed with an out-of-focus statue in the same pose in the foreground.

But the transposition of real woman and inanimate figure is no better exemplified than by the shop mannequin, which is designed to mimic the female form but is neither emotive nor unique. In *Fashion at the Edge: Spectacle, Modernity, and Deathliness* (2003), Caroline Evans referenced the writings of a well-known Marxist philosopher: "When Walter Benjamin proposed that fashion, unlike biological woman, was both deathly and unreproductive, he used the metaphor of the mannequin to make the point: 'the modern woman who allies herself with fashion's newness in a struggle against natural decay represses her own reproductive powers, mimics the mannequin, and enters history as a dead object.'" Guy Bourdin was among the first fashion photographers to present the voided, "dead" adverse of woman in the form of the modern store mannequin. In an image for French *Vogue* of May 1975, Bourdin shot a group of naked dummies from inside a store window. They seem to be gazing longingly out to the street where two "real women" are walking by. The irony of the image is that the humane and expressive qualities are allocated to the mannequins, while the exterior street scene seems still and dissociative, the women emotionless and vacant.

Often, the imagery of the mannequin in fashion photography presents the female form without nuance alongside the found object and the found image, as another ordered unit—a Marxian commodity on display. In *Sexuality and Space* (1992), Mark Wigley declared, "Order in general depends upon an ordering of the body, which is to say, a detachment from it." This detachment is crucial to the minimal body, which is in some sense present only in various measures of absence. Gernreich created genderless body stockings in the early 1970s, perhaps to reflect his opinion that "the basic masculine-feminine appeal is in people not in clothes. When a garment becomes sufficiently basic, it can be worn unisexually." These designs, executed in black to further conceal the body's distinctions, whether male or female, rejected any associations derived from color as well.

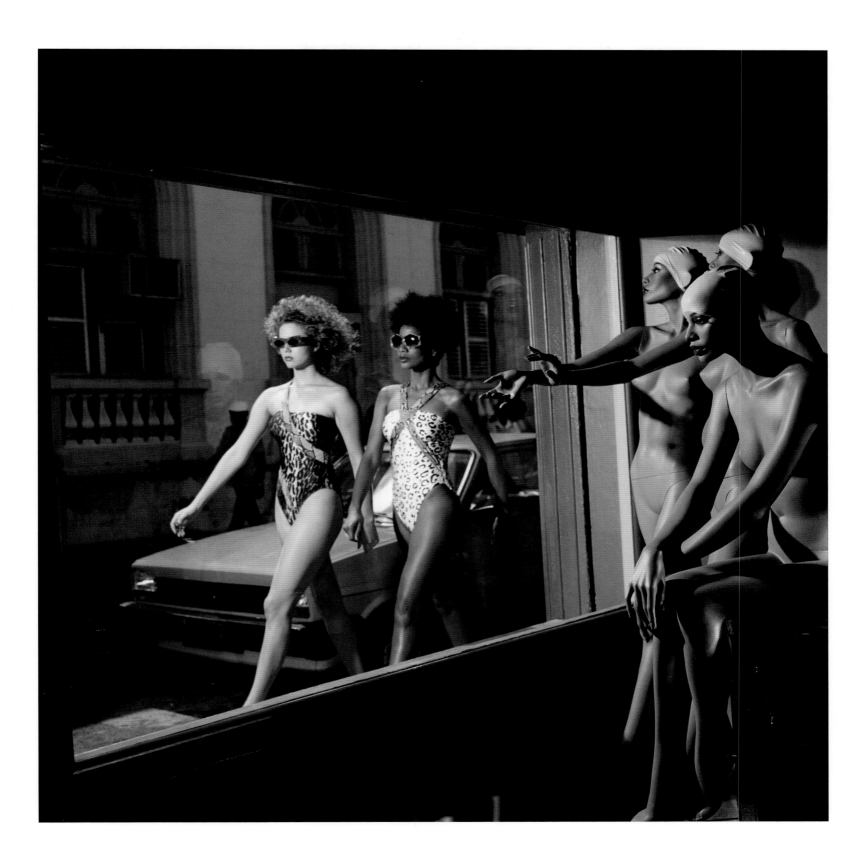

Opposite: Cape, Yohji Yamamoto, Fall/Winter 2001–2; photograph, Nathaniel Goldberg, *Numéro*, October 2001. This page, clockwise from top: Jacket, Prada, Fall/Winter 2001–2; photograph, Nathaniel Goldberg, *Numéro*, October 2001; Ensemble, Rei Kawakubo for Comme des Garçons, Fall/Winter 1984–85; Illustration of a Rei Kawakubo for Comme des Garçons silhouette, Mats Gustafson, *Vogue Italia*, 1997.

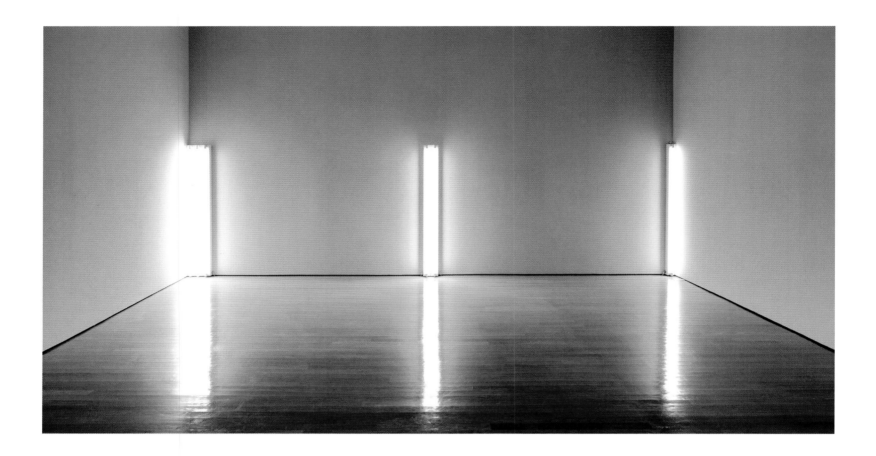

Above: Dan Flavin, *the nominal three (to William of Ockham)*, 1964–69. Opposite: Bodice, Sophia Kokosalaki, Fall/Winter 2002–3.

As the hue of the bohemians, the mods, and the Blousons Noirs, black has, in the late twentieth century, come to be associated with antifashion and control. Wilson expounded, "Black is the colour of bourgeois sobriety, but subverted, perverted, gone kinky." Quinn more specifically associated black with the minimalist removal of allusion: "As an expression of nihilism, the Existentialists anchored the void to fashion decades ago, its blackness taken as the definitive signifier of the abyss, and the ultimate collapse of meaning." The monochromatic rendering of the ebony tincture was certainly this signifier for Frank Stella within the borders of his geometric *Black Paintings* and was similarly employed by Yohji Yamamoto, whose plenary application of black has been a signature of nearly every one of his collections since his Paris debut in 1981. The latter cited his inspiration, "The samurai spirit is black. The samurai must be able to throw his body into nothingness, the color and image of which is black." Yamamoto eschewed decoration for the delicious void of basic black. Together with the off-centered seam, the cut-out, and the off-set collar or sleeve, Yamamoto's black lends credence to the traditional Japanese aesthetic of *wabi* (irregularity and rusticity)/*sabi* (purity and simplicity), which Fukai claims "led the 1980s into minimalism."

The Yamamoto black is omnipresent in his more contemporary collections as well, and affords the designer an enigmatic manipulation of both proportion and dimension via large onyx panels of broadcloth, canvas, and twill. In Nathaniel Goldberg's "L'Ombre" images for *Numéro's* October 2001 issue, Gernreich's unisex bodysuit is reiterated and enlivened by minimalist capes, capelets, and jackets from the Fall/Winter 2001–2 collections. While each photograph offers a cold, white background to polarize the silhouette in the foreground, one image captures a Yohji Yamamoto cape in mid-sway, its excessive girth swashbuckling the model's diminutive frame. While rendered all in black, the drape of the cape's neck reveals a white satin lining; the interplay of black and white in the robelike constitution presents a monastic figure in which gender and sexuality are repressed.

Peter Lindbergh's 1984 photograph of a Rei Kawakubo for Comme des Garçons ensemble depicts a similarly darkened subject, yet her funereal garments, bruised eye, and pale skin, washed out by the nothing-ness of the backdrop, insinuate a compounding isolation. Shrouded by swaths of asymmetrical wool yardage in a variable gray scale, more "poverty du luxe" than luxury fashion, Kawakubo's figure embodies the *wabi* notion of solitude. Whereas the veils within Chalayan's collections are generally symbolic and function as a device of spatial distinction, Kawakubo's have always worked to abstract and dislocate the female body as

well as the margins of the fashion object itself. In a 1997 illustration of a Comme des Garçons dress for Italian *Vogue*, the artist Mats Gustafson captured the essence of the twentieth-century Kawakubo ideal as a shadow that has lost its body, a haunting, vaguely feminine figure whose cohesion is a tailored waistline framed by an ambiguous ink-black shape. Gustafson's ghostly form evokes the pioneering efforts of the Dada photographer Christian Schad, who placed objects on sensitive paper and flooded them with light, so as to produce a phantom shape. "Schadography," though later explored by Man Ray to more dramatic effect, was quick to subvert the traditional techniques of capturing a subject and instead sought to reframe it as a divided whole composed of tangible structure and partnered shadow.

Minimalism relies on the interaction between tactile form and experiential space, a dynamic that is demonstrated par excellence in Nathaniel Goldberg's framing of a Fall/Winter 2002–3 Sophia Kokosalaki bodice. An exemplar of the minimal body, the anonymous torso featured in this image becomes an ideally androgynous foundation for Kokosalaki's jigsaw-puzzle composition of gaping black scraps connected over bare flesh by fragile crocheted threads. Goldberg captures a still life more than a portrait: here, nondescript flesh and reductive fabric intertwine against the negative space of the blank backdrop.

The expanse of the void, whether as a micro-geography or a compositional strategy, is vital to the presentation and manifestation of the minimal body. Like Miyake's inflatables, Alaïa's knit bands, or Kawakubo's shrouds, Dan Flavin's serial repetitions of the fluorescent bulb, cornerstones of minimal art since the 1960s, present reductive, even skeletal, frameworks for the viewer, where space becomes as active as the design's tactile components. The Pop artist Allen Jones, best known for sculpting the limbs of the lingerie-clad pinup into a functional chair or table, captured the essence of the minimal body in his 1976 *Cut-A-Way* drawing. He depicted a layered aggregate in which textile, muscle, bone, and their interstitial spaces are revealed as egalitarian tiers, one after the other.

Whether they emulate, abstract, or simply negate the presence of the human figure, the aforementioned works seek to expose the inherent cohesion of the dressed body as a symbiosis—however uneven—of physique and fabric. These reconceived bodies realize Vinken's "postfashion" vision as pillars of reduction and deconstruction, their makers the purveyors of a new primal form.

"LOOK AT ANY WORD L
YOU WILL SEE IT OPE
FAULTS, INTO A TERR
EACH CONTAINING ITS

ONG ENOUGH AND
N INTO A SERIES OF
AIN OF PARTICLES
OWN VOID."

—Robert Smithson, "Strate: A Geophotographic Fiction," *Aspen*, 1970

SINCE THE EARLY 1990S THE COLLECTIONS OF MARTIN MARGIELA, HELMUT LANG,

Hussein Chalayan, Miuccia Prada, and Raf Simons have emphasized simplicity of shape and realistic form, focused on aesthetics over function, and employed repetitive structures and serial systems or progressions. These principles materialize in the designers' interpretations of deconstruction fashion, defined by Barbara Vinken as the demonstration of constructedness. In 1993 the late *New York Times* columnist Amy Spindler noted the origins of the deconstructed entity in the literary criticism of the French philosopher Jacques Derrida and cited the *Oxford English Dictionary* definition: the act of undoing the construction of a thing. In "Deconstruction Fashion: The Making of Unfinished, Decomposing and Re-Assembled Clothes" (1998), the historian Alison Gill associated the term "deconstruction" in fashion with garments that are unfinished and transparent. Approaching deconstruction through a minimal lens, the moniker encompasses the reduction and exposure of an object's fundamental design in order to highlight construction and rejects the intentional destruction or demolition of a garment through tearing or fraying the fabric or pattern or the restructuring of garments through misplaced or reassembled component parts. The garments are unfinished with care for the traditional sewing techniques.

In the catalogue for the Metropolitan Museum of Art 1993 Costume Institute exhibition *Infra-Apparel*, which focused on the tendency of fashion to disclose its inherent elements, the curators Richard Martin and Harold Koda referred to clothing with evident structure and clear use of materials as "minimal objects." Like the minimalists of the 1960s, the deconstructivist designers discussed here have created garments that concentrate on the specifics of form, pattern, and fabric rather than on the garment's essential purpose as a body covering. These designs reveal the various elements and processes of dressmaking and reduce the pattern to its fundamental parts; the subject of each of these designs is the garment itself. These designers have exposed interior elements and turned the inside outside, used transparent fabric or weaves, and employed methods of layering or accumulating fabric to create garments that are diagrams of the construction process.

Fashion theorists have labeled Martin Margiela the founder of deconstruction in fashion—a master of reduction. A graduate of the Royal Academy of Fine Arts in Antwerp, Belgium, and a descendent of the famed "Antwerp Six," which also included Dries Van Noten and Ann Demeulmeester, Margiela founded his eponymous house in 1988. *Infra-Apparel* was the first exhibition in which Margiela's work appeared in the United States. The curators included him as a way of exemplifying conspicuous design and equated his primary interest in the fundamental materials and processes of dress with minimal art.

The designer's work is characterized by the exposure of the elements of the dressmaking craft or what Margiela refers to as the "icons" of the tailor's or the couturier's atelier. In his Spring/Summer 1995 collection, the primary elements of design, including the lining, the seams, and the darts, were exposed, thereby making public his constructive process. In a different version of the technique from the Fall/Winter 2003–4 collection, the waistline seam was cut and dropped open to reveal the lining and

shaping darts on the interior. Margiela maintained the same attention to skill and craft in the typically hidden details as he did to the surface of the piece. In his Fall/Winter 1997–98 collection, he directed further attention to the sartorial process by presenting the dressmaker's form as the foundation of the garment. He created several versions of a jacket made of linen canvas based on the mannequin, or dressmaker's dummy. All tailoring marks are apparent, with the occasional addition of silk fabric draped across the bust or hanging free from the body in certain variations. A sleeveless shift dress of coarse cotton from the Fall/Winter 1997–98 collection contained a label that read, "*Toile* of a garment after its first fitting: all rectification marks and faults remain apparent."

Such constructive revelations find kinship with the American minimalist Richard Serra's stacked sculpture for the Los Angeles County Museum of Art's 1969 *Art and Technology Project*. The sculpture illustrates Serra's attentive exposure of the material properties of form and interest in exhibiting his own methods of construction. It conveys a moment in time, a frozen snapshot of the work in progress, challenging the viewer to imagine both its original components and its completion.

Like Margiela and Serra, the Austrian designer Helmut Lang concentrates on the exhibition of the interior structure of a garment. Lang designed under his own label from its founding in 1986 through his resignation in 2005. In a series of looks from his Fall/Winter 1999–2000 collection, he brought the shoulder padding of sleeveless shift dresses and shirts to the exterior. For Spring/Summer 2003, Lang's designs for both men's and women's shirts and sweaters were radically cut down to their adjoining foundation seams. Lang stripped a cardigan sweater to its frame, leaving only straps of knitted cotton at the neckline, shoulder, elbow, wrist, waistline, and along the placket of the center front opening. This skeletal cardigan is the designer's reductive reading of the traditional sweater shape. In another example from that season, Lang dissected a T-shirt, leaving only a neckline and a raglan sleeve seam. Here, the garment becomes a purely aesthetic object, as it no longer serves its function or purpose: to conceal or protect the wearer. According to Gill, the designer's linear frameworks created idealized forms of known garments through the literal production of seams alone. This strategy was used as well by Sol LeWitt, who evoked the idealized cube by negating its planarity and offered an attenuated building block instead, outward edges intact.

In addition to methods of reversal and subtraction, various designers, including Hussein Chalayan, Miuccia Prada, and Raf Simons, highlight structure as a primary element of design through transparency. In the exhibition *Le monde selon ses créateurs,* or *The World According to Its Designers,* Margiela transformed a group of dresses by presenting them under an X ray to reveal the seams. Chalayan exposed the generally hidden undergarments and shaping seams of suit and skirt ensembles in his Spring/Summer 2000 collection through the use of a light-colored, transparent fabric, which, like white, accentuated the form and its construction. A series of transparent shift dresses in Miuccia Prada's Spring/Summer 1997 collections for both Prada and Miu Miu reveals the body and discloses the layers of undergarments beneath. The display of seaming as a design feature or motif is clearest in Prada's transparent plastic overcoat from Fall/Winter 2002–3. Here, she refers to the fashionable use of plastic fabrics in the boutique clothing of the 1960s, and in Gernreich's 1960s creations, outlining each seam of the tailored coat, including pocket and

wrist-strap seams, in black and bright orange thread. These examples illustrate the minimalist notion that an object's purpose or meaning should be secondary to its aesthetic status. The intention of the transparency is purely formal.

Conversely, in designs by Chalayan and Raf Simons, who has helmed the Jil Sander collection since 2004, transparency is not just a formal strategy but also a structural necessity. A series of garments from Chalayan's Spring/Summer 1999 Geotropics collection is characteristic of the minimalist tradition of building in progressions or serial systems. He presented a group of translucent white sleeveless sheaths on a sequence of models. The first model appeared in a single sheer dress. Each successive model wore an additional identical dress tacked flatly to her front. The transparency of the initial dress was obscured but vital to the presentation of the final layered model. Recently, in a Spring/Summer 2008 collection for Jil Sander, Simons created dresses by fusing together simple circle and square shapes in pale, transparent silk tulle. The repetitive layering of "one thing after another" recalls LeWitt's and Carl Andre's structures and speaks to the minimalist goal of geometric unit-by-unit construction. The Palestinian artist Mona Hatoum's 1990s installations *Short Space* and *Light Sentence* exemplify this use of transparency through layered mesh panels and illustrate the minimal environmental dualities of interior/exterior and protection/exposure.

The aforementioned designers concentrate on a methodology that intentionally reveals the dress-making process through the exposure of typically concealed elements of pattern making; a reduction of garments to their basic, fundamental parts; and an exploitation of transparency and repetition. Their counterparts in the realm of sculpture and installation similarly situate their objects in various stages of breakdown, reduction, or transparency. The resulting "decon-structures" convey an intentional focus on their own constitutive elements and the evidence of their creation or process as a means to reveal themselves as bare minimal objects.

—**Amanda Haskins**

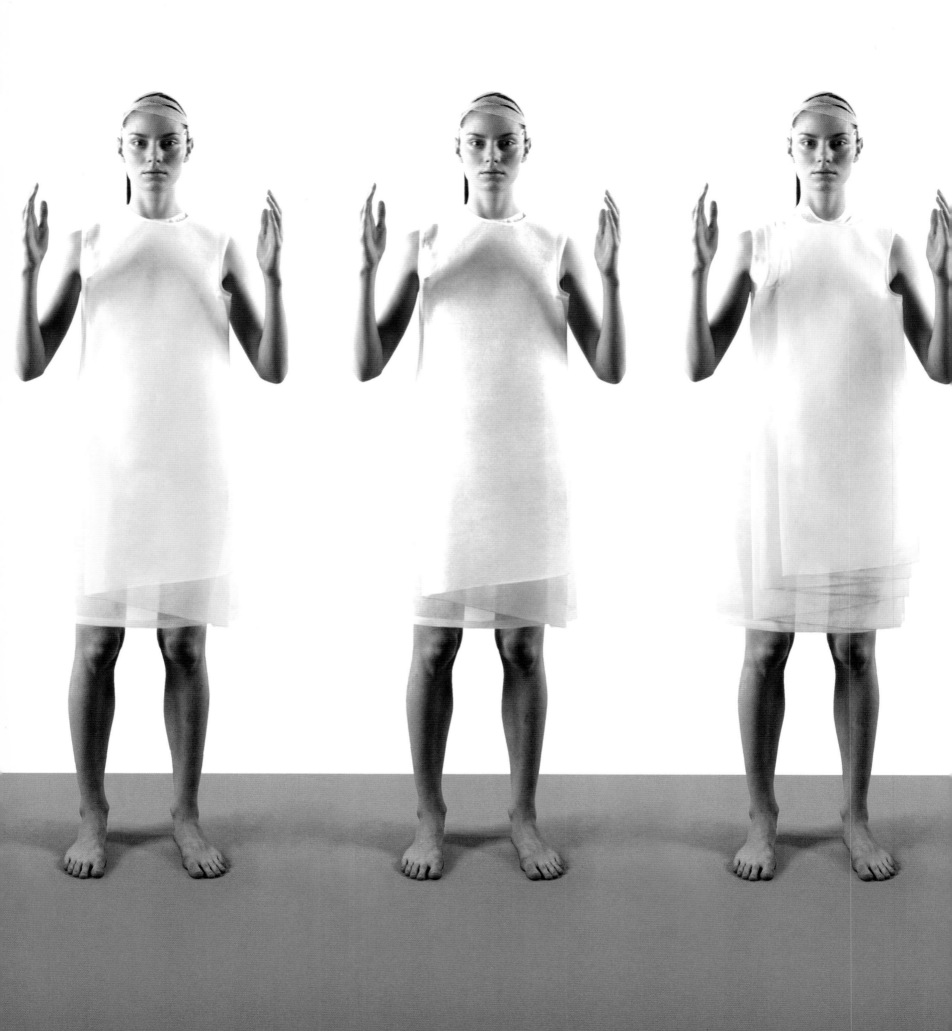

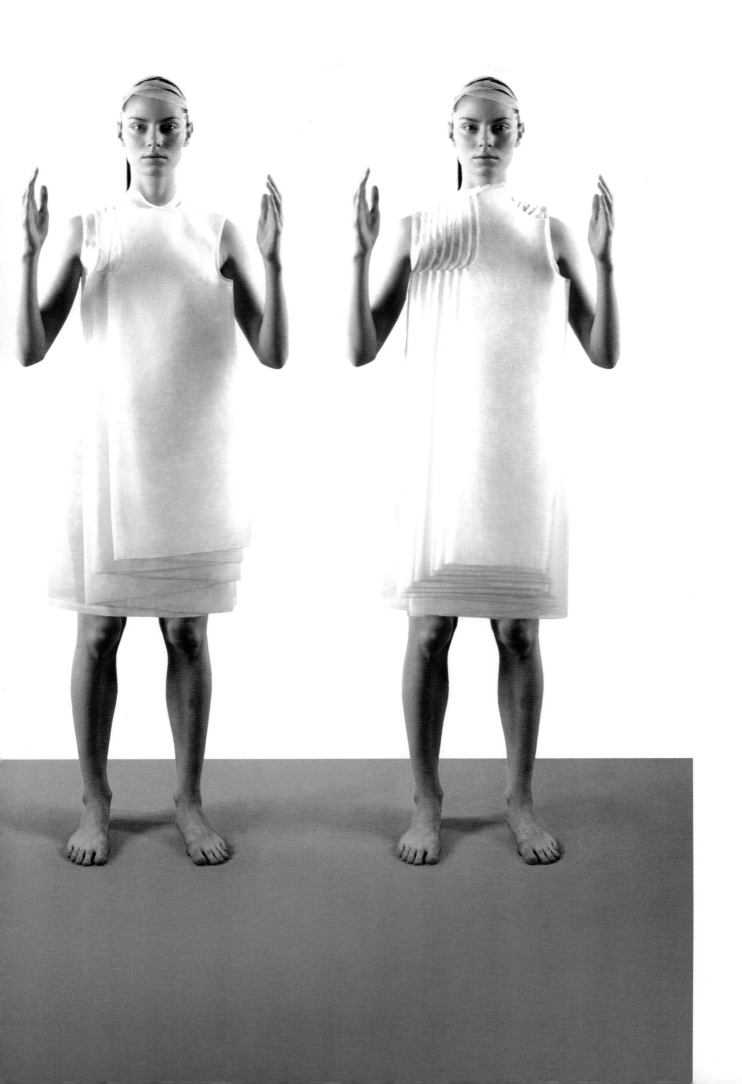

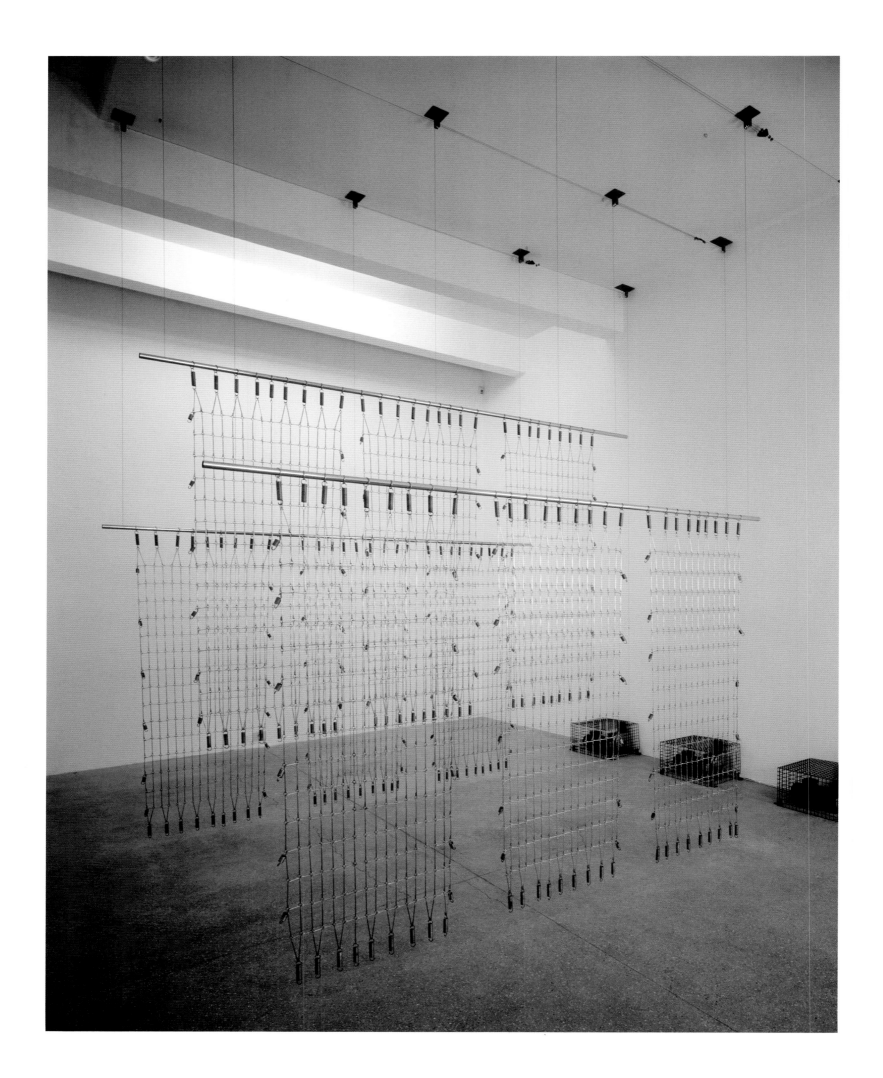

Page 103: Dress (detail), Martin Margiela, Fall/Winter 2003–4.

Page 108: Bodice, Martin Margiela, Fall/Winter 1997–98.

Page 109: Scrap sculpture for LACMA Art and Technology Project, Richard Serra, 1969.

Page 110, left and right: Ensembles, Helmut Lang, Spring/Summer 2003.

Page 111: Sol LeWitt, *Incomplete Open Cube*, 1974.

Page 112: Ensemble, Rudi Gernreich, worn by Peggy Moffitt, Fall 1964.

Page 113, top: Dress ensemble, Miu Miu, Spring/Summer 1997. **Bottom:** Trenchcoat, Prada, Fall/Winter 2002–3.

Pages 114–115: Slip dress ensemble (front and back), Prada, Spring/Summer 1997.

Pages 116–117: Ensembles, Hussein Chalayan, Geotropics collection, Spring/Summer 1999.

Page 118: Mona Hatoum, *Short Space*, 1992.

"MINIMUM IS THE ULT

MATE ORNAMENT."

—Rem Koolhaas, *Harvard Design School Guide to Shopping*, 2000

4.

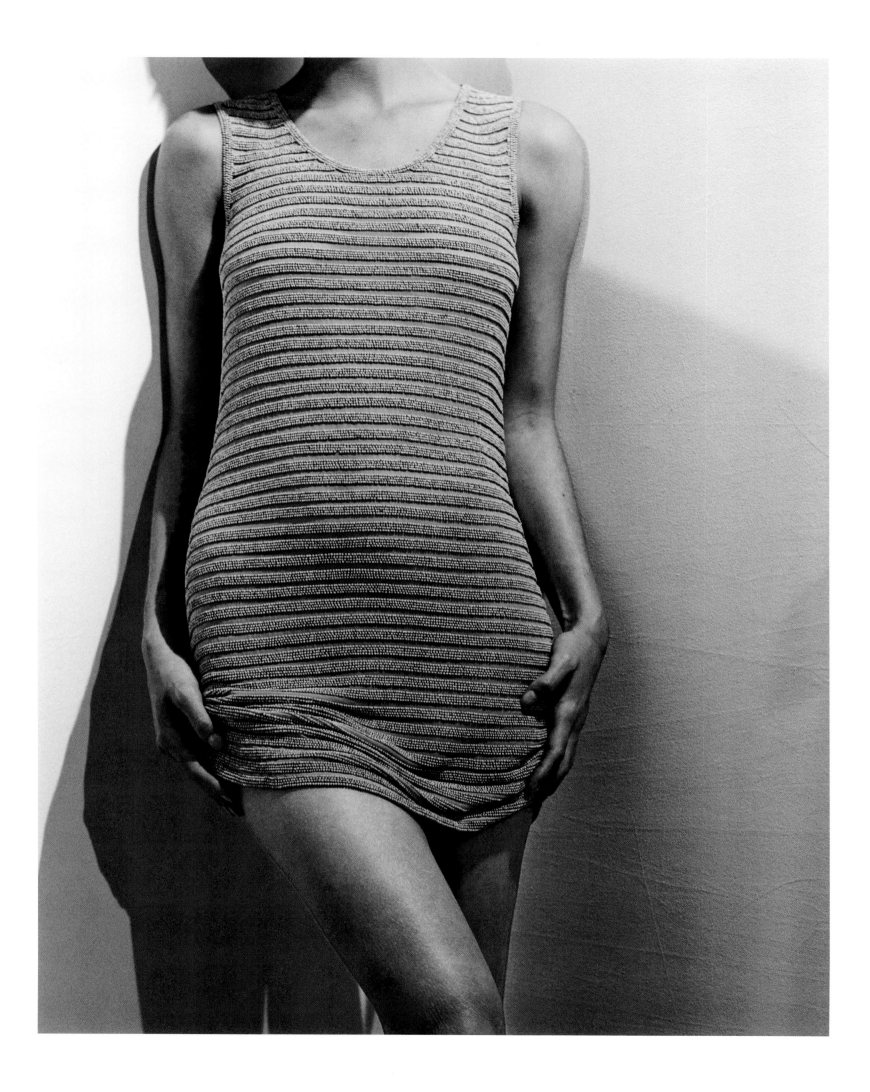

WHEN RENOWNED FASHION PUBLICIST ELEANOR LAMBERT ORGANIZED A RUNWAY

show of Italian and American designs at Versailles in 1973, the growing dominance of New York style, particularly in contrast to the staid, formal offerings of the French couture, was clarified on a world stage. No longer relevant or avant-garde, the Western European cultural authority that had for so long dictated fashion and presented it to a consuming public was in a postmodern cultural crisis, thus offering the American fashion industry, alongside the Italian prêt-a-porter, the opportunity to rise to prestige. Hal Foster suggested that minimalism and pop helped to "carry forth the American order: pop (ironically but brazenly) with its consumer-culture icons, minimalism (connotatively) with its 'universal' forms that conjure up the architectural monoliths and corporate logos of American business." In its dedication to simplicity in all its manifestations— from the muted palette to the undecorated surface—American fashion allied itself with minimalism's "universal forms" but inserted a requisite quality of functionality as well. Whereas the minimal movement had started out as a highbrow discourse on the pure aesthetics and antipurpose impulse of basic structures, those structures had, in the postminimalist landscape, been modified self-referentially to incorporate both a feminist undercurrent and a greater complexity of form. These allowances effectively paved the way for a proto-progressive collection of easy separates that would come to dictate American style.

Diane von Furstenberg's 1972 wrap dress, composed of three vertical panels of fabric, two side seams, an overlapping wrap closure at center front, and a waist sash of matching printed jersey, presented itself as an early minimal prototype: the perfect cornerstone for the laissez-faire wardrobe of the contemporary woman. So as to be appropriately restrained for the purview of career dressing, 1970s fashions boasted a neutralized palette, comprising nuanced taupes, khakis, olives, and rusts. The designers Halston, Calvin Klein, Ralph Lauren, and Donna Karan for Anne Klein emerged as the frontrunners in the creation of what the American fashion press dubbed "real clothes for real people."

The sultan of the "soft 1970s," Roy Halston Frowick, known by his middle name, was an early minimalist and was labeled "Mr. Clean" by *Women's Wear Daily* for his presentation of relatively unstructured silk and wool jersey separates as well as those in his signature Ultrasuede fabric. Although the 1960s pillbox hat was a widely copied and reinvigorated design, Halston has often been credited with its invention during his reign as a milliner for the Seventh Avenue star sartorialist Norman Norell. In 1964 Halston told *WWD* that New York fashion would "go on simplifying, everything uncluttered. This is a tailor's world, not a dressmaker's world." By the following decade, Halston had created a slew of minimal champions such as the 1974 "tube," which wound around the body and incorporated only one seam, and the "flying saucer" top, composed simply of two circles, tacked along their circumferences with openings for the neck, waist, and arms. In a February 1975 article entitled "American Fashion: The Movers," *Vogue* decreed, "More than a way of dressing, Halston is a way of life." With Halston's avid championing of the American fashion industry as an institutional infrastructure that utilized both the cultural capital of New York and its network of production firms to commercialize a refined, minimal aesthetic, this "way of life" was, in fact, a distinctly American one.

Page 123 and opposite: Advertising images featuring Christy Turlington, Bruce Weber for Calvin Klein collection, Spring/ Summer 1991.

In "How New York Stole Modern Fashion" (2000), the cultural historian Norma Rantisi recognized that "New York always had a specialization in mass markets given its origins in ready-to-wear production. Now that fashion was becoming 'the business of commercializing art,' New York's designers were well situated to ride the fashion wave."

As Halston emerged as a key minimalist figure in early 1970s fashion, Bronx-born Calvin Klein was also making a name for himself with effortless, monochromatic separates. Although he started out producing coats, by the mid-1970s his impact on the broader fashion panorama was inarguable. A 1976 advertisement captured the iconography of the early Calvin Klein brand. In what appears to be an old bedroom or attic, a crisp white men's dress shirt is pulled tautly over a female dress form. The mirror of a polished wood Colonial armoire reflects the sans-serif Calvin Klein logo. A model in lace-trimmed underwear leans against the bedroom door, her naked breasts hidden by shadow. And, almost as an afterthought, Calvin Klein himself is pictured in the corridor, leaning casually against the wall. The layers of this image—the absolute, classic status of the Calvin Klein design; the American heritage of the label; the androgynous appeal of the Calvin Klein ideal; and the reigning influence of the designer himself—speak volumes about his vision, not to mention his preeminence in the creation of an evolved minimal style. Klein famously quipped, "Minimalism is not about abandoning pattern or print. I see minimalism to be a philosophy that involves an overall sense of balance, knowing when to take away, subtract. It's an indulgence in superbly executed cut, quiet plays of color tones, and clean, strong shapes."

Although undoubtedly minimalist in focus, Klein's aesthetic also contributed to a crucial dialogue preexistent within 1970s dressing—that of feminism and female empowerment. The fashionable 1970s woman purported to be indifferent to her appearance, as to admit vanity was akin to decimating serious professional viability. Caroline Milbank observed, "Grooming became covert: hair had to look as if nothing had been done to it . . . makeup had to look natural. . . . Fashion became simpler, both in terms of how it looked and in that fewer garments were required to meet a variety of needs." In Bruce Weber's masterful images of Christy Turlington for the Spring/Summer 1991 Calvin Klein collection campaign, these styling strategies remained intact. The photographs appear as candid snapshots in which Turlington's wild locks and spare makeup concede only to the progressive shapes of Klein's slip dress and T-shirt top. A graphic interplay of shadow and form strengthens the elegant reductivity of the designs themselves and posits Turlington as an isolated figure, independent and self-assured enough to playfully lift her skirt for Weber's lens.

The streamlined, androgynous wardrobe that Klein, and to some extent Halston, developed cultivated a prescient dialogue with the 1980s and 1990s installations of postminimalist female artists. Janice Antoni's *Gnaw* (1992)—a performance during which the artist literally gnawed away at two six-hundred-pound cubes of chocolate and lard then used the spit-out shavings to create heart-shaped candy trays and (with the lard) three hundred tubes of lipstick—seamlessly connected the feminist criticisms of bulimia and consumerism with the minimalist's attention to process and the universal form of the cube. Rachel Lachowicz's 1991 *Coma*, which comprised caged cubes of red lipstick, hung with invisible fishing wire in staggered formation within a white gallery space, alluded to Andy Warhol's suspended *Silver Clouds* (1966) but took the ephemeral composition of

the silver clouds and anchored them as tangible plastic entities. Both works served to expose the dominant patriarchy of traditional minimalism and challenged its "universal" appeal by employing the female commodity of lipstick as an apt raw material for the "caged" presence of the postmodern feminist discourse. By repositioning minimalist art within the female arena, Antoni and Lachowicz acknowledged the importance of minimalist technique to a ubiquitous feminist movement, which ultimately included an enlightened way of dressing.

As a forward-thinking woman in a male-dominated New York fashion industry, Donna Karan understood the importance of easily interchangeable, mutable separates in establishing a feminist-friendly working wardrobe. In one of her early designs for Anne Klein, Karan presented a beige angora sweater dress, which was in turn photographed by Richard Avedon for an August 1973 *Vogue* spread entitled "The Kinds of Clothes America Loves Best—Casual with a Snap." The model Lauren Hutton was captured mid-leap, liberated by the comfort and ease of the sweater dress. The simplicity and wearability of such designs have become crucial to Karan's reputation as the engineer of the working woman's wardrobe, a legacy that was secured by the founding of her own label in 1985 and the subsequent creation of her "seven easy pieces." The monochromatic "pieces," which included wrap tops, a dress, and her now-iconic black bodysuit, contributed to Karan's credo for effortless sartorial versatility. In *Fashion, Desire and Anxiety: Image and Morality in the 20th Century* (2001), the fashion theorist Rebecca Arnold suggested, "Labels like Donna Karan and Calvin Klein provided the essential wardrobe for those who wished to be viewed as serious and career-minded."

These minimal designs and the aesthetic of New York career clothing began to influence the works of avant-garde designers from other fashion industries. While Ladicorbic Zoran, a Yugoslavian immigrant who arrived in the United States in 1971, channeled Halston's work through rigorously basic garments in lavish, if restrained, textiles, Issey Miyake took an interest in the American employ of the working-class fabrics of cotton knit and denim. Miyake ultimately was inspired to look to his own heritage and adapted the quilted sashiko cloths and durable cottons of Japanese laborers' clothes into oversize tops, coats, and loose pants for his lower-priced Plantation label. In a 1983 *New York Times* article, Miyake told June Weir, "I'm working hard on Plantation, my less expensive collection. I see many people wanting comfortable clothes that are easy to care for. So many

129

Opposite: Photograph, Richard Avedon, Janice Dickinson, blouse and pants by Issey Miyake, New York, April 1977. © 2010 The Richard Avedon Foundation.

women say, 'I'm not interested in fashion. I want clothes to last for years.' I thought that after the T-shirts and jeans, I could make clothes that are simple, interchangeable. . . . I have only two sizes and half of the styles can be worn by men. I use strong fabrics—cottons for summer and washable wools for fall and winter." When one such ensemble appeared in *Vogue* in July 1977, the magazine declared, "Issey has the Prototype."

Miyake's standardized sizing and army-drab fabrics were also likely derived from the militaristic references rife in 1970s American fashion: Ralph Lauren's khaki and olive fatigues, which *Vogue* claimed were "everybody's favorite new knock-about uniform," and Rudi Gernreich's spring 1971 Back to School collection provided ample source material for Miyake's martial duds. "Back to School" was coined by the journalist Leon Bing in reference to the Kent State shootings the previous year. Yet with their rigid structuring, basic patch pockets, banded belt details, and clean lines, Gernreich's designs spoke more clearly to minimalist restraint than political criticism. His fondness for the regimented, controlled body of the uniform extended to the following season as well, when he reinterpreted classic American football regalia.

An exemplary model for the minimalist designer, the uniform connoted restraint and order within its very constitution and, in its typical capacity as requisite dress for an army of soldiers, implied easy reproduction and serialization. Vinken suggested, "Although in themselves premodern phenomena, uniforms, owing to their massive presence in bourgeois society, have a unique status in that they represent the only place where masculinity is literally 'on parade.'"

The markings of the masculine uniform helped to further the androgynous directive of 1970s minimalism but also affiliated the impeccable minimal silhouette, a crisp monochromatic figure, with the aesthetic of the dandy. In 1960 William Klein photographed the model Dorothea McGowan, clothed in a typical Chanel design of white nubby tweed with navy banded trim, as she advanced up a staircase from the banks of the Seine. The Brandenburg trimming derives directly from the decoration of the military uniform, but when paired with the saturated geometrics of Chanel's light-and-dark design it also insinuates the designer's persistent reference to the nineteenth-century male dandy, a minimal precedent. Chanel's signature minimalism served as a benchmark that fused dandyism's tenets of quality, reduction, and attention to detail. The dandy's visual identity is best deciphered by the words of Max Beerbohm, the quintessential post-Brummellian dandy, who declared, "Dandies make themselves. Whatever they may be by birth or nurture, dandies are born anew as dandies when they first dress themselves according to the dandy code. The dandy self, naked and fresh, is a figure in black and white. Completely dressed, almost completely monochrome, he is, to put it simply, a written thing." An author of the minimalist vernacular, the dandy offered a cogent monochromatic model, simultaneously duplicable and fiercely unique. Beerbohm's vision in particular aptly describes the Bauhaus director Walter Gropius, an early twentieth-century champion of standardization and organization. According to Mark Wigley, Gropius dressed every day in black trousers, white shirt, and slim black bow tie, and "his short mustache, trim figure, and swift movements gave him the air of a soldier." Gropius utilized simplicity and restraint as a means to access the aesthetic of the modern, the progressive, and the productive. His "uniform" was not so much fashion as antifashion— understated to the point of being nondescript—lending to its characterization as a classic style that could

Opposite: Ensemble, Rudi Gernreich, Resort collection, 1971.

Top: Suit, Gabrielle "Coco" Chanel, worn by Dorothea McGowan, Fall/Winter Haute Couture collection, 1960; Photograph, William Klein, *Vogue*, October 15, 1960 and French *Vogue*, October 1960. Bottom: Drawing, Richard Neutra, *S. Pauls, Bank Holy Day, London*, August 4, 1920. Opposite: Photograph, Mert Alas & Marcus Piggott, "Boy Kate," *Vanity Fair*, September 2006; Ensemble by John Galliano for Christian Dior, Fall/Winter 2006–7.

be reinterpreted again and again as a minimalist suit par excellence. Richard Neutra's 1920 drawing of the era's modern, stylized silhouettes reiterates the stark dandy figure in both male and female variations as a pillar of reductive form.

Nearly a century after Neutra's sketch, the photographers Mert Alas and Marcus Piggott envisioned Kate Moss as the preeminent postmodern dandy in the formal uniform of a tuxedo designed by John Galliano for Christian Dior. Moss's sun-kissed locks are effectively hidden underneath a fur-felt top hat to emphasize the image's masculine posturing, and the composition is saturated in grayscale to evoke the black-and-white portraits of the iconic silver-screen androgynes Marlene Dietrich and Greta Garbo. Striking in its juxtaposition of the revered plainness of the tuxedo and the ornate decorations of the rococo-style armchair on which Moss sits, this image stresses the importance of relative presentation in dandyism. As Elizabeth Wilson wrote, for the dandy, "image was everything."

In some sense, Mert and Marcus's portrait resonates because the tuxedo has persisted as a virile symbol for gender manipulation nearly since its invention. It has also been a useful guise for actresses and public figures as diverse as Liza Minnelli, Bianca Jagger, and, in recent years, Sofia Coppola. These women have all been associated with the tuxedo wardrobe, utilizing it to convey a potent yet ambiguous sensuality—a quality intrinsic to the late twentieth-century minimalist wardrobe.

The designs of the 1970s isolated and promoted a cool, removed sexuality reliant on a monochromatic configuration of easy, conservative separates, but by the 1980s minimalist fashion embraced a more severe silhouette and the coordinated suit of the traditional dandy was transformed to project strength and domination. The 1980s "power suit" introduced an angular, hyperbolic shoulder line and columnar cut that ultimately hid the female musculature and created a more predatory, epicene ideal. In the 1981 photograph *Blue-Black in Black on Brown*, Jean-Paul Goude presented the model Grace Jones, hair buzzed into a boyish flattop, as an archetypal power dresser in a severely cut black blazer, her bare, nearly flat chest exposed to replace the standard white dress shirt. As evidenced by the title of the image, Goude also sought to comment on the growing racial diversity in fashion. An editorial image of Stella Tennant in a Giorgio Armani blazer from his Fall/Winter 1996–97 collection tellingly juxtaposes Goude's vision, referencing his posturing and reiterating the enduring popularity of the black tailored jacket. The

Armani photograph also apposes Jones's confrontational stare with Tennant's diverted gaze; Jones's powerful "black on brown" with Tennant's expressionless white on gray; Jones's hermaphroditic silhouette with Tennant's flamboyant hair and quietly sloped shoulder. These disparities map the transformative journey of the minimalist dandy over a fifteen-year period but also highlight the impact that Armani himself had on women's tailoring, having designed the unstructured jacket in the mid-1970s. In *Giorgio Armani* (2000), Suzy Menkes explained, "By bringing comfort and freedom of movement to tailored uniformity, Armani marked twentieth-century fashion and underscored its linear, masculine quality."

Armani's initial successes in the late 1970s were the offspring of a prosperous Milan prêt-a-porter yet born within a fairly unstable political and social situation in Italy as a whole, as the Red Brigades were terrorizing citizens in Rome and the Italian government turned over eight times between 1975 and 1980. The revolutionary zeitgeist of this period included the new wave of Italian feminism, which undoubtedly informed Armani's androgynous womenswear, built for both comfort and utility. Armani's work reduced the body, whether male or female, to carefully controlled abstractions, tapestries of basic forms illustrated with muted colors and basic, if luxurious, textiles. In an editorial spread for the July 1988 issue of Italian *Vogue*, photographer Marianne Chemetov captures the old-world charm of early cinema in her soft focus but showcases an enlightened Armani-clad dandy in stark juxtaposition. In one image, the model's cropped bob haircut, black summer wool suit, and men's oxfords exemplify the androgyny of the Armani ideal. Moreover, the clarity of his sartorial line demands the figure's effortless recline and the stylist's omission of accessory decoration. Years later, the designer gave *Vogue* his sage advice: "A sharply defined silhouette is the starting point for elegance. Each element you add only risks spoiling the line." Whether via the unstructured ease of the late 1970s, the severe tailoring of the 1980s, or the austerity of his 1990s basics, Armani was crucial to the formation of the minimal dressing movement of the late twentieth century and to the concept that equated reduction and restraint with notions of good taste. His subtle, streamlined style was consistent to the point of redundancy: sartorially, the 1988 Italian *Vogue* image could well have been mistaken for a late 1970s design, although the postmodern light treatment and waifish subject belie this early date.

In *The Fashion Business: Theory, Practice, Image* (2000), Arnold explained, "Financial and personal indulgence is as much a part of consuming the sleek trouser suits made by Armani, as it is in the purchase of a sparkling Versace outfit, but the former wear the mask of puritan abstinence, of rational, functional design and the longevity of the 'classic.'" Armani's classics were executed in loose crepes and leno weaves— textiles that appeared expensive yet still rustic enough to insinuate utility and longevity. The Armani suit embraces the fashion theorist Anne Hollander's summation of the basic coordinated ensemble in *Sex and Suits: The Evolution of Modern Dress* (1994) as "an attractive guise of nudity." Neither invasive nor overbearing, Armani's designs presented an effortless, timeless aesthetic that simultaneously embraced both mass-produced phenomenalism and the distinction of private artisanship. Recognizing this duality, Menkes asserted, "Perhaps only in Milan, the heartland of modern design, could a tailor have envisaged making factory line slipcovers for the human frame—reminiscent of the beige calico shrouds that are placed over basic chairs at every Armani event."

Opposite, left: Photograph, Jean-Paul Goude, *Blue-black in Black on Brown*, 1981. Opposite, right: Jacket, Giorgio Armani, worn by Stella Tennant, Fall/Winter 1996–97; Photograph, Paolo Roversi, Italian *Vogue*, December 1996.

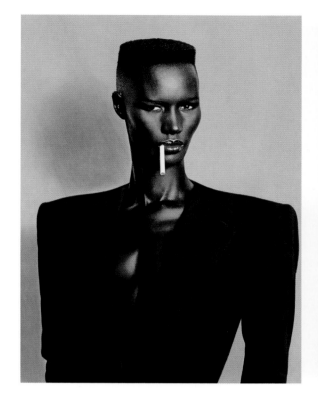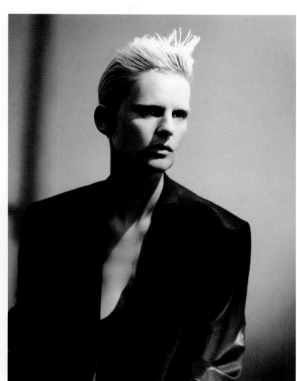

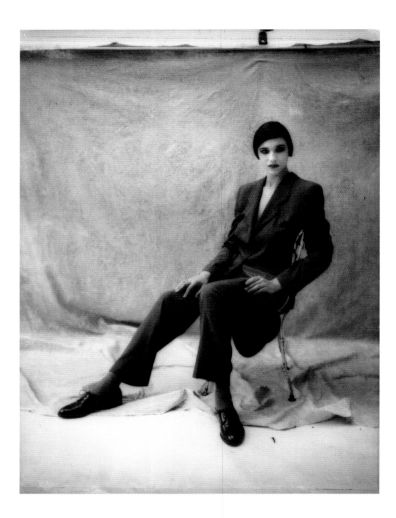

Above: Suit, Giorgio
Armani, Spring/Summer
1988; Photograph by
Marianne Chemetov for
Italian *Vogue*, July 1988.
Opposite: Photograph,
Deborah Turbeville,
Vogue, May 1975;
ensembles by Jean-Louis
Scherrer, Stephen
Burrows, André Courrèges,
and Emanuel Ungaro.

The Italian prêt-a-porter, with its adherence
to sartorial classics, and the American fashion industry,
whose practitioners prioritized practicality and
astringency, jointly imposed a more disciplined body
ideal upon the global consumer by the late 1970s in
order to uphold their minimalist renderings. Cult
fitness emerged to engineer a standardized, reproducible
woman to occupy serially manufactured fashions. An
image from Deborah Turbeville's telling 1975 photo-
graphic series *Bath House,* shot in New York City,
featured models Chris Royer, Sara Kapp, Marcia Turnier,
and Yasmine positioned as interchangeable bodies
clad in look-alike white swimsuits or robes. Instructed
to either stretch or appear physically exhausted from
exertion, the models embodied the modern-minded
consumer, as concerned about her corporeal foundation
as her wardrobe of sportswear separates.

The fitness craze of the early 1980s unsurprisingly
cultivated a market for what Elizabeth Wilson called
"aerobics style." Aerobics style boasted revolutionary
textile innovation and reinterpretation, as sweat-shirting,
Lycra, and other synthetics previously used solely for
athletic garments could now be found in more advanced
designs and ready-to-wear products. The explosive
popularity of Norma Kamali's 1981 Sweats collection
crystallized this style, as her moderately priced fashion-
forward designs in fleece-backed sweat fabrics were
intended more for a daytime excursion to the super-
market or office than to the gym. Kamali's designs
and those that followed in the early 1980s seemed to
catalyze the existence of a mass-market minimalism
that boasted simple shapes and serial production but
eliminated any conceptual or financial threat to avid,
unbridled consumption. This mass minimalism was
codified for the broader consumer population by the
middle of the decade, with the dramatic success of
The Gap, a widespread retail vehicle that would provide
basic models and low-cost fabrics season after season
with little variation.

Although first established in San Francisco as a
jeans and records store in 1969, The Gap had by the
late 1980s become a multinational conglomerate with
branches in Paris, London, and Vancouver, all dedicated
to selling a range of denim styles and cotton T-shirts
that were invariably marketed through "classic" or
"basic" style lines. The retailer typically hired popular
models and actors to appear in its advertisements
and commissioned leading fashion photographers to
shoot them in a thinly veiled attempt to elevate the status
and exclusivity of its products via celebrity association.

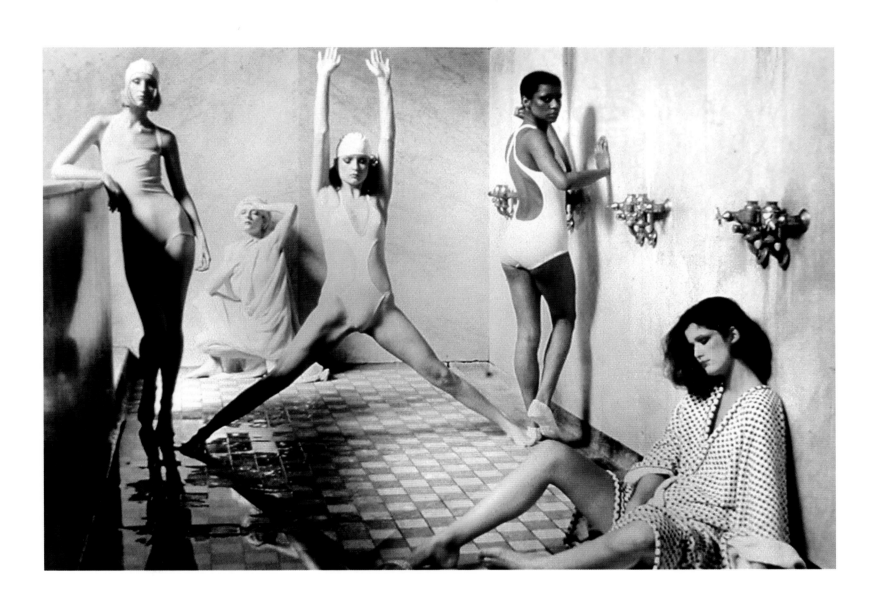

Herb Ritts photographed Countess Vera von Lehndorff, better known as the high-profile 1960s model Veruschka, for one such advertisement in 1989. In the photograph, Veruschka stands, in stark contrast to the colorful, playful shapes she showcased in previous decades, against a muted gray backdrop in a black turtleneck, black stretch pants, and black leather boots: cornerstones of an androgynous, minimal wardrobe. The only Gap product in the ad is the turtleneck, which retailed for $19.50; the pants and boots served only to reinforce the aesthetics of a characterless foundation and were not mentioned in the ad. No detail within these shapes was clarified; their appeal lay in their vitality as basics, their easy maintenance, and their portability. The designer name, along with any visible championing of design itself, was rejected for The Gap label, an emblem of both democratic accessibility and universal style.

While The Gap's products were not unique, expensive, or difficult to find, the company still shrewdly created ample demand by helping its consumers to perceive themselves as specialized experts in modern dressing. A typical ad for the retailer by the early 1990s read: "Appreciation. It's an affinity you have for simple lines and simple shapes. In recognition of how everything begins with them, there's Classic Gap." Such campaigns effectively allowed the middle- or lower-class customer to believe that she possessed the discriminating eye and cultivated aesthetic "appreciation" of the upper class; the campaigns thereby effectively inferred and affirmed each consumer's individual good taste.

This individual taste was formulated by the choice layering of The Gap's limited range of simplistic cuts, offered in a multitude of colors. Giorgio di Sant'Angelo served as an early precedent for The Gap's mix-and-match strategy. Sant'Angelo, who styled for Diana Vreeland in the 1960s, had by the following decade created a series of body-conscious separates in monochromatic arrays that could effectively be tied, coordinated, and arranged according to the wearer's tastes. (His knit wrappers also directly inspired the creation of Sandra Garratt's 1980s minimalist Multiples concept, which included endless iterations of tube waistbands [or head-bands or hip belts], straight-cut tops and skirts, and tapered pants, all configured in plain cotton jersey to be worn correspondingly with any other item.) Ignited by the pioneering efforts of Sant'Angelo's high-end jersey separates and accentuated by the popularity of Garratt's boutique modular dressing units, The Gap's exhaustive promotion and merchandising effectively posited the mass-market consumer as designer, thereby removing any internal designer authority or emotiveness from its brand. The 1980s Gap demographic, hungry for a dictatorial presentation of wardrobe classics, ultimately reinforced the minimal instincts of high-end American fashion designers such as Calvin Klein and in turn paved the way for the success of designer diffusion lines hocking these classic shapes but with the added cachet of a designer name.

Even though Klein's premiere collection was still relevant by the early 1990s, the licensed lines were his cash cow. If Coco Chanel's iconic perfumes and Christian Dior's hosiery, perfume, and jewelry franchises of the late 1940s were early catalysts for the commercial alliance between the ready-to-wear trade and the fashion industry, Klein's unisex perfumes, jockey-style underwear for both sexes, and jeans provided a universal brand identity that appealed to every socioeconomic consumer class. Zack Carr, an assistant designer at the Calvin Klein company throughout the 1970s and early 1980s, reflected upon Klein's ability to produce sought-after minimalist products at various price points: "From the beginning, Calvin's clothes were not fashion for a

certain economic group or a certain shape or a certain social echelon. They are clothes for everyone. They are very democratic, but they are still chic, they still have ideals." Klein's works, though prototypical of American postmodern minimalism, were undoubtedly influenced by the jeans and T-shirt aesthetic of mass-market retailers such as The Gap and were often portrayed similarly in fashion editorial layouts. Mert Alas and Marcus Piggott eliminated all superfluous decorative elements in their 2006 advertising images for Calvin Klein by focusing simply on two shirtless models in mutations of the company's iconic jean. Set against a flat gray background, their images invoke both the simple composition of the Gap advertisement and the white space of 1960s fashion photography. Straightforward in its basics messaging, the campaign reinforced the legacy of CK Jeans as a coveted designer brand at an accessible price point and additionally distinguished itself from the platforms of Gap-esque retailers by casting veteran Klein model Kate Moss as the female figure. Moss, whose waifish constitution and insouciant smirk imparted the androgynous cool of Klein's label for nearly a decade, helped to lure a younger demographic as early as 1992, when she posed alongside the rapper Marky Mark (Mark Wahlberg) in a wildly successful Calvin Klein underwear campaign.

Klein's products, like Ralph Lauren's and Tommy Hilfiger's, have traded on the progressive American design legacy of functional minimalism. The ancillary lines of such companies served to hook the aspiring dresser, who sought the label inasmuch as the look, and in fact cultivated and encouraged a disposable consumer lifestyle in which a pair of Calvin Klein jeans and a cK cardigan might anchor an otherwise pedestrian ensemble of replaceable Gap articles. In this way, the American companies maximized their "designer" status yet often produced covetable pieces that were every bit as nondescript as a Gap classic and, when incorporated into a consumer wardrobe of mass-market retail commodities, existed as just another basic in the phantasmagoria of the minimal wardrobe.

The popularity of reductive, dispensable clothes also impacted the 1990s home furnishings market, which saw the rise and importation of retailers such as IKEA that peddled singles of streamlined, modernist furniture and housewares to allow each consumer a unique domestic mise-en-scène. Tokujin Yoshioka's *Honey-Pop Chair* of white paper, with its collapsible accordion configuration, evokes the "junk" cardboard chairs of Frank Gehry's creation but moreover symbolizes a commodity culture of endless, unidentifiable minimal objects that the entire world would embrace as a means toward simplification and individualization by the end of the century. In *The Fashion Business,* Arnold expounded, "Minimalism . . . seemed to offer an escape from constant consuming, from the confusion and violence of contemporary society and yet, ironically . . . this frequently involved buying more."

By the 1990s the extraordinary marketing mechanisms of the minimalist labels began to be dissected by cultural critics who launched an attack on the purveyance of the overpriced, reductive fashion classic similar to that of the 1960s art journals on early minimalist works. In "He's Got the Whole World . . . in His Pants" (1995), the writer Steve Daly observed, "Most of [Calvin Klein's] products are, after all, on just the right side of generic . . . and yet we keep coming back for anything bearing The Name, always rendered in that immaculately tasteful, almost faceless typeface." The problem of not-enough-art—or, in the case of late twentieth-century minimalism, not-enough-fashion—was cleverly obscured by the potent power of

Opposite, top: Tokujin Yoshioka, *Honey-Pop Chair*, 2000. Opposite, bottom: Advertising image, Albert Watson for Prada, Spring/ Summer 1989.

the designer emblem. As the myth goes, the Calvin Klein logo, clean and understated, was developed in the early 1970s for all print promotion and was lifted from one of their press kits by assistant designer Jeffrey Banks for a series of special gift T-shirts. The fashion press embraced the logo as a crucial component of the company's shirt. As such, it was applied to every Calvin Klein product, from elasticized underwear bands to sleek eyeglass frames. By the 1990s this sans serif font was inextricably linked not only to the production of the Calvin Klein label but also to the international popularity of American designer style, manifested by jeans, T-shirts, workman's jackets, and sneakers.

It is impossible to cite the prominence and proliferation of the American designer logo, whether a clean, typed "Calvin Klein" or a Ralph Lauren polo horseman, without acknowledging the branding of the Italian fashion industry. Where the American logo represented a well-edited collection of basics, the stamps of Armani, and certainly Prada, provided the cachet of reduction yet possessed the additional distinction of European exclusivity that was certified by the "Made in Italy" label. A Prada advertisement that ran in *Vogue*'s March 1988 issue offered a snapshot into the charmed life of the Prada customer, the subject's body framed at the neck and knee so as to allow the reader to readily imagine herself as the reclining model—casually clothed in the "classic" items of a white men's dress shirt and black wool pants. With her black leather Prada bag flung carelessly beside her along with the morning's newspaper, she leafs through a massive novel. This calculated snapshot of contemporary leisure—with its disparate citations of privilege— is congealed and centralized by the white Prada logo at center, even if the clothing items themselves are as unremarkable as the mass-produced essentials of the American mass-market retailer. In "Prada and the Art of Patronage," the journalist Nicky Ryan observed, "Through a process of symbolic 'transubstantiation,' the application of the designer logo causes the manufactured garment to be transformed into a couture creation. In this way, the designer or creative director constructs a unique and charismatic identity for himself (or herself), which is conferred on the label and by extrapolation, the product." In the case of 1990s minimalism and specifically the high-end white shirt versus the mass-produced one, the designer label elevates the product's prestige and imbues it with greater importance, much in the same way that Duchamp's signature converted a found object into a ready-made. The curator Andrew Bolton has commented on the significance of the house label as a reiteration of the logo and an emblem of individuality and "authorship"; he compares the effect of the designer label to "an artist's signature . . . when applied to a work of art."

The intersection of fashion and art finds a crucial vortex in the conflation of the museum gallery and the contemporary minimalist boutique. In Andreas Gursky's *Untitled IX* (1998), a colorful selection of high-end bra and panty sets is displayed in equidistant spacing, hanging from two inset backlit racks. The photograph also includes the well-tread mauve carpet of the retail space and its expressionless wall. Gursky documented the austere minimalist shelves of the Prada boutique in his Prada series in 1997, when the fashion company was looking to reinvent itself in alliance with popular artists and architects. Gursky, who is known for his saturated snapshots of consumer spaces and bleak landscapes of corporate production plants, depicted Prada's key accessories—the shoe and the bag—on white shelving set into a discerning pistachio-green wall. The products are given ample space to be viewed as independent entities and are showcased in a manner akin to that of the

Pages 142–43: Andreas Gursky, *Untitled IX*, 1998. Opposite: Tom Sachs, *Prada Toilet*, 1997.

art object on display. As Ryan noted of the boutique's minimal design, "The simple geometry and frontal presentation of the constituent elements might suggest an altarpiece where mundane artifacts are transformed into iconic objects of worship." This retail style was duplicated by nearly every luxury fashion firm in the late 1990s. The approach effectively removed the commercial associations of the fashion object in order to elucidate a work in sole dedication to and promotion of its own aesthetics, thereby attracting cultured collectors instead of simply consumers. Rem Koolhaas labeled this strategy "the stealth laundering of luxury."

In 1997 the sculptor Tom Sachs configured his *Prada Toilet* out of the brand's discarded retail boxes. The *Toilet* is a viable Dada object, conceptual and "found." It cleverly nods to the Prada customer's disposable income and further condemns the wasteful packaging of the fashionable commodity, but its most potent message is its criticism of Prada's posturing. Whereas Gursky's photographs validate the gravitas of the Prada design, Sachs's *Toilet* reveals the transparency of this marketing by presenting the coveted Prada wrapper, complete with stamped logo, as just another piece of cardboard. Sachs's work is mined from the late 1980s installations of the postminimalist Jac Leirner, such as *Names* (1989). Leirner collected plastic and paper shopping bags from companies as diverse as J.Crew and Christian Dior then sewed them together side-by-side onto a polyester backing to configure a vast quilt for exhibition. Leirner claims that her goal was to provide a "terminal position" for these objects of exchange and that there is no larger social or political context intended beyond the physical configuration of the quilt. This notion of terminality implies the death of the bag's commercial value as a living entity invested with the cachet or reputation of the company it represents. Therefore, the company logo is divested of its allusive and illusive properties and is returned to its tangible characteristics.

Opposite, left: Runway presentation, Calvin Klein, Spring/Summer 1997. Opposite, right: Slip dress, Marc Jacobs, Fall/Winter 1996–97.

With the Prada logo omitted from many of Miuccia Prada's 1990s offerings, her designs would be divested of their value and even their purpose. Functional American minimalism had reached its apogee by this time, and no matter how high-end the design firm, the creative result often fell in line with the indistinguishable basics being offered by both competing brands and mass-market retailers. Prada recognized the importance of distinguishing her collections with function-driven, high-tech elements such as industrial zippers and durable nylons to keep up with mass consumer demand, but, as Ginger Gregg Duggan observed in her *Fashion Theory* article "The Greatest Show on Earth" (2001), "Function is no longer as important as the appearance of functionality." Prada's Spring/Summer 1997 collection featured an ensemble of a men's khaki broadcloth shirt with envelope patch pockets buttoned to the neck, paired with flat-front khaki trousers and a chunky black leather workman's belt. The design, more janitorial uniform than fashionable look, was in line with Prada's attenuated minimalism but appeared somewhat absurd on the fragile frame of the runway model, especially as her hair was pulled hastily off her face into a sloppy bun atop her head. Miuccia's Spring/Summer 1991 nylon-blend parka included the constructive details of a wide bodice breadth and a drawstring hood. An editorial image for the May 1991 issue of Italian *Vogue* cleverly belies these functional allowances, closing the hood over the model's eyes as she lunges forward, as if to convey the blindness of wearing a high-priced fashion commodity for its utilitarian capacities.

However closely Prada, Calvin Klein, Armani, and Donna Karan streamlined their collections with the mass cultural trend of functional minimalism, even going so far as to create lower-priced lines such as cK, Prada Sport, and Armani/Exchange in order to clarify the accessibility of their styles, ultimately their high-end creations had to fulfill a more exclusive design strata in order to maintain sales, let alone cachet. In *The Anti-Aesthetic: Essays on Post-Modern Culture* (2002), Jean Baudrillard explained, "The commodity is readable . . . the commodity always manifests its visible essence, which is its price." Although the use of rustic or everyday fabrics was to a certain degree a vital component of minimalism's interaction with democratic American style—exemplified by Prada's iconic 1988 black nylon backpack—fashion's minimal basics, whether engineered in New York or Milan, distinguished themselves from the mass market's correspondent reductive shapes by the lavishness of their textile employ.

In keeping with Geoffrey Beene's declaration that "only the immensely wealthy can afford to be excessively simple," in the late 1990s designers such as Calvin Klein and Marc Jacobs found in the simple slip dress the perfect reductive form in which to clothe their high-end clientele. In her article "Luxury and Restraint: Minimalism in 1990s Fashion" in *The Fashion Business* (2000), Arnold observed that minimalist forms such as the slip dress offered "a much subtler, but no less powerful form of status assertion . . . this could perhaps be called inconspicuous consumption: wearing clothes whose very simplicity betrays their expense and cultural value, when quiet, restrained luxury is still revered as the ultimate symbol of both wealth and intelligence." Arnold's summation is bolstered by Adolf Loos's insistence in the late nineteenth century that the fashion of the very wealthy must be modified according to its ability to retain exclusivity. In other words, the fashionable elite wears "not what is exhibited in the streets, but a secret."

Marc Jacobs outfitted Shalom Harlow in a ruby red slip decorated with crystal beading for his Fall/Winter 1996–97 runway show, while Calvin Klein garnered rave reviews for parading all his Spring/Summer 1997 models down the runway in multicolored variants of the same layered transparent sheath. The slip dress had become Klein's archetypal design in the early 1990s, and the designer continued to produce its iterations until the end of the decade. In reflecting upon their significance to the minimalist movement in fashion, Bernadine Morris observed that Klein's slips "show the designer as a minimalist, but it is a rich minimalism." In a *New York Times* column entitled "A Mostly Minimal Look in London" (1993), Amy Spindler documented the migration of the luxe slip dress to the London firms of Flyte Ostell and Ghost. She concurred with Morris on the lavishness of the sumptuous slip fabrics and minute frames and then playfully quipped, "If you had $1 for every slip dress shown in London, you might actually be able to afford one."

When Corinne Day photographed Linda Evangelista in a basic white slip in 1993, she clarified the sheath as the quintessential reductive garment, the guise of nudity itself. Evangelista appears vulnerable and isolated, covering her breasts in mock shyness. Her slip becomes a cloak, which, in profile, simultaneously represses the female distinctions of bust and hip and conceives an androgynous sexuality on par with that typically emoted by the adapted masculinity of the suit. The minimalist white and its suppression of overt feminine sexuality is best demonstrated by the juxtaposition of Dan Flavin's *Barbara Roses* of 1962–65 and its sequel, *mini-white (de-flowered abstract antidote to the Barbara Roses)* of 1965–66. The former, a play on the name of the 1960s "ABC Art" critic Barbara Rose, is configured of a common flower pot that contains a clear light bulb, inside of which sits a blooming flower. Although contained, the ornate rose opposes the reductive minimal shapes of the pot and the bulb. When Flavin corrected this decorousness by "deflowering" *Barbara Roses* with an abstracted white bulb, he implied that this white skin rejected the naturalistic purity of the rose but imposed a codified sexuality, removed and ambiguous.

Opposite: Photograph of Linda Evangelista, Corinne Day, British *Vogue*, 1993. Above: Dan Flavin and Sonja Flavin, *The Barbara Roses 3D*, 1962–65.

Above: Photograph,
Deborah Turbeville,
"American Movers,"
Vogue, February 1975,
featuring Halston, Elsa
Peretti, and Betsy
Theodoracopulos in
ensembles by Halston.
Opposite: Deborah
Turbeville, *Bath House,
New York, Vogue*, 1975.

The androgynous figure of 1990s minimalist fashion owes everything to the spare, utilitarian shapes of the 1970s American minimalist designers. Halston created the first slip dress in 1974 with his notorious "skimp" and similarly established a reputation for glamorous restraint that would come to inform the brand imagery of Prada, Jil Sander, and Helmut Lang, among others, in the decades to follow. In 1975 Deborah Turbeville, who would become a central figure in the evolution of late twentieth-century photographic realism, shot a picture of Halston in his "orchid palace." The palace was an exclusive atelier for customers who ordered pieces priced above $1,000 and was outfitted with low-slung white Ultrasuede couches, strategically placed orchids, and little else. Halston is pictured alongside client Betsy Theodoracopulos, who is seated in the "skimp," and collaborator Elsa Peretti, who designed all the jewelry worn in the shot. Turbeville accurately captured Halston's particular brand of minimalism, but she also succeeded in extracting and promoting something even more visionary: a palpable figurative alienation. Although Halston, Theodoracopulos, and Peretti occupy the same minimal space, they are not necessarily engaged with one another. Halston's dark glasses make him inaccessible, and Peretti, leaning back at the fringe of the photograph, presents a figure both opulent and withdrawn. Turbeville's listless subjects became the foot soldiers of a distinct stylistic clique; platonic American sportswear garments cloaked their angular, waifish frames. Her images, rendered in grainy textures and set in nondescript public spaces— as evidenced particularly by her Bath House series— served as early precedents for a minimalist visual language. Turbeville helped pioneer an aesthetic of removal—of gender, of emotion, of ornament—that would inform minimalist imagery in the late twentieth century and provide a crucial backdrop for a reading of the minimalist commodity.

The minimal lifestyle gained exposure and recognition in the last decade of the twentieth century via the infinite production of interchangeable basics and the diverse, multi-label marketing strategy of the high-end minimalist brand. This lifestyle was championed by a progressive androgynous figure and promoted clean, effortless lines underscored by strong masculine details. Despite the constant imposition of "individualization" in 1980s and 1990s fashion advertising, minimalism provided a default simplicity, a collective aesthetic of good taste that the consumer was quick to endorse.

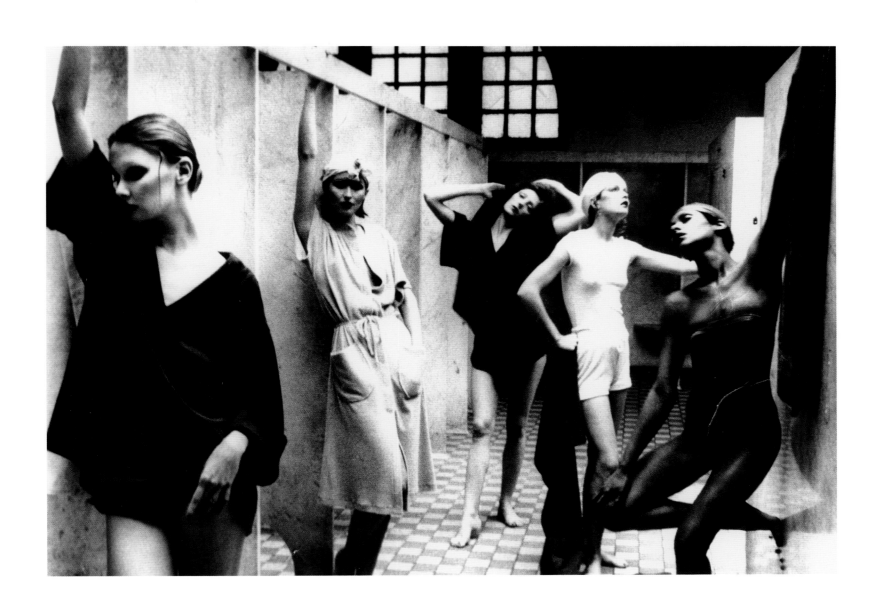

"WHAT IF NOTHING WAS FINALLY HAD TIME TO OUR MINDS WERE AS ROOM, AS BLANK AS EMPTY AS OUR EYES?"

HAPPENING, AND WE
SIT AND THINK, BUT
MINIMALISTIC AS THE
OUR FACES, AND AS

—Amy Spindler, *New York Times*, March 24, 1998

5.

Real-ism: Designing the White Cube

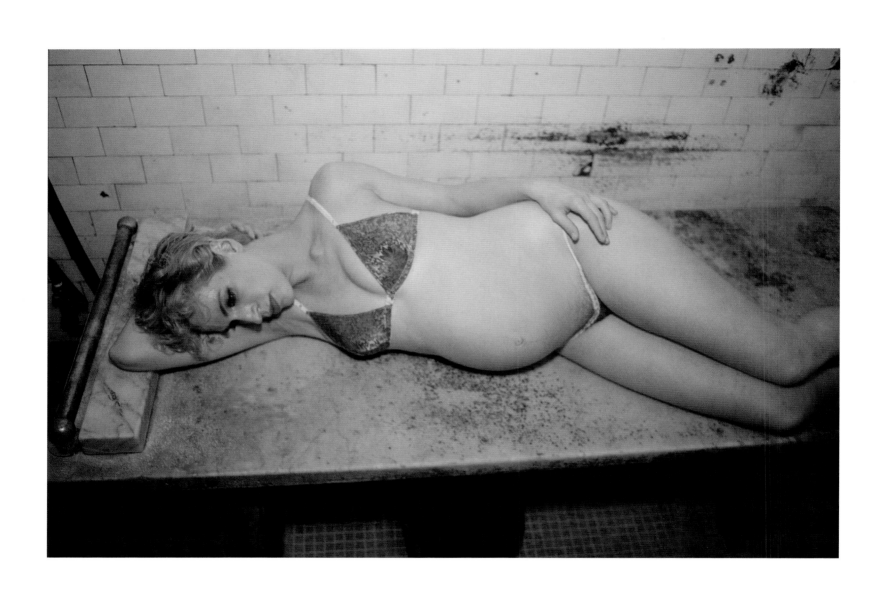

IN THE 1998 *FASHION THEORY* ARTICLE "THINNESS AND OTHER REFUSALS IN

Contemporary Fashion Advertising," curator Katharine Wallerstein affirmed the direct link between the "bared down, anti-frills, and anti-glamor aesthetic" of 1990s fashion photography and the decade's "emphasis on streamlined minimalism in clothes and design." The saturation of ready-to-wear with the reduction, simplicity, and accessibility of minimalist clothing brought with it a rejection of illusionism in fashion photography in favor of gritty realism. This movement served to visually insert reductive design into the austere environments of the non-place: locations both bare and nondescript—which would ultimately become a postmodern focus of minimal representation. The genealogy of this trend was derived from the originary fine-art purveyors of minimalism, who were intent on creating imagery that lacked artifice or representational idealism and rigorously delineated the obdurate physical presence of the objects that they had created. The journalist Amy Spindler linked 1990s fashion photography with formal minimalism more intrinsically when she noted that the blank yardages and basic shapes of minimalist fashions, when pared with the despondent, aloof expressions of the models, provided a conformist anonymity. In her view, the minimalist dresser became yet another unidentifiable subscriber whose personality, as well as that of the designer of her clothing, was effectively repressed. This withholding was bolstered by a black-and-white photographic treatment in fashion editorial and advertising, which not only elucidated line and contrast more clearly but also reduced the image's visceral impulses and instead promoted an environment of restraint. Regarding the ultimate effect of this grayed composition, Wallerstein wrote, "These images capitalize on a language of documentary realism to create a drama of hunger, abjection, and lack."

In her seminal study *The Photograph as Contemporary Art* (2004), the photographic theorist and curator Charlotte Cotton explored the relationship between the realism of 1990s fashion photography and the contemporary art photograph, which commonly "takes as its subjects the non-events of daily life: sleeping, talking on the phone, traveling by car, being bored and uncommunicative." Whereas fashion photography traditionally strove to create drama, artifice, and theatricality as a means to delineate glamour for the consumer, the new realist snapshots of the 1990s took inspiration instead from an art-historical legacy: "deadpan" photography. Deadpan was concerned primarily with capturing the banality of everyday objects or commonplace landscapes, omitting any cultivated or artistic perceptions. Cotton noted that the deadpan style, exemplified by the work of photographers such as Stephen Shore, Andreas Gursky, and Thomas Struth, is often characterized as Germanic, as its champions were consistently graduates of the Kunstakademie in Düsseldorf, trained under the tutelage of Bernd Becher. In collaboration with his wife, Hilla, Becher rigorously examined pre-Nazi industrial objects and structures then recorded them as snapshots of a past era. In a 1980 series of photographs entitled *Water Towers,* Becher's depictions of the straightforward, non-emotive, physical presence of each of the variously shaped buildings is enhanced by their exhibition in a grid composition in which each tower becomes distinctive only for its relationship to the one above, beneath, or next to it.

Page 155: Bernd and Hilla Becher, *Water Towers*, 1980. Opposite: Nan Goldin, *Rebecca at Russian Baths*, New York City, 1985.

In the realm of fashion photography, deadpan moved from the avant-gardist fringes of art to the mainstream fashionable image via various pioneers who ultimately affected the mass appropriation of this style in the 1990s. Bob Richardson's 1960s photographs of derelict environments and subcultural style niches informed the emergence of fashion pseudorealism later in the century, but Nan Goldin, who began her documentary efforts in the 1970s by taking snapshots of her bohemian friends, was instrumental in the success of the deadpan trend. Whereas image-makers such as Avedon and Penn were fashioning reductive studio portraits to frame the most exclusive styles, Goldin chose to document "real" people wearing "real" clothes. One of Goldin's best-known series, photographed in New York City's Russian and Turkish Baths in 1985, featured women wearing seedy lingerie or vintage boy's cotton underwear and posed without makeup or styling in the dingy chambers of the bathhouse. These images referenced the homosexual jurisdictions of the 1980s both in their choice of location and in the cross-dressing costumes of their subjects. The photographs also presented each woman organically, without artifice, emotional nuance, or judgment, thus adhering to deadpan's characteristic honesty and objectivity. Further, the realness of each subject was emphasized by her corporeal disparity from the ideal model physique; these women were pale, in some cases overweight, and did not adhere to the typical facial features considered beautiful at the time. The few photographs that featured high-fashion designs were categorized as style snapshots and therefore served, as Elliott Smedley noted in *Fashion Cultures: Theory, Explorations and Analysis* (2000), to "challenge conventional ideals, suggesting that fashion was now more democratic and that anybody could be fashionable."

Based in London since 1986, the German-born artist Juergen Teller draws from the deadpan realism and familiarity of Goldin's images, but his raw, overexposed lighting pushes the envelope of documentary styling and inserts an eerie abstraction, a suffocated minimalism, into otherwise ordinary snapshots. Teller's approach, exemplified by his advertising campaigns for Marc Jacobs from 1998 to the present, requires his subjects to be caught off guard in order to elicit genuine emotion. Although Jacobs has consistently employed celebrity subjects to star in these campaigns, the icons are shot in the deadpan manner, photographed in their "homes" or other intimate settings to insinuate ordinariness—a commonality with the pedestrian consumer. One campaign took this strategy a step further: just two years after Winona Ryder's arrest at Saks Fifth Avenue in Beverly Hills for shoplifting several designer items, including some from the Marc Jacobs collection, she appeared as the face of the designer's Spring/Summer 2003 advertising. In the first image from this series, Teller captures her in what appears to be genuine surprise, perhaps to see someone unexpected at the door. In the next frame, she is sitting happily, showing off her gift of a basic Marc Jacobs cardigan straight out of the box. A nondescript living room, outfitted with modernist furniture and vintage carpets, served as the backdrop "home" for these images. Teller's message was obvious: if you want Marc Jacobs (badly enough to steal it), you can acquire it, too.

Derivative as they are of the spontaneity and wholesomeness of 1990s American catalogues, Teller's intimate portraits perfectly represent Jacobs's American sensibility. At the time, mass-market retailers such as J.Crew, Lands' End, and L.L. Bean created page after page of pseudo-real imagery: groups of models engaged in instantly identifiable American suburban activities such as barbecuing, swimming in

Opposite: Advertising image featuring Winona Ryder, Juergen Teller for Marc Jacobs, Spring/Summer 2003.

JIL SANDER

Avenue Montaigne, Paris.

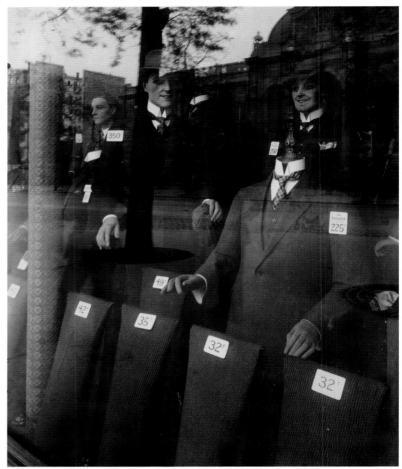

the backyard pool, or raking leaves, all outfitted in the comfortable, casual pieces of the decade's disposable minimalist wardrobe. Moreover, the models appeared naturally happy—not posed or, necessarily, poised. According to the journalist Matthew Debord's article "Texture and Taboo: The Tyranny of Texture and Ease in the J.Crew Catalog" in the August 1997 *Fashion Theory,* "affected expressions" were "outlawed in Crewland." High-fashion photographers such as Juergen Teller took note of the overwhelming success of this style and, conflating the high-art deadpan strategy with the photographic realism of 1990s consumer culture, developed an aesthetic that resonates with the straightforward appeal of minimalist style. In *Chic Clicks* (2002), contributor Olivier Zahm reviewed the contemporary trend toward visual realism and pinpointed "a certain minimal reflectiveness about the medium of photography. The aim [of *Chic Clicks*] is to identify those fashion photographers and magazines that resist the dissociative trend (that is, the tendency to regard glamour as a world apart)."

Goldin's and Teller's images, as well as those of the retail catalogues, share the desire to invent and elucidate the pedestrian shopper, the average consumer. Although this transposition of consumer as model has been a strategy of fashion consumption since the advent of the department store and its partnered catalogue promotions of the nineteenth century, the late twentieth-century fashion photograph was able to achieve something more potent than its predecessors: the aura of the ordinary. The "average" person, here more familiar than one's next-door neighbor, was set within astoundingly average circumstances. The consumer was not just equal to these photographic subjects; she was *better* than they were. In capturing the banality of the late twentieth-century home, activity, and pedestrian, the deadpan photograph effectively captured modernity.

Since the emergence of portraiture and panoramic photography, image-makers have sought to reveal the essence of modern life, though this endeavor has been typically executed via a spurious arrangement of modern elements into an attractive, covetable aggregate. Contrarily, the early twentieth-century photographer Eugène Atget observed the interstitial spaces of the Parisian landscape as intuitively, efficaciously modern. Whereas the grand promenades of carefully clothed consumers were exploited by the photographic frame to reflect a bourgeois spectacle, for Atget the vagrant street peddlers and empty sidewalks were more revealing. In *Sexuality and Space* (2002), Molly Nesbit observed, "Atget had to bring modernity into the document somehow; increasingly he did so by setting out absence, seeing modernity as a vacant, hollow space . . . instead of completeness, Atget gave the viewer ignorance." Atget offered a metropolis without the bourgeois spectacle or the grand structures of Paris as a backdrop, supplemented instead by the rag pickers and cart vendors, citizens oblivious to figurative portraiture. In this way, Atget disclosed a true glimpse of the city at its most raw, reductive state. In his 1925 image *Magasin, Avenue de Golbins,* Atget presents the saccharine grins of mannequins on display, performing for an absent audience. The empty sidewalk, reflected carefully in the glass, trumps these artificial subjects as the barren focus of the image. In this frame, as in many others within Atget's vast portfolio, the impressive Parisian building serves only as a boundary to the empty space on view. Nesbit identified the critical role of the city's structures, which "circumscribed a nonbourgeois low modernity, what can now be identified, though nebulously, as the *populaire.*"

Opposite, left: Advertising image, Craig McDean for Jil Sander, Fall/Winter 1995–96. Opposite, right: Eugène Atget, *Magasin, Avenue de Golbins*, 1925.

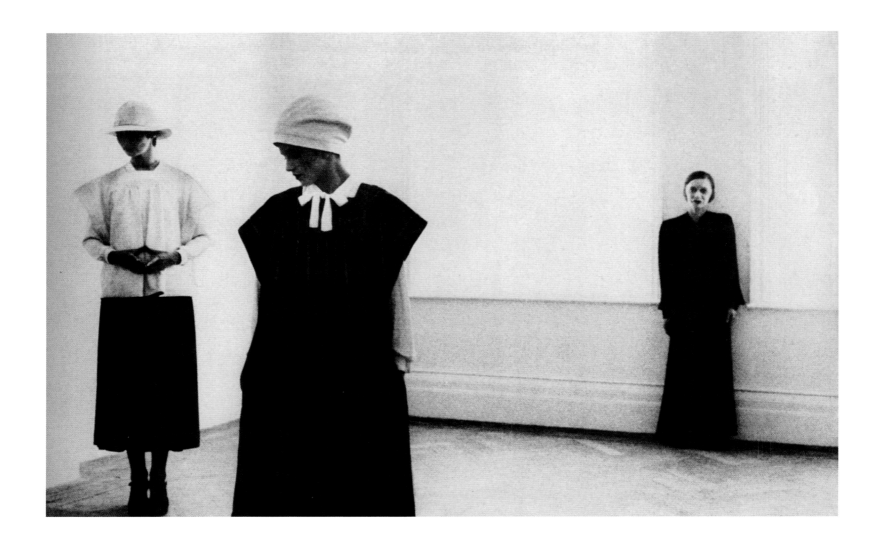

The compass of Atget's unnuanced void was obliterated, made irrelevant in the late twentieth-century fashion advertisement. While the 1990s deadpan or realist photographers behind these images similarly empowered the empty spaces of modern life, their concentration was more intimate: Atget's photographs clarified the nebulous spaces of early twentieth-century Paris, sanctioned by surrounding buildings, as the stomping ground of the *populaire,* while the late twentieth-century fashion advertisement lured consumers with the void of the commonplace interior, where the vastness of the white wall often dominated the composition. In a hyperbolic rendering of this strategy, the celebrated minimalist Jil Sander released a Fall/Winter 1995–96 ad campaign that featured, among other ordinary objects, a scuffed wood chair tucked neatly behind a smooth wood desk, both set against a white wall. The bold sans-serif font displaying Sander's name and her boutique address are put forth as the only distinctions in this banal landscape. Sander's fall collection that year met with rave reviews; Spindler praised the designer's "stern" "luminarias" and explained, "The [catwalk] images seared the mind, as mindless minimalism does not." Even though the clothing garnered such acclaim, it was still omitted from the advertisement frame, replaced by the empty void of the deadpan interior. Although these advertisements were meant to entice customers, in actuality they emoted isolation and withdrawal and presented the fashion space as a non-place. In this regard, these images accommodated the consumer's imagination of the artist's space, abandoned and raw; by endorsing the product, the consumer could participate in the process of design, thereby joining the artistic tribe of minimalist design.

The photographer Deborah Turbeville was a master projector of the non-place. A contemporary of Goldin's, Turbeville was also enamored of depicting reality, but hers was a surreality positioned neither in the studio nor the pedestrian haunt. In a photograph for the February 1975 issue of *Vogue*, Turbeville arranged three models dressed in Jean Muir's reductive fashions and spaced equidistantly within an unmarked white cube. The "white cube," as the undressed set of the modern gallery space, provides an immediate context for the reductive shapes of modern design.

Yves Klein, an early minimalist, clarified the impact of the unmarked white cube with his 1958 presentation of an empty gallery at Iris Clert's in Paris that he titled *Le Vide*, or "The Void." Just two years later, Arman dialectized Klein's "Void" with *Le Plein* ("The Full"), which, rather than negating the impact of Klein's cube, served to emphasize its relevance as a transcendental space. In *Inside the White Cube: The Ideology of the Gallery Space* (1986), the journalist Brian O'Doherty noted the appeal of the white cube as a structure that allowed art to "take on a life of its own." Yet within the white cubes of fashion photography, particularly in the last quarter of the twentieth century, the models and the clothing they wore took on the energy of the cube itself: a nullified presence, reduction to the point of suppression. O'Doherty cites this mutation as "an extraordinary strip-tease" in which the art inside the cube bares itself until it is contentless except for its own material properties.

The 1980s post-minimalist works of Fred Sandback exemplify this process; his canvases are often blank and white, save for a diagonal line or two off center, which serves both to elucidate the minimal properties of the line itself and to challenge the perceptual flatness of the vast white space. In reference to Sandback's 1985 *Untitled, Isometric Construction*, the curator James Cuno remarked in the exhibition catalogue *Minimalism and Post-Minimalism: Drawing Distinctions* (1990), "Sandback uses line to represent edge, which in turn alludes to the boundaries of space." With Sandback's basic line absent, the white surface is boundless, unchanging, and therefore presents itself alternately as an "ultra space" or a "non-space." In the Introduction to *Inside the White Cube*, the art critic and novelist Thomas McEvilley inferred that the white cube's unwillingness to systematize its own space creates "a surrounding matrix of space-time that is symbolically annulled."

The stark, realist fashion imagery of the 1990s finds a suitable home in the white cube, albeit one where space and time are not simply annulled but irrelevant. In Kayt Jones's photograph of the designer Raf Simons for *i-D* magazine's October 1998 issue, the white cube becomes a cell—both a capsule for and a sensor of Simons's quotidian activities. A full ashtray and coffee mug sit next to his makeshift white bed, his coat hangs from an invisible hook, and his row of monitors broadcasts various images. Merryn Leslie's styling affects a still environment where Simons is both captive and king but not actively either. Fashion space, whether boutique, window, advertisement, or editorial, typically distances itself from the "real," so Simons's cube, with its alienating reality, becomes the space of antifashion, of basic shapes and simple garments. Within the white cube, Simons's possessions are clarified as minimalist commodities. Bradley Quinn observed, "As a setting for fashion, non-places and heterotopias are intended to generate a realistic feel, beckoning the viewer into an urban wasteland whose inhabitants have salvaged their clothing, but not the world they live in."

Opposite: Photograph, Deborah Turbeville, "American Movers," *Vogue*, February 1975; ensembles by Jean Muir. Pages 164–165: Photograph featuring Raf Simons by Kayt Jones, *i-D*, October 1998.

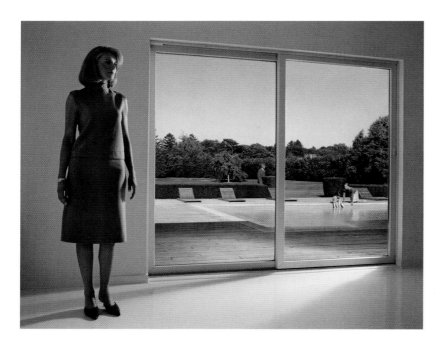

Above: Photograph,
Philip-Lorca diCorcia,
"A Perfect World," *W*
magazine, September
1999. Opposite, top: Mark
Steinmetz, *Route 316,
Barrow County, Georgia*,
2005. Opposite, bottom:
Photograph, James
Moore, *Harper's Bazaar*,
July 1967; ensembles by
Geoffrey Beene.

Philip-Lorca diCorcia's editorial for *W* magazine's September 1999 issue offers a world that is clarified, unlike Simons's, within a larger social context. In diCorcia's "A Perfect World," the cube offers a transparent window so that the mundane if modern landscape of the residential pool is visible on the outside, enlivened by sunlight, topiaries, and human play. Inside the boundaries of the cube, here posited as the interior of a suburban home, the photographer's subject seems paralyzed and emotionless. Her drab coordinated ensemble, austerely minimalist, is so monochromatic that it seems nearly colorless itself. The floor of this "cube" is hardened and reflective, and its walls post no personal effects. The room is so bare that one wonders whether this "perfect" house is vacant or just minimally decorated. Although the subject is still, she seems neither alarmed nor surprised by the vacancy of her surroundings; indeed, she is a natural, fluid fixture within the space. In the context of diCorcia's photograph, the white wall becomes representative of the refined minimalism of 1990s high fashion. As the backdrop for the sleek minimal affectations of wealthy 1990s suburbia, the white wall's neutrality is decimated; instead, as O'Doherty asserted, "It stands for a community with common ideas and assumptions."

The democratic realism of late twentieth-century fashion photography amply presented the emerging tribe of minimalist subscribers and fortified their vision via the omnipresence of the white wall; transparent, the wall had grown to encompass the non-places of highways, warehouses, and air strips—boundless non-locations where the figures became abstracted within the vastness of a nondescript cube. In the black-and-white photography of Mark Steinmetz, the blanket of the white wall is replaced by a thick haze of gray that serves to further neutralize his subjects. In the 2005 photograph *Route 316, Barrow County, Georgia*, Steinmetz's focus is an abandoned gas station, austere in its gray-scale geometries. The image relates the significance of the transnational highways of America as linear bonds between the desolate or suburban dwellings in which the minimalist tribe is captured authentically.

The detached stillness of *Route 316*, emphasized by the serial organization of its forsaken pumps, sits in stark contrast to the cultivated decoration of James Moore's highway in a 1967 photograph for *Harper's Bazaar*. Moore showcases Geoffrey Beene's streamlined fashions on two beautiful models, their minimal clothing and angular bodies paralleled by the mechanical joints of a stalled station wagon. The image conveys Moore's

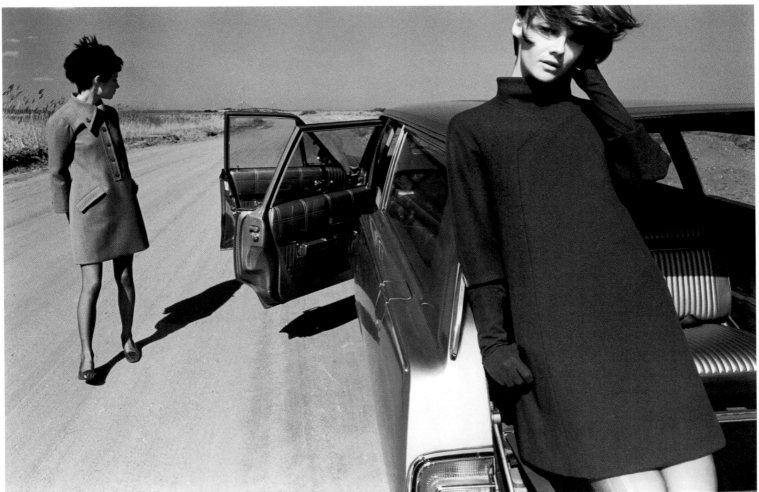

pioneering attempts at realism—with one model glancing back toward the hood of the car in evident concern and the other appearing in foreground, visibly discouraged by this "bump in the road." Yet even given the feasibility of these circumstances, Moore's viewer can sense the nuance of vibrant color within the grayscale image as well as the emotion and dynamism that the image strives to impart. Moore's photograph speaks to the movement of documentary reportage in American photography—a school championed by Walker Evans and Dorothea Lange, whose "candid" snapshots of the country's working classes were intended to elucidate the living conditions of "real" Americans. But where Evans's abandoned churches and derelict family portraits sought to resonate emotionally with the viewer, the photographic vein from which Steinmetz descended eagerly annihilated emotiveness in favor of a withdrawn reality that could be neither accessed nor understood beyond its fearsome physical presence. These photographs, derivative of the deadpan and documentary styles, were the realist portraits of the minimalist neo-tribe, whose members were insouciant waifs and strung-out drifters, sartorially and psychologically defined by their apathy.

These portraits circulated 1990s minimalism for a younger, more disenfranchised consumer. They were championed initially by the British magazines *i-D* and *The Face* and later by *Purple, Dutch,* and *Self-Service* internationally. The grunge movement in music, led by iconic bands such as Sonic Youth, Nirvana, and Pearl Jam, catalyzed an association of the "grungy" slacker with minimalist fashion; grunge's sartorial laziness was expressed through the careless layering of monochromatic, designer-less separates. Cindy Sherman's 1984 self-portrait prophesied the requisite components of grunge imagery: messy unkempt hair, characterless clothing (at least what the viewer can see of it), and, above all, a despondent lack of interest or engagement. A black-and-white Prada image from the same season, shot by Peter Lindbergh, delineated a more high-art grunge sensibility: the faceless model is dressed in a semitransparent black shift, her emaciated frame barely concealed by a basic black bra and panty set, with a lit cigarette burning in one hand and a nylon Prada tote looped around the other arm. Instead of the usual fashion shoe or pump, her Prada lace-ups are informal, functional, even ugly. The conflation of these elements—dissociation, simplicity, desaturation, and messiness—would come to configure an "aesthetic of the cool."

Opposite: Cindy Sherman, *Untitled (#133)*, 1984. Above: Photograph, Corinne Day, *i-D*, January 1993; Sarah M in a sweater by Maison Martin Margiela.

In a March 1994 *New York Times* column, Spindler explained, "It was passion for simplicity that led to minimalist design; it is fatigue that popularized it. Many designers have fallen into minimalism as the dressing equivalent of swallowing food to fill your stomach—bypassing the fussy taste buds completely." In Corinne Day's photograph for *i-D*'s January 1993 issue, the magazine's house model Sarah Murray is styled in "high" and "low" minimalism with a luxurious, if basic, Martin Margiela sweater and various items from Portobello Market in London. Her somber black ensemble is further muted by the solitary space of the white cube, but her sneakers belie any supposed sophistication, instead championing the functionalism that American minimalist fashion helped to promote in tandem with Spindler's element of "fatigue." The minimalist lack of fussiness contributed to a broader aesthetic lack of pretentiousness; as withdrawn as the minimal model had become, she still avidly ascribed to the realist rhetoric conveyed by her unkempt body and unfettered clothes and contained by the white cube. The plenary adaptation of this aesthetic was over-arching: the look of the "real" was as prevalent in the fashion and culture photography of the 1990s as it was on the street corners where such trends originally proliferated, lending credo to Wallerstein's assertion that "subculture may feed the media, but the media has certainly fed subculture." By the mid-1990s unembellished realism dominated the decorative arts and home markets as well, intuiting the minimalist consumer's yearning to begin to decorate the white wall with objects of similar divestiture. Wallerstein cited the example of Pottery Barn, whose very name implies "a return to purer, real-er times." She explained, "The pared-down look of a chest of drawers (pared down to absolute simplicity . . .), painted to look old and even to seem as if the paint were peeling, denotes, like the black-and-white photograph of today, a return to truth."

These commodities, reduced to their most basic elements then weathered a bit more, were mirrored by the fashionable decon-structures that began to appear in the 1980s but reached their apogee in the consumer market alongside the influx of realist marketing. Helmut Lang's modernist wardrobe of sleek, streamlined garments—each subtly manipulated to reflect a self-effacing artistry—embodied this raw edginess, while still retaining the restraint of the minimalist pattern. An ensemble from Lang's Fall/Winter 1997–98 collection, modeled on the runway by Kate Moss, comprised a pair of standard chinos topped by a double-layered white tank top. The final touch to this austere ensemble came with the addition of a fluorescent pink mesh band

that wrapped not only around Moss's torso but bound her arms as well. As a trashy, grunge-style overlayer, this band served as a distraction from the simplicity and bland cohesion of the underlying ensemble. Regarding Lang's impact on 1990s minimalism, Rebecca Arnold observed that it "was Lang's cool, urban silhouettes that married basic shapes with edgy colour combinations and advanced technological fabrics, which were both the crucial look for fashion insiders, and the key influence on other designers, eager to find a new vision of the modern."

Lang's Fall 1997 design reiterates the steel grate of Anthony Caro's 1966 *Carriage,* which was painted blue to stick out obstinately against the white wall of the modernist gallery. Caro was a frontrunner in the early minimalist movement. His sculptures, like Richard Serra's, are all self-supporting and often configured from rough industrial materials and found metals, as if to imply reduction to the point of delapidation. Caro's work, with its jagged edges and awkward angles, finds likeness with the sleazy exposure of photographic realism. In *The Anti-Aesthetic: Essays on Postmodern Culture,* Jean Baudrillard explained the shift from the taboo to the emphatically lewd in the imagery of contemporary culture: "It is no longer . . . the traditional obscenity of what is hidden, repressed, forbidden or obscure; on the contrary it is the obscenity of the visible, of the all-too-visible, of the more-visible-than-visible."

Subcultural style niches previously disregarded by mainstream art and culture began to creep into fashion imagery through the work of the Parisian demimonde photographer Brassaï in the 1920s and via Bob Richardson in the 1960s. Richardson was interested in a more provocative and, effectively, a more real, more inclusive vision of the fashionable. His subjects were cross-dressers and glamazons, and his compositions were riddled with subversive and dangerous props. His rebellious snapshots served to inform the work of a number of artists. When Richardson died in 2005, Bruce Weber told Cathy Horyn of the *New York Times,* "There's no textbook, no award, but there is this Bob Richardson school of photography. And it's an anti-school. He was the first guy who said it was OK to underexpose the film, to not show the clothes."

Richardson's son, Terry, has become a star photographer in his own right, and his grainy, realist images of celebrities and models in compromising, often sexually suggestive positions against the mirror of a white wall have come to influence the marketing of mainstream fashion companies, most notably American

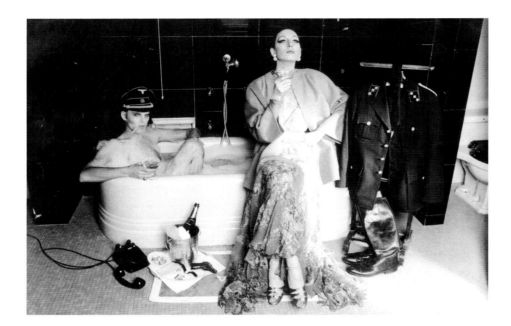

Apparel. Although Terry's work has helped to clarify his father's legacy, the younger Richardson has undoubtedly been inspired by the photography of Corinne Day as well. Self-taught, Day helped familiarize the global consumer with the anti-glamour of 1990s fashion photography, which journalist Iwona Blazwick described in a 1998 article for *Art Monthly:* "Constructed tableaux are rejected for a truth located in the artless, the unstaged, the semiconscious, the sexually indeterminate and the pubescent—the slippages between socially prescribed roles."

In Day's *Summer of Love* photographs for *The Face* in 1990, a fifteen-year-old Kate Moss emerged as model exemplar of such tableaux. By 1993 Moss and Day were close friends, so when Day photographed her for a British *Vogue* spread entitled "Under Exposure" that year, Moss allowed her full disclosure. "Under Exposure" showcased Day's grainy, underdeveloped photographic style but also highlighted Moss's diminutive wardrobe, composed of a black transparent top, see-through white panties, and black socks. Caught in candid posturing standing on her bed against the blank white wall of her London flat, her undernourished frame on full view and her wanderlust stare seemingly drug-induced, Moss epitomizes the anti-styled, anti-commercial aesthetic of the early 1990s minimalist photograph. Nothing exists beyond the white walls of Moss's room. As a subject, she garners neither admiration nor sympathy but simply reflects the insouciance of the era's fashions. Wallerstein expounded, "Kate Moss rose to fame as a model not by virtue of traditional high fashion glamour, but rather by virtue of her abject mien, distanced manner, and wan, androgynous look." Moss typified the extreme thinness of the 1990s fashionable ideal, presenting a figure divested of curves, linear to the point of nearly ceasing to exist.

Day's models continued to occupy the anti-glamour ideal that the pubescent Moss popularized— waifish frame; stringy hair; sunken, disheartened posture—as the 1990s progressed. Her photographs, exemplified by *Tania* (1995), would also consistently rely on the realness of the intimate snapshot, enhanced by the disenfranchised spaces of motel rooms, alleyways, and degenerate housing. The post-minimalist Rachel Whiteread created sculptural objects in the early 1990s that provided a similar seediness to Day's lewd portraits. Cast in plastic, wax, and rubber, Whiteread's works exploited banal materials and took their cue from familiar entities, ranging from the bookshelf to the female torso to, perhaps most famously, an abandoned mattress. The 1991 orange rubber cast mattress, entitled *Untitled (Double Amber Bed)*, was installed leaning up

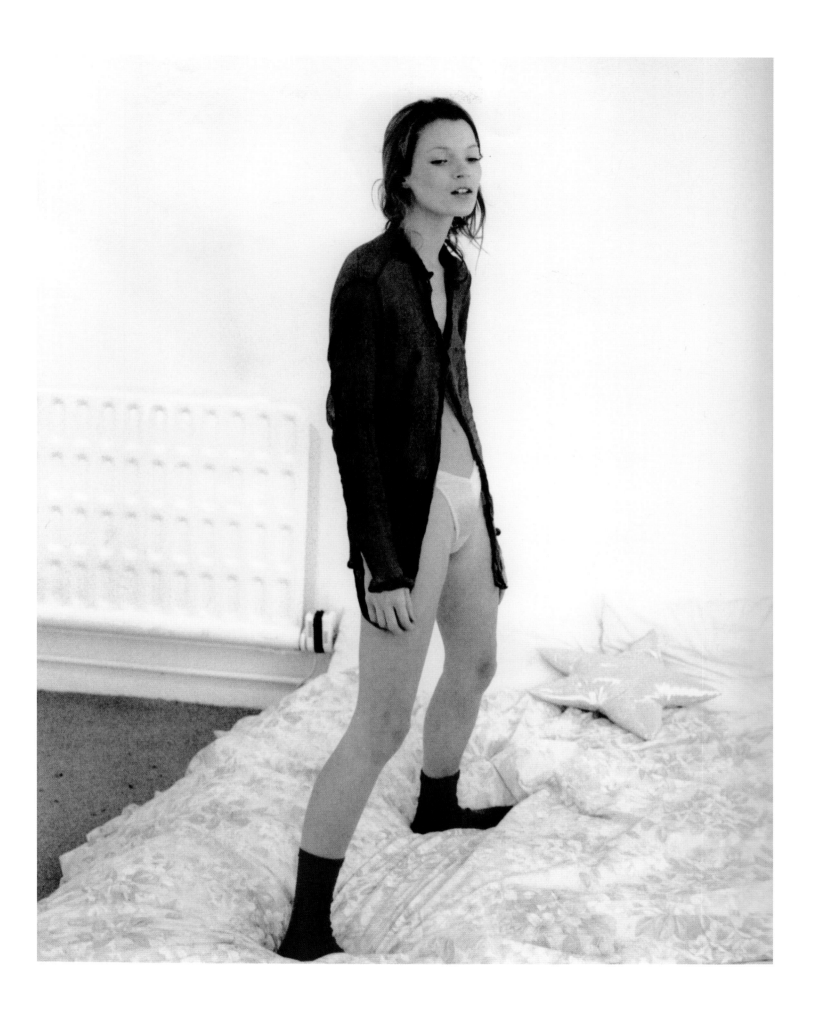

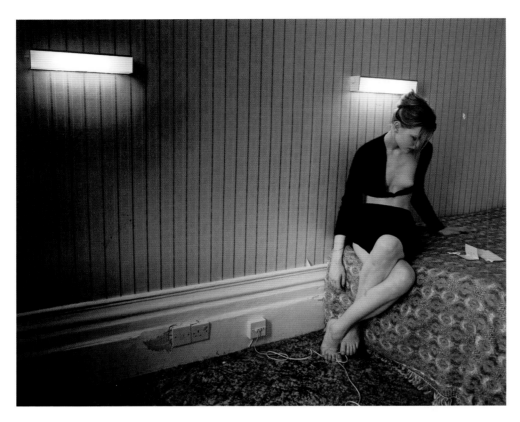

against the gallery wall, which effectively recreated the urban curb repository of the week's trash. Whiteread strove to emphasize each object's flaws, thereby elaborating its real physical properties.

In Damien Hirst's 1996 ceramic plate edition *Home Sweet Home*, Whiteread's urban detritus and Day's seedy intimations are fused in a topographical image of an overflowing ashtray. The design's plenary application on the plate's surface inhibits any distraction from its revolting focus. With all dangerous implications of chain smoking intact, Hirst's imagery defies its alarming content and doubles as a functional item for display and consumption. *Home Sweet Home* embraces and broadcasts the youthful disregard, deathliness, rebellion, and obscenity implicit in Day's fashion photographs.

In *The Return of the Real* (1996), Hal Foster reflected on the broader aesthetic realm of despondency in which fashion's photographic realism had become emboldened: "If there is a subject of history for the cult of abjection at all, it is not the Worker, the Woman, or the Person of Color, but the Corpse. This is not only a politics of difference pushed to indifference; it is a politics of alterity pushed to nihility."

The anorexic subjects of 1990s fashion photography, trapped physically and emotionally by the imposing walls of their white cubes, embody Foster's politics of otherness: their skeletal frames, cloaked haphazardly in the reductive shapes of minimalist design, ultimately cease to broadcast any commonality with the consumer and forgo vitality for mortality. The photographer Willy Vanderperre devised Jil Sander's advertising campaign for Spring/Summer 2008 with this dejected 1990s model in mind. Although Vanderperre's is a studio composition rather than a candid snapshot, his hardened, pale subject is evocative of a young Kate Moss, and her neo-minimalist geometric sheath of layered, fractured planes presents a masking white skin. This garment imposes the repression of the white wall but also succeeds as a screen between body and cloth. Omitting the model's organic silhouette, the sheath becomes a cloak of nihility and is juxtaposed with a bare skull to emphasize this extreme reductivity.

Vanderperre's photograph, with its derivations from the "cult of abjection," becomes a pastiche of late twentieth-century minimalism and therefore does not achieve the honesty or the intimacy that the works of Goldin, Day, Sherman, and Teller boast. Even as these 1990s photographers exemplified the minimalist trend of photographic realism, replacing color with black and white, decorousness with starkness, softness with angularity, ostentatiousness with restraint, in actuality they were not photographing reality. In *Adorned in Dreams*, Elizabeth Wilson resolved, "The great promise of photography was that it would tell the 'truth.' Yet the 'truth' of photography is only a more convincing illusion, selection and artifice lurking behind the seeming impartiality of the mechanical eye." In concurrence, Wallerstein noted the role of the 1990s realist model as nothing but a more convincing performer; "numbed" and "burned out," these subjects "are not simply unsmiling, they are resolutely unsmiling." In Vanderperre's imagination, the mask of the "real" reveals its dramatic fissures, and, harkening back to James Moore's "reality," the image becomes a spectacle that imposes narrative and emotion on the white cube.

In their 1997 photograph *The Widow (Black)*, Inez van Lamsweerde and Vinoodh Matadin successfully manipulate the requisites of the 1990s fashion image by presenting a prepubescent girl as the central figure against a white backdrop. The child's round face and youthful features become hyperbolically withered and jaded. She is transformed as well by the dual insinuations of the widow: her dress boasts the

Opposite, clockwise from top left: Corinne Day, *Tania*, 1995; Damien Hirst, *Home Sweet Home*, 1996; Rachel Whiteread, *Untitled (Double Amber Bed)*, 1991.

nineteenth-century sleeve and somber mourning hue of Queen Victoria, yet the white-tailed taxidermy bird that sits atop her hip suggests the fang of the deadly spider. With the protrusion of a female hand into the white wall at the girl's back, its womanly red-lacquered nails clutching a headless Victorian bride, the narrative of the portrait eventually supercedes its vacant setting and withdrawn figure. These allusions—typical of postmodern fashion photography—shatter the controlled passivity of the white cube, thereby rebuking the image's minimalist objectivity.

Like minimalist art itself, the minimal sensibility of 1990s realist photography emerged as a dialectical barometer of aesthetic freedom and constraint. Its straightforward presentation, white walls intact, reduced the fashion and the figure to the bare essentials of their respective forms, but in its ambition to document the ennui of the "real," this photographic style also ran the risk of unknowingly facilitating an alternate fashion narrative, albeit one of decay, mortality, and absence.

If Wilson's assertion is accurate, and the truth of the art photograph is simply another illusion, then minimalism must revert back to the live gallery or the straightforward gallery shot in order to present forms uninformed by the photographer's eye or the stylist's imagination. The artist Roni Horn configures abstract renderings of tactile shapes and photographs in which blurring or texturing of a recognizable image presents altogether alternate forms. In *Key and Cue, No. 288* (1994–2003), Horn presented a narrow elongated beam of solid white aluminum, which, save for its surface lettering, would have all but receded into the white wall at the Whitney Museum of American Art, where it was exhibited in fall 2009. Instead, Horn applied large black plastic lettering that read, "I'M NOBODY! WHO ARE YOU?" in backward, bleeding, block letters down the length of the beam. Vicente Todoli, director of the Tate Modern Gallery in London, where Horn's mid-career retrospective originated, explained in *W*'s November 2009 issue, "[Horn's] work requires silence . . . it makes you aware of your condition as an individual and confronting the world." In fact, Horn's work does more: the bleeding type of each letter obscures and negates its original alphanumeric meaning, providing instead an abstract pattern akin to Mel Bochner's universal number systems of the 1960s. When the viewer is finally able to decipher Horn's message, he is immediately transposed with the artwork itself, reading Horn's type from the inside out. The minimalist pioneer Eva Hesse similarly manipulated the viewer's role and position within the expanse of the white cube with her iconic 1965–66 artwork *Hang-Up*.

Hesse's brushed steel frame beckons the white wall to fill its internal void and attaches the classic hanging wire of gallery artwork not only to its face but extended into the viewer's space on the floor. *Hang-Up* challenges the critical museological concern of how an artwork is hung but also achieves the vision of 1990s photographic realism. In viewing Hesse's work, one finds oneself inside the work, staring through the borders of the frame into the void of the white wall, which becomes both a window and a captor.

Within the realm of contemporary fashion, the white cube gallery can be found as the set of the fashion show. As an exhibition that lends itself easily to the serial composition and capitalist drive of the mid-century avant-garde, the fashion show employs the white walls of the modernist gallery as the backdrop for its parade of seasonal fashions. Although designers such as John Galliano and Alexander McQueen, among others, have transformed these white runways into phantasmagoric locations, nearly filling the white cube to Arman's limit, the minimalist designers of this era have exploited the magical capabilities of whitewash to present their creations as cohesive "singles," minimalist works of art in their own right. For his Spring/Summer 2001 runway presentation, Hussein Chalayan introduced a group of models clothed in dresses made of platonically sculpted sugar glass. Chalayan allowed his audience to partake in the dressmaking—or unmaking, in this case—process by commissioning a final model to approach the glass-clad figures with a blunt hammer to shatter the very structure of the dress. The show invoked the "happenings" of the 1960s, when artists encouraged patron participation as a means to eliminate their own dictation, prioritizing each audience member's personal experience of a work in progress. O'Doherty recalled, "Happenings were first enacted in indeterminate, nontheatrical spaces—warehouses, deserted factories, old stores. Happenings mediated a careful stand-off between avant-garde theatre and collage. They conceived the spectator as a kind of collage in that he was spread out over the interior—his attention split by simultaneous events, his sense disorganized and redistributed by firmly transgressed logic." Both revelatory and reductive, Chalayan's shattered dresses realize the void of the white gallery space in its most minimalistic context. The visual properties of his objects, first whole and then broken, are carefully and clearly revealed.

Despite the illusory nature of the "real" photograph, the artists Cindy Sherman and Ellen von Unwerth have succeeded in the minimalist goal of engaging the spectator

Opposite, top: Eva Hesse, *Hang-Up*, 1966. Opposite, bottom: Roni Horn, *Key and Cue, No. 288*, 1994. Above: Runway presentation, Hussein Chalayan, Ventriloquy collection, Spring/Summer 2001.

as an integral component to understanding the work itself. Foster explained, "In the early work of 1975–1982 . . . Sherman evokes the subject under the gaze, the subject-as-picture. . . . Her subjects see, of course, but they are much more seen, captured by the gaze. Often . . . this gaze seems to come from another subject, with whom the viewer may be implicated." In Sherman's 1983 photograph *Untitled #122*, a woman, her face obscured by a tumble of frizzy blond hair, affects a rigid, almost atrophied stance, apparently waiting for her viewer's codification and judgment. The white expanse behind her extracts any remaining vibrancy from her clothes or skin, enabling a clear reading of the figure it frames. Sherman's scrutinized subject functions in opposition to von Unwerth's carefree woman about town, as captured by a Fall/Winter 1995–96 advertising campaign for Alberta Ferretti. Von Unwerth subscribes to Helmut Newton's strategy of "glimpsing" a moment, but her model seems keenly aware of the attention that she garners. Impeccably composed in an elegant black sheath dress, with the classic minimalist accessories of black handbag, pumps, and sunglasses, the model struts self-consciously toward the sidewalk. In this frame, Unwerth offers a diaristic image—an intimate portrait in a public space—that not only begs for the attention of the viewer but in fact is made unique by the viewer's gaze alone. This image affirms Baudrillard's observation of postmodernity: "The loss of public space occurs simultaneously with the loss of private space. The one is no longer a spectacle, the other no longer a secret."

Just as minimalism sought to represent itself purely, with neither traditional composition nor calculated emotion incorporated, so too did the deadpan and realist photographic schools of the late twentieth century strive to offer an intimate, unnuanced viewing of a despondent generation. Instead, a grainy, avant-garde realism emerged in which the white cube became the dwelling of a minimalist neo-tribe. In "A Note: Art + Fashion, Viktor & Rolf" (*Fashion Theory*, 1999), the late curator Richard Martin remarked, "In witnessing the white-cube installation, we know that art and fashion share the ideal of the 'dreamy,' controlled, and perfected world." For Calvin Klein's Spring/Summer 2009 advertising campaign, photographer David Sims and creative director Fabien Baron visually fused the white wall with both garment and subject: Francisco Costa's platonic sartorial structure is itself a white cube, and model Anna Selezneva is no longer human but another expressionless, inorganic foundation upon which art can be mounted. With the postmodern convergence of "high" and "low," public and private, a new, postmillennial minimalism would come to embrace Martin's "perfected world," where classification and allusion were annulled and art, fashion, and architecture set forth to produce a series of equivalent forms, one after the other.

"PERFECTION IS ACHIEV
IS NOTHING MORE TO A
IS NOTHING LEFT TO TA

ED, NOT WHEN THERE
DD, BUT WHEN THERE
KE AWAY."

—Antoine de Saint-Exupéry, *Terre des Hommes*, 1939

6.

The New Minimalism

WITH THE ADAPTATION OF TWENTY-FIRST-CENTURY SOCIETY TO THE MECHANICS OF

technological advance—specifically with the development and domination of the World Wide Web and the presence of computerized design software and personal accessories—the realms of fine art, fashion, and architecture have begun to emulate a clean, machinist aesthetic. More than futurism in the kitsch 1960s sense, these disciplines dedicate themselves wholly to innovative engineering in order to create the most cohesive, essential objects possible. Minimalism, with its reductionist language, disinterest in psychological conceptualism, and purity of form, has reemerged to facilitate countless artistic fusions in the twenty-first century, reliant upon the movement's embrace of the interspecificity of form. In the *New York Times* article "Who's Afraid of Minimalism?" (August 25, 2009), Francisco Costa told the journalist Cathy Horyn, "It's not the 90s minimalism, that's for sure." The minimalist design of the twenty-first century is not 1960s minimalism, with its basic A-line shapes and space-age spin, or the democratic minimalism of 1980s basics dressing either, but comprises a clique of easily recognizable designers who have repositioned minimalism within the compass of fine art.

In a gallery shot of the opening of *Primary Structures: Younger American and British Sculpture* at the Jewish Museum in 1966 a guest wore a re-creation of Donald Judd's "box": a cubic shape with edges that ran perpendicular to her shoulder line and fell vertically into a square frame just above her knees. Both sculpture and garment, this dress emphasizes the mission of minimalism to float ambiguously between media but ultimately reads as more of a costume than a functional garment. When the Japanese fashion designer Shinichiro Arakawa presented his Fall/Winter 1999–2000 collection in the Paris gallery Espaces Commines, he invoked the avant-gardism of the "Primary Structures" dress by hanging canvases that doubled as garments. After clothing each model in a sheath that corresponded to the frame behind her, Arakawa posted the directions with which to "consume" his designs. They read: "Take the canvas out of the frame. Put your head through the opening and stick your arms through the armholes. Wrap the fabric round your body and do up the zip or buttons. The garment is now ready to wear." One of these designs— a monochrome, as it was composed entirely of lipstick-red wool twill—reiterated the early canvases of Frank Stella, in which the geometric line literally leapt off the canvas, creating an alternate dimension to the one presupposed by the hung frame. Moreover, Arakawa's work reexamined the minimalist sheath of 1990s fashion for its construction rather than its utility; every seam was clarified, every panel delineated in order to stress the physical presence of the object and the formal aspects of its design.

Neo-minimalist fashions utilize high-tech textiles in order to affirm their reading as designed objects rather than simple garments. The New York designer Yeohlee, like Issey Miyake, has tirelessly pursued new fiber technologies for her sleek, modernist designs and has crafted dresses that exploit the stiff drape of Lurex or featherweight silk organdy to clarify hyperbolically sculpted shapes. In one of the most ground-breaking collections of his career, the Balenciaga designer Nicolas Ghesquière engineered "total look" ensembles in robin's-egg blue, lemon yellow, and blush pink for his Spring/Summer 2008 presentation.

Page 185: *Primary Structures* exhibition at the Jewish Museum, New York City, April 27– June 12, 1966. Opposite: Dress, Shinichiro Arakawa, Fall/Winter 1999–2000.

The hues of these garments harkened back to those used by Cristóbal Balenciaga, the house's founder, and Ghesquière's reflective, armoresque planes seemed an organic leap from Balenciaga's plenary use of the rigid silk gazar weave. The actress Jennifer Connelly starred in photographer David Sims's advertising campaign for this collection. Captured in perfect stillness, she seemed to simultaneously mimic the rigidity of each shape and provide the waifish foundation for its diverging graphic volumes at hip and shoulder. At the collection's premiere, the journalist Sarah Mower interviewed Ghesquière for Style.com, and the designer excitedly recalled his inspiration for such voluminous iterations: "Car bodywork. Sports cars!" As such, each pattern component was backed with "sports-derived foam," pieced into the larger design with curvilinear topstitching and cut along its skirt, pant, and sleeve hems with an ultrasound machine for added precision.

In a Fall/Winter 2010–11 collection that *New York Post* editor Serena French dubbed "glazed, polished, ergonomic perfection," Francisco Costa created multiple iterations of austere, sleeveless shift dresses for Calvin Klein that conveyed an even more cohesive architectonic aesthetic than Ghesquière's ensembles. Without decoration or overwrought sartorial details, straightforward in their basic constitutions, Costa's designs offered an early modernist sensibility. Yet the collection's fabrics, which Costa dubbed alternately "leathery" or "stingray," are evolved architectural skins—no longer raw (early modernist), but refined (neo-minimalist).

Just as the makers of the caged crinolines of the 1850s employed steel as a new industrial fortifier par excellence to uphold the undergarment's concentric circles, so too have recent minimalist designers utilized materials such as anodized, brushed, and buffed aluminum, paper-thin leathers, and reinforced plastics to give their works a visionary quality. These constituents, more equipped to form machines than works of art, have in turn provided the new minimalism with a cold ineffectuality that draws from the 1990s abjection but manifests in more severe shapes. The Italian designer Alberto Del Biondi, the proprietor and lead designer of the one hundred-person Industria Del Design studio, began his career as a cobbler in the 1980s but moved into the broader design realm to create interiors and industrial objects as well. In 2008 he

told the *Surface* journalist Patrizia Scarzella, "I don't limit myself to functionality. . . . Through the simplification of an object, I identify its core values, the ones that lie in the essence of things." Del Biondi's shoe prototype with a steel heel evidences this mantra: neither functional nor decorative, the rigid, angular pump is more sculpture than footwear. The aesthetic of Biondi's steel shoe has moved into the consumer market via the platonic shapes and industrial materials of the cobbler Nicholas Kirkwood's designs, which have been commissioned for the collections of Chloé, Rodarte, and Phillip Lim, among others. In a black patent leather slingback sandal for Nina Ricci's Fall/Winter 2009–10 collection, Kirkwood obscures the natural arc of the foot in a flat crescent and includes a modified stiletto heel to counter a cantilevered platform sole under the toe. The design is angular and fetishistic to the point of cruelty and speaks to Kirkwood's intention to create "something more aggressive." Yet with all its threatening connotations, Kirkwood's shoe is more fascinating as the essential convergence of heel, sole, and upper as the integral components of footwear design. Each of these structures is clarified simply and independently yet ultimately services the phenomenal impact of the design as a whole.

In an image for the September 2007 issue of French *Vogue,* the photographer David Sims and the stylist Marie-Amélie Sauvé envisioned the model Sasha Pivovarova in a Maison Martin Margiela white tuxedo jacket with black leather lapels. Sauvé cleverly rolled one sleeve higher than the other, laid the front panels of the jacket flat against Pivovarova to highlight their asymmetry, and emphasized the starkness of the white jacket with muted black leggings. The model's dark lipstick and pale complexion afford the image an added connotation of vampiric predation, a holdover from the cold vacancies of 1990s fashion photography. The overall sartorial effect is a jumbled geometry, topped off and grounded by the shoulder line, which extends to both right and left in sharpened points and encompasses the breadth of a football player's shoulder pads. This image was included an editorial entitled "Femmes d'Envergure" ("Women of Scale"), which featured neo-minimalist designs that reject the natural female form in favor of exaggerated abstract geometries more expansive in some cases than even the nineteenth-century bustle or leg-o-mutton sleeve. Crucial to the original minimalist works as well, the variable of scale is highly important to the neo-minimal manifestation and is used both to designate high fashion from mass production and to reimagine the fashion object as a sculptural one.

For *Space for Your Future: Recombining the DNA of Art and Design* at the Museum of Contemporary Art Tokyo in 2008, the architect Junya Ishigami built his *Balloon,* a one-ton skewed cube of shiny aluminum that was suspended above the exhibition space. According to its promotional material, the intention of the exhibition was "to reconstruct physical space as a conceptual idea which can allow us a glimpse into future ways of living more closely fitted to individual sensibilities and ways of thinking." *Balloon,* with the inherent lightness that its title implies, forces the viewer into an alternate reality where one must reassess the physical characteristics of a previously familiar entity. The sculpture's angular composition and ominous weight challenged any previous association of the traditional balloon of rubber and hot air. Ishigami's *Balloon* still floated, but as it was wedged between two converging walls, the sculpture created a tension within the gallery, pushing both its vertical and horizontal limits.

Opposite, clockwise from top left: Junya Ishigami, *Balloon,* 2007; Shoe, Nicholas Kirkwood for Nina Ricci, Fall/Winter 2009–10; Photograph featuring Sasha Pivovarova in a jacket by Maison Martin Margiela, Fall/Winter 2007–8, David Sims, French *Vogue,* September 2007.

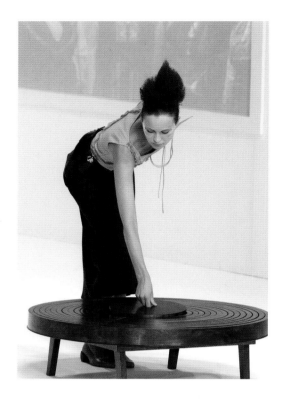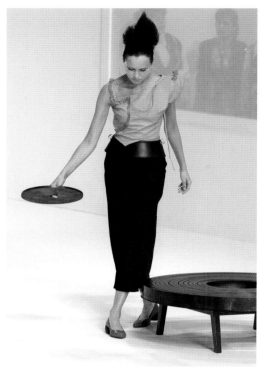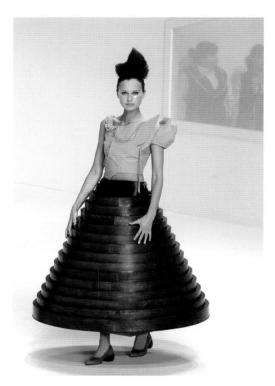

Richard Serra's massive COR-TEN steel crescents, spirals, and "snakes" are some of the best-known minimalist structures to exploit this tension in the contemporary gallery space. Contributing to the force and dynamism of Serra's sculptures, the irregularity of their interstitial spaces in certain places constricts the environment of the viewer to the point that passage appears difficult. This claustrophobic positioning is compounded by the rigidity of the steel itself: the reverse tension inherent in each arc appears to have the capacity to snap back into a straight line, thereby annulling the very spaces it previously delineated.

In the fantastical exhibition *Richard Serra: The Substance of Time* (2005) at the Guggenheim Museum Bilbao, several of the artist's distorted walls of orange weathered steel, including two from his famed Torqued Ellipses series (1993–98), were displayed sequentially. When the exhibition is viewed from above, Serra's work looks like a topographical map, like a composition of shaded spaces delineated by cutting lines—some thicker, some thinner—that ultimately navigate the gallery path. Serra's sculpture has often been assessed for its reliance on the drawn line; in "About Drawing" (1977), the artist explained, "The interval between the thickness of concentric circles, how many and how large, defined the form. Drawing was implied in the activity. The making of the form itself, whether lead rolls or pole pieces . . . was implied in the drawing within the physical transformation of material from one state to another."

In Serra's work, the visitors move seamlessly from the inside to the outside of alpine walls that serve to differentiate the private (contained) space inside a spiral from the public (exposed) space alongside a snake. Hussein Chalayan's Fall/Winter 2000–1 presentation, set in London's Sadler's Wells Theatre, mirrored this designation of space by converting the personal garment into shared household furniture. Chalayan used the bare walls of the white cube—the space of the gallery, not the fashion show—for his installation, which featured a group of models onstage behind armchairs and tables. Each model removed the covering of a piece of furniture and put it on her body, but the pièce de résistance of the show occurred

when a model stepped into the center circle of the wood coffee table, pulled it up to waist level, and affixed its bindings to her waistband. When she stood upright, the table's concentric circles fell away one by one into the form of a ridged cone skirt, its table legs folded into the frame of the hem. In *Hussein Chalayan,* Suzy Menkes explained, "The 'table dress' was intended as the highlight of the whole project, what he describes as 'a piece that becomes a monument and the other clothes the disciples.'" Serra and Chalayan both manipulated the size and proportion of the spiral to configure quintessential minimal objects, each of which moves between several a priori classifications—Monument, Sculpture, Furniture, Fashion, Building—and relies on the consumption and digestion of the viewer to locate its purpose.

Mark Wigley has stated, "Architecture is no more than an effect of surfaces, an effect that is facilitated by the structure that props the surfaces up, but one that is, in the end, independent of that structure." Serra's works, set within the broader space of the Bilbao exhibition gallery, amply created such an architectonic effect, with the patterning of the slats' edges forming a cohesive compositional network of lines. The Mexican architect Fernando Romero, a disciple of Rem Koolhaas, and his firm, Laboratory of Architecture (LAR), design buildings that, similar to Serra's sculptural style, emphasize the constructive distinction of the line within the larger three-dimensional object, thereby delineating interstitial spaces akin to those between cloth and body. Romero's *Chinese Bridging Tea House* (2004), a large trapezoidal pink structure that bridges two elevations and sits above a small valley on the Jinhua landscape in Beijing, exposes its honeycomb-like interior walls and utilizes the irregularity of post-minimal geometry to affect an origami-esque shape. The continuum of directed folds in the origami tradition is generally intended for figurative representation but also speaks to the importance of modular structures in Japanese modernist design, as exemplified by the order of the kimono. Origami manifests a series of geometric folds to configure a representative whole, which, in the case of the John Galliano for Christian Dior Spring/Summer 2007 collection, could be viewed as an abstract couture giftwrapping for the underlying body. Design duo Zowie Broach and Brian Kirkby of Boudicca were similarly inspired by the folds of origami for their Invisible City collection of Fall/Winter 2006–7, in which their "Black Lowry" dress appeared frozen in self-suspension amidst fixed staircase pleats. These garments revised the sculptural genius of Issey Miyake's 1995 "Minaret" dress,

193

which appeared as a rigid accordion-pleated lantern when worn but collapsed into a flat disc of concentric rings when discarded. Galliano's folds remain static on and off the corporeal shape and comprise a collection that Sarah Mower praised as a "return to form, and then some."

While these designs exploit the angular geometries of early minimalism, neo-minimalist design also included those objects that showcase elaborate twists as well as rounded and curved projections, all made possible by the advent of digital design. Bradley Quinn cited "the range of tilted forms, unusual shapes or interstitial structures reflected in the new architectural paradigm of digitally created buildings," but these "blobitectures" were also evident in works of fashion and interior design. Featured in the Metropolitan Museum of Art's *Superheroes: Fashion and Fantasy* exhibition (2008) and aptly named after the *Fantastic Four* villain the Silver Surfer in the May 2008 issue of *Vogue*, Giorgio Armani's couture creation exploited the exaggerated lines of the historic dress, but its sleek silver satin fabric molded a curvilinear form neither decorative nor romantic. The design's princess-line stitching appeared more mechanical joint than seam, and natural sartorial curves at shoulder and hip were aggrandized beyond the dictates of wearable fashion.

Wendell Castle has been building chairs, tables, lamps, and other interior objects that utilize the smooth, textureless surfaces, irregular shapes, and futuristic aerodynamics of blobitecture since the 1960s, exemplified by his popular 1969 *Molar* chair. Castle worked with wood for a brief period in the 1970s, but had by the 1980s returned to white, black, and electric-hued plastics and added fiberglass as a raw material to create a portfolio of warped, bloblike furniture. But where Armani's dress melds its planes into a reductive whole, Castle's designs celebrate the superfluous bump and serve their purpose as utilitarian objects, albeit decorative ones. Conversely, Ron Arad's *MT3* (2005), rotation-molded from polyethylene, is actually clarified as a rocking chair only in its associated promotional material, while its rigorously reductive design trumps function and dissociates it almost completely from the traditional rocking chair configuration. *MT3* is, at first glance, merely a hollow tubelike sculpture, with a yellow-orange interior and white exterior, distorted on top via a deep dip in its otherwise convex frame.

Arad's *MT3* also elucidates another aim of blobitecture, which is, according to Quinn, to "decentre perspective and deprivilege any single viewpoint, creating a system of

architecture that has no intrinsic front or back." One can technically sit atop *MT3,* but its circular constitution redirects the eye to an infinite cycle of absorption that ultimately subverts any top/bottom, right/left reading. In a stretch cotton tank dress for the Calvin Klein Resort 2008 collection, Francisco Costa eradicated the dimension of the built arc to affect a printed design of color-block amoeba-shaped circuits. While the dress's graphic pattern falls in line with minimalist geometry, its wide, wavy bands lead the eye out of the frame. The white center of the design moves seamlessly into the pale backdrop of the runway and joins its negative space, destroying the aggregate female frame in favor of blobitecture's decentered perspective.

Although formal minimalism discouraged figuration, post-minimalism embraced allusion, as long as it appeared in as reductive a manner as possible. The post-minimalist John Newman, quoted by the *Art in America* journalist Wade Saunders in 1985, explained, "Before, I wanted my work to be exclusive of any association or reference so that it would be primarily cerebral, apprehended like a structural model. . . . Now I'm fascinated with the enormous wealth of reference that comes into play when you do something as simple as, say, curve a plane. That curved surface suddenly is full of implications—sexual, biological, technological, baroque." Costa's dress, strict in its structural simplicity, dares to curve its planes. Nonetheless the planes still retain their flatness, making an accurate reading of a three-dimensional figure, with all of Newman's implications, impossible. Alternately, when the architects Zaha Hadid and partner Patrik Schumacher designed *Aura-S* and *Aura-L,* gold, curvaceous sculptures that arc around one another in a futurist abstraction, they sought to emulate the proportional system of the Italian Renaissance man. The works were created in commemoration of the five hundredth anniversary of legendary architect Andrea Palladio's birth and were installed in Palladio's Villa Foscari ("La Malcontenta") during the 2008 Venice Biennale. The renaissance

Opposite, top: "Black Lowry" dress, Boudicca, Invisible City collection, Fall/Winter 2006–7. Opposite, bottom: Fernando Romero and Laboratory of Architecture (LAR), *Chinese Bridging Tea House,* 2004. Above, left: Photograph, Craig McDean, "Superheroes," *Vogue,* May 2008; dress by Armani Privé. Above, right: Ron Arad, *MT3,* 2005.

architect sought to create harmony and balance based on Euclidean geometry in each room of La Malcontenta, and Hadid and Schumacher strove to offset this balance with the severe modernity and asymmetry of the interlocking *Auras*. Hadid believes that her structures should be presented like minimalist design—as reductive, aerodynamic forms that rely on the circumstances accorded by their environment and are beholden to the perceptions of their visitors.

As a critical space to draw in new patrons, the designer boutique, which houses the exquisite creations of high-end fashion, has emerged in the twenty-first century as a vital tool in the configuration of the neo-minimalist identity. In fact, minimalist design has, in recent decades, become the aesthetic of choice for the boutique architect. In *Deluxe: How Luxury Lost Its Luster* (2007), the journalist Dana Thomas conveyed the experience of shopping in the luxury district of any urban metropolis and emphasized the interchangeability (or irrelevance) of the brand name: "Walk up to a luxury brand store and a dark-suited man with a listening device tucked in his ear will silently pull open the heavy glass door. Inside there is a hush as slim, demurely dressed sales assistants await you in a posh minimalist space in neutral tones with chrome accents. The first thing you'll encounter are shelves full of the brand's latest fashion handbags, as well as its classic designs, displayed like sculptures, each lighted with its own tiny spotlight."

Comme des Garçons, under the guidance of matriarch Rei Kawakubo and a slew of different architect collaborators, was an early pioneer of the minimalist interior. A perfectionist, Kawakubo insisted that few garments sit upon the shelves of her boutiques, and Barbara Vinken pointed out that this effectively created the environment of a gallery rather than that of a store. She inferred, "The small number of garments occupying a large space creates . . . a museum, in which one can just as well come to contemplate the artworks as to buy something." The Comme des Garçons flagship boutique in Paris was minimal in its holdings to the point that it remained completely empty, with the collection brought out by request only. The Tokyo boutique

Opposite: Zaha Hadid and Patrik Shumacher, *Aura-L* and *Aura-S*, 2008. Above: Dress (two views), Francisco Costa for Calvin Klein collection, Resort 2008.

for the company's Tricot line, designed in 1982 by Takao Kawasaki, featured intersecting slabs of concrete complemented by natural wood shelving and black leather and chrome furniture, the latter of which, according to Penny Sparke in *Modern Japanese Design* (1987), functioned as "stones in a Zen Buddhist garden: they help to empty the mind in order that it can begin to fill again."

John Pawson, another early master of retail minimalism, designed the 1995 Calvin Klein boutique in New York and filled it with Donald Judd furniture. Pawson has worked consistently with the Calvin Klein company to engineer spaces that mirror the house's reductive mandate, which itself emerged as a carryover from Calvin Klein's personal style, dubbed by the editor Ingrid Sischy as "monastic and fantastic." In *Minimum* (1997), Pawson described that term as "the perfection that an architect achieves when it is no longer possible to improve it by subtraction. This is the quality that an object has when every detail, and every junction has been reduced or condensed to the essentials. It is the result of the omission of the inessentials."

In the neo-minimalist boutique, exemplified by Balenciaga's Paris flagship store at 10, avenue George V, the "essentials" have been embellished to showcase display structures that are themselves geometric works of art. The Balenciaga boutique echoes the futurist-driven, aerodynamic collections of creative director Nicolas Ghesquière, who once said of a runway model sporting one of his designs, "She looks like a solar panel, no?" Ghesquière designed the Parisian boutique with the help of the French artist Dominique Gonzalez-Foerster and the lighting designer Benoit Lalloz and has been instrumental in fusing the exclusivity and restraint of retail minimalism with the craftsmanship of the neo-minimalist object. The boutique's austere white walls are inset with white and pale blue trapezoidal enclaves, and an intense red light is projected on the reflective ceiling of an otherwise rigidly industrial room.

The Comme des Garçons boutique in New York's Chelsea neighborhood is similarly neo-minimalist, with its inclusion of an underground tunnel of curved steel and several voluminous structures rendered in pure white. Quinn compared this space to Serra's *Torqued Ellipses*: "They introduce shapes and abstractions that appear arbitrary yet collude with each other to generate positive and negative tensions throughout the space. The structures do not represent any conventional retail design but present customers with a unique environment that tantalizes the eye and displays the garments in a sculptural guise."

These retail spaces are the result of the luxury fashion industry's fusion of commodity functionalism and highbrow artistry—a convergence that has even impacted the presentation of staid fashionable ready-mades such as the little black dress and the women's suit, which, in the late twentieth century, were promoted for their accessibility and versatility as opposed to their uniqueness or exclusivity. Bottega Veneta's Fall/Winter 2006–7 advertising campaign transforms the fashion magazine's prior designations of the little black dress—to be worn on the street, getting out of a cab, or having dinner—and instead presents a little black dress as the uniform of the lady of leisure, posed coolly beside her expensive modernist desk, which in turn props up her fashionable alligator handbag. These accoutrements exist within the frame as window dressings of sorts, but the dress is set apart as a minimalist work of art, its clean flat seams joining planes of expensive black wool. This dress, which has been sartorially engineered to its greatest simplicity, cannot be emulated or mimicked and does not need the traditional accessory enhancers to convey its distinction.

Opposite, clockwise from top left: Flagship boutique: Comme des Garçons, New York; designed by Rei Kawakubo and Takao Kawasaki; entrance by Future Systems, 1999. Flagship boutique, Comme des Garçons, Paris; designed by Shona Kitchen, 2001. Flagship boutique, Calvin Klein, New York; designed by John Pawson, 1995.

In an October 2009 *W* editorial entitled "Art + Commerce," the photographers Inez van Lambsweerde and Vinoodh Matadin depict an androgynous model in a white three-piece Yves Saint Laurent suit, posed inconspicuously in various galleries of the Centre Georges Pompidou in Paris in front of avant-garde works, including those of the artists David Smith and Chuck Close, among others. The suited figure is a constant throughout the editorial, juxtaposed in each photograph with a different high-fashion model. In one image detail, the androgynous model leans against Magdalena Abakanowicz's *Abakan Grand Noir,* a 1966–67 mutation of Oldenburg's mounted *Braselette.* In this alliance, the nondescript white suit—an exemplar of mass-market minimal fashion consumption—is elevated to the status of the fine art object, while the oversized, tattered brown sweater of Abakanowicz's rendering is repositioned as a ready-made.

Through the minimalist lens, these fusions present the modernist tension between original and copy, but they also reaffirm minimalism's initial aim as an elevator and isolator of the ordinary. Maison Martin Margiela's Replica designs take second-hand fashion archetypes such as the trenchcoat or the bomber jacket from different periods and remake them stitch for stitch, finally adding to the new iteration a label that delineates all information relevant to original date, provenance, and style. Margiela, who has been creating Replicas since 2003, disavows any authorship of the garment that has been reproduced. In some regard, this disavowal confirms that these works are, or can be, mass-produced as opposed to "designed," but Margiela delineates the process of reproduction so carefully each time that the objects enter the conceptual realm, thereby classifying themselves as art. The Replicas exist as minimalist commodity signs in which, as Hal Foster has suggested, "art and commodity are made one; they are presented as signs for exchange; and they are appreciated—consumed—as such."

Fashion is not the only consumer entity that is being repositioned as art via minimalist design. Sculptors such as Haim Steinbach, Jeff Koons, and Kiki Smith have appropriated commodities of everyday use: Steinbach, the Air Jordan sneaker or Frosted Flakes cereal box; Koons, the Shelton vacuum cleaner. Kiki Smith's 1999 sculpture of yellow glass, entitled *Yolk,* takes the neo-minimalist distortion of a standard sphere and imbues it with the pop cultural association of an everyday breakfast food. *Yolk*'s disproportionate scale also signifies its status as an art object. But where Smith offers a yolk

Opposite: Photograph (detail), Inez van Lamsweerde and Vinoodh Matadin, "Art + Commerce," *W,* October 2009; suit by Stefano Pilati for Yves Saint Laurent, Fall/Winter 2009–10; Magdalena Abakanowicz, *Abakan Grand Noir,* 1966–67. Above: Jeff Koons, *Balloon Dog (Yellow),* 1994–2000.

of unspecified origin, Koons and Steinbach provide, as does fashion, a brand name—"Shelton" or "Air Jordan"—which can then further lend to the sculpture's exchange value and further blur the relationship between fine art and coveted commodity. In Koons's 1994–2000 *Balloon Dog* (*Yellow*), the artist offers a quintessential example of both neo-minimalism and commodity sculpture. The work, rendered in lemon-yellow high-chromium stainless steel, comprises smooth, reflective arcs that result from each "balloon twist." Inflated to monumental size, the sculpture is repositioned from the domain of children's entertainment to the gallery—be it the rooftop of the Metropolitan Museum of Art or the gardens at Versailles—of highbrow art consumption.

Like Koons, the artist Damien Hirst has consistently re-created the banal as art object par excellence. His 2007 *Diamond Skull,* a platinum cast of a real human skull dated between 1720 and 1810, which Hirst covered in 8,601 diamonds totaling $20 million, was reputed to be the most expensive piece of contemporary art ever offered on the market, for 50 million GBP. While this particular work utilizes the reductive figure of the human skull, its ostentatious surface application nullifies its status as a minimal object. Conversely, when Hirst was inspired by the diversity of color to be found in a common if overstocked medicine cabinet, he standardized pills of all sizes and markings into simple, multicolored dots and arranged them in equidistant rows on a white or cream-colored canvas for his Spot Paintings series, which included *Untitled #4, Spot Painting* (1992), *Biotin—Propranolol Analog* (1995), *LSD* (2000) and *Diethylene Glycol* (2006), among others. Manolo Blahnik reimagined Hirst's "spots" in 2002 as a pair of "Dots" ankle boots. *LSD*, in particular, references a hallucinatory arrangement of pills and the drug-induced stupor that might be catalyzed by their contents, but the actual effect of Hirst's Spot Painting series is similar to that of Ellsworth Kelly's *Nine Squares* (1976–77): an abstract serial system that offers nothing beyond the logic of its own arrangement.

The Japanese artist Yayoi Kusama has also used the dot to create various serial compositions, but hers are neither equally spaced nor of the same size. In Kusama's 2000 installation *Dot's Obsession—New Century,* her dots are wound around spherical and bowling-pin shapes and sprawled across the gallery's walls in a neo-minimalist distortion. Kusama's work speaks to the likeness of all things, seen through her eyes as an application of dots ad infinitum. In her 1960 *Obliteration Manifesto* she quipped, "My life is a dot lost among a million other dots." The implications of her statement and of her work as a whole introduce the dot as a nonemotive, easily duplicable structure, but one that can affect the entirety of the earth's population in abstract representation.

Purveyors of digital illustration utilize the pixel—another modular repetitive article—as their dot of choice and reimagine Kusama's wrapped canvases as fragmented frames of pixilated figuration imposed upon ephemeral spaces and shapes. For Prada's Spring/Summer 2009 look book, Rem Koolhaas, a frequent collaborator with the Prada company, created a series of composite illustrations based on the patterns and themes of Miuccia Prada's designs. The resulting artwork, executed by Jeruniverse and Lok Jansen, manipulated the interstitial spaces between physical garment and background composition and in so doing presented an ambiguity between design and imagined space. One image from this book delineated a tight frame that cropped the head and legs of the model in order to focus on the length of the dress alone.

Opposite, clockwise from top left: Ellsworth Kelly, *Nine Squares*, 1976–77; Photograph, Philip Meech, Prada look book, Spring/Summer 2009; dress by Prada; Damien Hirst, *Diethylene Glycol*, 2006.

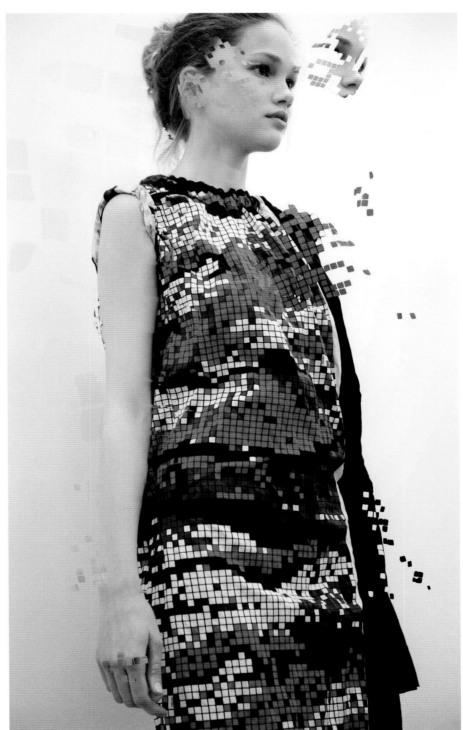

A shift patterned with intermingled red, black, and gray pixels, the design welcomes the digital explosion that literally lifts the dress's surface pixels and scatters them as flecks into thin air. This image invokes Carl Andre's *Spill (Scatter Piece)* of 1966, for which the artist emptied eight hundred small white blocks from a canvas bag onto the floor of the gallery, allowing "gravity and chance alone" to determine their placement. In this way, Andre could eliminate the predetermined composition of his piece. Koolhaas's Prada image is fashioned from a premeditated and engineered design, yet the seemingly authentic dispersal of its runaway pixels adheres to the minimalist mandate of a visible artistic process. Moreover, it divides the traditional minimalist grid to affect an ambiguous neo-minimal composition that exists somewhere between the record of a real garment and an alternate illustration.

The prominence of digital rendering, like the advent of synthetic dye for fabric, cultivated a greater diversity of color in early twenty-first-century fashion and art. Electric and Day-Glo hues were employed extensively in the 1980s and reemerged after the muted tones of the 1990s to broader clarification in the digital palette. Effusive coloration also ushered in two movements that would come to impact the neo-minimalist trajectory: simulationism and neo-geo. Although the palette of formal minimalism was strictly monochromatic or duotone, simulationists such as Sherrie Levine, Jack Goldstein, and Peter Halley painted minimal geometries and basic shapes that absorbed a wide range of saturated colors, often within the same work. Simulationism referred to mid-century abstract painting as its foundation, but instead of pinpointing the figure as a source for dissociation, the movement's purveyors recycled preexisting abstract shapes and compositions in order to produce a representational effect without any direct connection to the tangible world. Foster explained the movement: "Simulation corresponds to a short-circuit of reality and its reduplication by signs."

While Jack Goldstein's canvases featured amoebic blobs as backdrops for a serial application of flat, basic shapes such as circles or rectangles, Levine's works tended to appropriate the works of 1960s minimalism and the mid-century avant-garde directly. Her 1991 installation *Melt Down (After Yves Klein)* was a series of small canvases, each painted a different color, as though Klein's signature blue had become schizophrenic, and her *Fountain* of the same year re-created the like-titled 1917 work by Marcel Duchamp, except Levine cast her "fountain" in bronze.

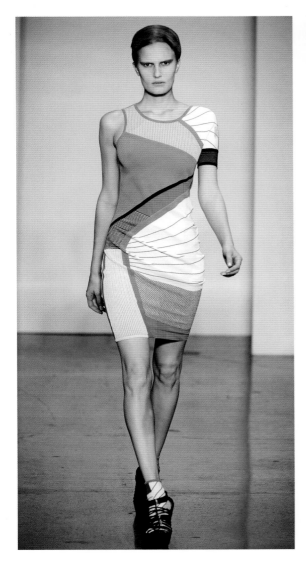

Peter Halley is alternately labeled a simulationist, a minimalist, and a neo-geo artist, as his works generally depict the familiar but abstracted structures of either "prisons" or "cells"—effectively lines or squares—in bright surreal colors. Halley's 2006 painting *Prison* clarifies a non-hierarchical collage of simple shapes, composed of an orange and purple cell structure against a flat lime-green terrain, the ground beneath the cell denoted with a yellow band that runs along the bottom of the canvas. Halley's work is strictly reductive but relates to some of the fragmented geometries of the neo-geo movement, which are now influenced as well by digital illustration. Sarah Morris, a British-American neo-geo painter and filmmaker, draws from the strict linearity of architecture and urban geography to create canvases of intersecting and converging lines in which intermediate planes are rendered in different colors to affect a stained-glass aesthetic.

Jeremy Leibman's "Neo-Geo" editorial for issue 73 of *Surface* (2008) highlighted the influx of bright geometric patterning in twenty-first-century high fashion. The Scottish-born Londoner Jonathan Saunders has, since his house's founding in 2003, decorated the surfaces of simple shift dresses and skirts with unique kaleidoscopic geometries, both hand-painted and digitally rendered, while lesser-known contemporary designers such as Frankie Xie for Jefen and Julian Louie employ geometric juxtapositions within the high-tech textiles of their ensembles. Alexander McQueen's Resort 2010 collection featured an ensemble of alternating blue and magenta bands that intersected at lapel, peplum, and thigh to form chevrons, ultimately rendering a graphic neo-geo composition. Perhaps the most devoted neo-geo sartorialists, the New York design duo Ohne Titel, which literally translates from the German to "without title," utilizes geometry as the basis for constructive iterations as diverse as a knit dress and a silk satin pantsuit. For their Spring/Summer 2010 collection, Ohne Titel designers Flora Gill and Alexa Adams embellished one stretch synthetic minidress with an abstract geometric pattern that conveyed the expanse of Serra's arcs and the jittery fragmentation of Morris's canvases simultaneously and in addition incorporated the model's gait as a transformative element in the design's reading. The aforementioned painted works and geometrically devised fashions of the twenty-first century as well as the period's aerodynamic sculptural pieces born from fine art, architecture, and fashion designations insinuate the presence of digital technology in rendering a newly mechanized and streamlined minimal aesthetic. In the

Lanvin advertising campaign for Fall/Winter 2005–6, this presence is made more evident: in one image, the model's legs fuse to form one elongated ankle and her shadow stretches out to both the right and the left, while another captures a sitter whose limbs have been lengthened and her head enlarged so she appears as an alien life form.

Where various minimal designs of the late twentieth century sought to emulate, abstract, or re-conceive the human body as a primary structure, the new minimalism envisions it as a digital network of fractured planes, not unlike the "model" in Sølve Sundsbø's 1998 *Wired* image. Sudsbø worked with the stylist Cathy Edwards and the London post-production house Lost in Space to depict a woman composed entirely of platonic geometries—the digital evolution of Theo van Doesburg's 1917 *Zittend Nookt* ("Seated Nude") drawing. As with Serra's Ellipses series or Romero's *Tea House*, Sundsbø's line becomes a crucial component in reductive rendering. In an image from Koolhaas's Spring 2009 look book for Prada, the male model appears nearly bloodless in his pallor, which is emphasized by the inexpressiveness of a basic white button-down shirt from the collection. The lines of the digital grid, drawn across his head and chest, serve to present him as a near-human figment of the designer's imagination, but moreover ally him with the legendary science-fiction figure of the cyborg, as part human, part machine. In *Simians, Cyborgs, and Woman: The Reinvention of Nature* (1991), Donna Haraway, the professor and chair of the History of Consciousness Program at the University of California, Santa Cruz, explained, "Late twentieth-century machines have made thoroughly ambiguous the difference between natural and artificial, mind and body, self-developing and externally designed, and many other distinctions that used to apply to organisms and machines. Our machines are disturbingly lively, and we ourselves frighteningly inert." An editorial spread by Aorta and Lundland from the Spring/Summer 2009 "Luxury" issue of the British *125 Magazine* clarified Haraway's assertion. In this image, an impassive, otherworldly female figure is clothed in seamless light-blue stretch pants and a futuristic royal-blue Thierry Mugler jacket molded to her torso and cut sporadically with shiny insets of black leather as if to affect a fashionable armor. She stands rigidly, in opposition to the natural human environment that surrounds her, as an older gentleman sternly assesses her corporeal constitution. The man's previous drawings, which appear to be of a female nude, are affixed to the wall behind her, but the pad in his hand is blank, as he cannot seem to properly locate the figure before him. In both Koolhaas's image for Prada and Aorta and Lundland's for *125,* the model is presented as a lifeless, inert body—yet another form within the digital landscape. Caroline Evans inferred that this figure "suggests the uncanny switching between human and machine of modern industrial production."

The file of the digital artwork exists as an eternal original, regardless of how many times it is duplicated. Similarly, the cyborg of contemporary fashion imagery is a mechanical prototype—an abstract, reproducible figure upon which the minimal design is clarified in endless repetition. In one of Willy Vanderperre's Spring/Summer 2005 advertising images for Jil Sander, the photographer spliced together a repetition of the same image and replaced blocks of the composition with dead white space to highlight his digital manipulation. His model's cold stare is magnified by her mechanically limp hand, severely slicked-back hair, and androgynous ensemble of trenchcoat and modified ascot, all of which serve to reinforce Haraway's

Opposite, top: Photograph, Philip Meech, Prada look book, Spring/Summer 2009; shirt by Prada. Opposite, bottom: Sølve Sundsbø, *Wired*, 1998. Pages 208–209: Photograph, Aorta, "Her Serene Highness," *125 Magazine*, Spring/Summer 2009; jacket by Thierry Mugler.

vision of the cyborg as a "creature in a post-gender world." In *Sexuality and Space,* Victor Burgins claimed, "The city and the body will interface with the computer, forming part of an information machine in which the body's limbs and organs will become interchangeable parts with the computer and with the technologization of production."

When Marcel Duchamp painted his *Nude Descending a Staircase, No. 2* in 1912, he prophesized the fusion of human and machine as a repetitive platonic figure. The successive, stroboscopic image of this "nude" implied the forward movement of futurist dictate, and its golden hue realized Filippo Tommaso Marinetti's futurist vision of a "dreamt-of metallization of the human body."

Where the cyborg body is fixed, the neo-minimal garment is fluid and streamlined, with a clear emphasis on both movement and planarity. Function is less important than design, and simplicity overpowers intricacy. While the futurist dream of progress is actualized with the advent and incorporation of new technologies by every designation within the neo-minimalist spectrum, ultimately these new works subscribe to the less dramatic propositions of reductivity and commodification. Francisco Costa created a muted purple jacket for Calvin Klein's Spring/Summer 2008 collection, which was featured in a photograph by Sølve Sundsbø for *Harper's Bazaar* in July of that year. Sundsbø's image delineates Costa's rendering as a minimalist pillar: exploiting the rectilinear geometries of the traditional kimono, the unfettered fabric panels that wrap one over the other at center front to affect a high, sculptural collar. The jacket is neither ostentatious nor average but a perfect compromise between flat textile and sculpted garment. In Willy Vanderperre's advertisements for Jil Sander's Spring/Summer 2007 collection, Raf Simons's platonic minimal garment finds its location as well within the modernist gallery—or possibly the minimalist boutique— the cool white skin of which propels the deep purple planes of the minimal object forward in stark relief, an impact countered only by the emboldened red block-print logo stamped firmly upon the facing page.

In *Foundations of Modern Art* (1931), the painter and purist architect Amédée Ozenfant, in reflecting upon his work with Le Corbusier, declared, "What we wished to express in art was the Universal and Permanent and to throw to the dogs the Vacillating and the Fashionable." Minimalism, in all its iterations and materializations, seeks the same expression: to challenge conceptions of space and matter, to ensure purity of design, and to reduce form to its cogent, accessible essence—these are the tenets of longevity.

Opposite, top: Advertising image featuring Lily Donaldson: David Sims for Jil Sander, Spring/ Summer 2005. Opposite, bottom: Marcel Duchamp, *Nude Descending a Staircase (No. 2)*, 1912. Above: Photograph, Sølve Sundsbø, *Harper's Bazaar,* July 2008; jacket by Francisco Costa for Calvin Klein collection and cuffs by Herve van der Straeten. Pages 212–213: Advertising image: Willy Vanderperre for Jil Sander, Spring/ Summer 2007.

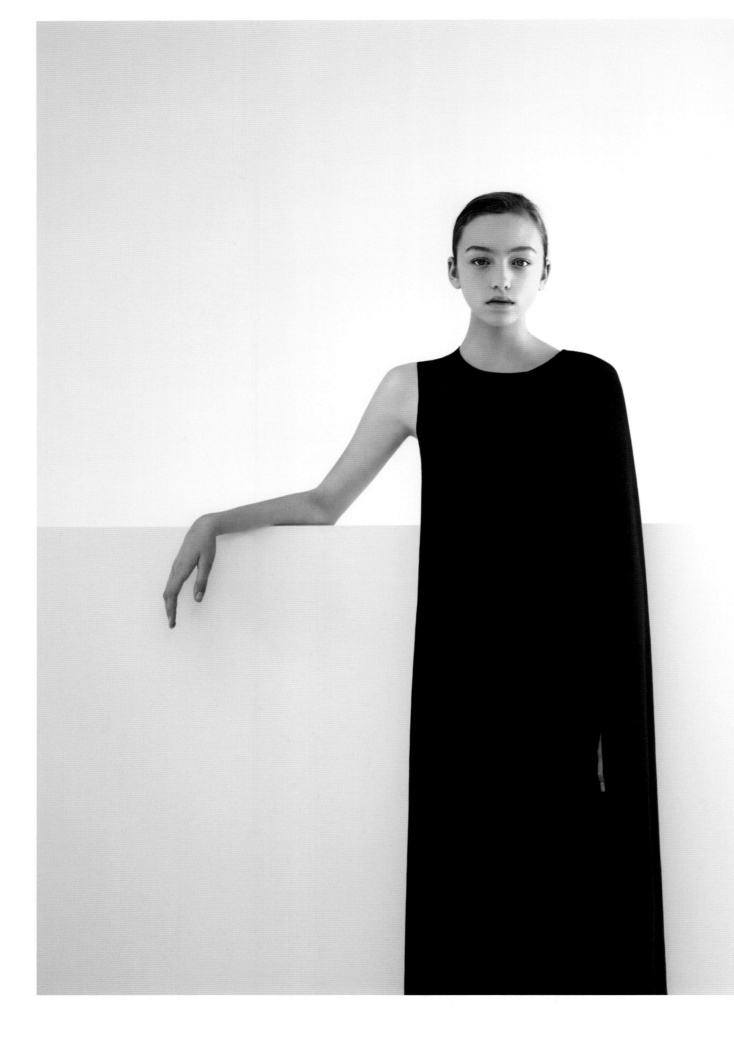

ACKNOWLEDGMENTS

From concept to realization, *Minimalism and Fashion* has been an extraordinary, revelatory process that would not have been possible without the support of a number of individuals. First and foremost, I wish to thank the minimalist designers, photographers, fine artists, and architects included here, whose visionary work continues to challenge our aesthetic and conceptual boundaries. I must convey my most heartfelt gratitude to my editor, Elizabeth Viscott Sullivan, whose belief in this project was unwavering, whose dedication was inspiring, and whose insights were vast and poignant. Francisco Costa, Malcolm Carfrae, and Jennifer Crawford at Calvin Klein have been an incredible pleasure to work with and have incited me to explore new interpretations of minimalism in both art and fashion. Amanda Haskins provided key insights on the subject of sartorial reduction during our many conversations, and I am thrilled that she decided to contribute her perspective to the body of this work. Iris Shih, Lelia Mander, and Pamela Barr have all been instrumental in the execution of this volume, and Christine Heslin's breathtaking design brought my text and images to life in a way that I never dreamt possible.

I am grateful for the generosity and patience of many individuals who aided in the accrual of images for this volume, but want to specifically thank Melissa Regan at Art + Commerce; Christine Brownfield and Gregory Spencer at Art Partner; Jennifer Belt at Art Resource; Cristin O'Keefe Aptowicz at Artist Rights Society; Fabien Baron and the Baron & Baron staff; Cari Engel at Calvin Klein; Daphne Seybold at Comme des Garçons; Shawn Waldron, Leigh Montville, and Elyce Tetorka at Condé Nast; Chris Constable; Rachel Nosworthy at Corbis; Joyce Fung and Julie Le at The Costume Institute at The Metropolitan Museum of Art; Butch Vicencio at Getty Images; Stéphane Houy-Towner; Maria Valentino and Nina Westervelt at MCV Photo; Denyse Montegut; Nicolas Moore; Jan Peterson; Randy Kabat and Bernice Cannistraci at Prada; Tamsen Schwartzman; Marcus Tomlinson; Gayle Taliaferro, Claudia Lebenthal, and Matthew Moneypenny at Trunk Archive; and Andrea

Mihalovic-Lee at VAGA. I am beholden to the staff and volunteers of the Humanities, Science and Business, and Performing Arts branches of the New York Public Library, the Library and Special Collections departments of the Fashion Institute of Technology, the New School's Adam & Sophie Gimbel Art and Design Library, and the Elmer Holmes Bobst Library at New York University for their tireless assistance during the course of my research. Several colleagues and scholars were generous enough to offer their ears and contribute their thoughts, including Jane Adlin, Paola Antonelli, Andrew Bolton, Hazel Clark, Marilyn Cohen, Laura Hoptman, Heike Jenss, Harold Koda, Patricia Mears, James Meyer, and Ethan Robey. Sarah Byrd and Jacqueline Wallace also deserve recognition, as they selflessly lent their time, energy, and enthusiasm to the ongoing research necessitated by *Minimalism and Fashion*.

Many friends and family members supported me during this project; their homes became transitional offices, and they appeared time and again for late-night cocktails or early-morning coffees, despite the decidedly minimalist-focused conversations such liaisons offered. Special thanks to Rima Anosa, Gregory Arata, Leslie Askew, Jesse Atlas, Naomi Azar, Chris Dixon, Kinson Gawrych, Brent and Dana Luria, Swanna MacNair, Hagar Ophir, Tweeps Phillips, Safron Rossi, Adam Roth, Jennifer Spitzer, Brenner Thomas, Eyal Vexler, and Aaron Wolfe. Bruce and Susan Luria and Oded and Ofra Dimant extended, in typical fashion, their boundless love and support, for which I am always grateful. Finally, I must thank my husband, Eyal Dimant, without whom my world—minimal pontifications and all—may have spun off its axis long ago.

BIBLIOGRAPHY

Articles

___. "American Fashion: The Movers." *Vogue* (February 1975): 109.

Armstrong, Lisa. "The New Snobbery." *British Vogue* (1995): 172.

Arnold, Rebecca. "Heroin Chic." *Fashion Theory* 3, issue 3 (1999): 279–96.

Beard, Alice. "'Put in Just for Pictures': Fashion Editorial and the Composite Image in Nova 1965–1975." *Fashion Theory* 6, issue 1 (2002): 25–44.

Belcove, Julie L. "Roni Horn." *W* (November 2009), www.wmagazine.com/artdesign/2009/11/roni_horn.

Betts, Kate. "La Nouvelle Vague." *Vogue* (September 1992): 228.

___. "9 Rei Kawakubo." *Time,* February 16, 2004.

Blazwick, Iwona. "Feel No Pain." *Art Monthly* (November 1998): 7.

Bourdon, David. "The Razed Sites of Carl Andre." *Artforum* (October 1966): 15.

Bowles, Hamish. "Fashion's Visionary." *Vogue* (March 1993): 426.

Brulé, Tyler. "It's Smart To Be Simple." *Independent on Sunday,* March 10, 1996, Real Life sect.

Buck, Joan Juliet. "The Eye of Geoffrey Beene." *Vogue* (September 1988): 650–54.

Colacello, Bob. "The Queen of Less Is More." *Vanity Fair* (October 1994): 165.

Conant, Jennet. "The Monk and the Nun: The Shock Value of Two Japanese Designers." *Newsweek* (February 2, 1987): 80.

Daly, Steve. "He's Got the Whole World . . . in His Pants." *The Face* (December 1995): 142.

Debord, Matthew. "Texture and Taboo: The Tyranny of Texture and Ease in the J. Crew Catalog." *Fashion Theory* 1, issue 3 (1997): 261–78.

Duchamp, Marcel. "Apropos of 'Readymades.'" *Art and Artists* 1, no. 4 (July 1966): 47.

Duggan, Ginger Gregg. "The Greatest Show on Earth." *Fashion Theory* 5, issue 3 (2001): 243–70.

Evans, Caroline. "The Golden Dustman: A Critical Evaluation of the Work of Martin Margiela and a Review of Martin Margiela: Exhibition (9/4/1615)." *Fashion Theory* 2, issue 1 (1998): 73–94.

Finkelstein, Joanne. "Chic—A Look That's Hard To See." *Fashion Theory* 3, issue 3 (1999): 363–86.

Flavin, Dan. "An Autobiographical Sketch." *Artforum* (December 1965): 24.

Fried, Michael. "Frank Stella's New Paintings." *Artforum* (November 1966): 22, 27.

Geldzahler, Henry. "A Preview of the 1966 Venice Biennale." *Artforum* (June 1966): 38.

Gill, Allison. "Deconstruction Fashion: The Making of Unfinished, Decomposing, and Re-Assembled Clothes." *Fashion Theory* 2, issue 1 (1998): 25–50.

Glaser, Bruce. "Oldenberg, Lichtenstein, Warhol: A Discussion." *Artforum* (February 1966): 20–24.

Gleuck, Grace. "Bringing the Soul into Minimalism: Eva Hesse." *New York Times,* May 12, 2006.

___. "The Antithesis of Minimalism's Cool Geometry: Fleshy Rubber." *New York Times,* February 13, 1998.

Hollander, Anne. "The Modernization of Fashion." *Design Quarterly* 154 (Winter, 1992): 27–33.

Horyn, Cathy. "Bob Richardson, 77, Who Energized Fashion Photography, Dies." *New York Times,* December 12, 2005.

___. "Updating Minimalism for Maximum Effect." *New York Times,* October 2, 2006.

___. "Who's Afraid of Minimalism?" *New York Times,* August 25, 2005.

___. "Zoran, the Master of Deluxe Minimalism, Still Provokes." *New York Times,* April 20, 1999.

Howell, Georgina. "Chain Reactions." *Vogue* (September 1992): 532, 537.

Ince, Kate. "Operations of Redress: Orlan, the Body and Its Limits." *Fashion Theory* 2, no. 2 (1998): 111–28.

Jobling, Paul. "On the Turn—Millennial Bodies and the Meaning of Time in Andrea Giacobbe's Fashion Photography." *Fashion Theory* 6, issue 1 (2002): 3–24.

___. "Who's That Girl?: 'Alex Eats,' A Case Study in Abjection and Identity in Contemporary Fashion Photography." *Fashion Theory* 2, issue 3 (1998): 209–24.

Judd, Donald. "Specific Objects." *Art Yearbook* 8 (1965): 74–82.

Knafo, Robert. "Issey Miyake Is Changing the Way Men View Clothes." *Connoisseur* (March 1988).

Kozloff, Max. "The Inert and the Frenetic." *Artforum* (March 1966): 44.

Krauss, Rosalind. "Richard Serra: Sculpture Redrawn." *Artforum* (May 1972): 39.

Lippard, Lucy. "Art Forum: Questions to Stella and Judd." *ArtNews* (September 1966).

___. From "New Nihilism or New Art?" Interview by Bruce Glaser, WBAI-FM, February 1964.

Loreck, Hanne. "De/constructing Fashions/Fashions of Deconstruction: Cindy Sherman's Fashion Photographs." *Fashion Theory* 6, issue 3 (2002): 255–76.

Martin, Richard. "A Note: Art + Fashion, Viktor & Rolf." *Fashion Theory* 3, issue 1 (1999): 95–102.

___. "A Note: Gianni Versace's Anti-Bourgeois Little Black Dress (1994)." *Fashion Theory* 2, issue 1 (1998): 95–100.

___. "Our Kimono Mind: Reflections on 'Japanese Design: A Survey Since 1950.'" *Journal of Design History* 8, issue 3 (1995): 215–23.

Melrod, George. "Lip Schtick." *Vogue* (June 1993): 88–90.

Mentges, Gabriele. "Cold, Coldness, Coolness: Remarks on the Relationship of Dress, Body, and Technology." *Fashion Theory* 4, issue 1 (2000): 27–48.

Morris, Bernadine. "Calvin Klein Teases with Longer Skirts." *New York Times,* November 6, 1991.

___. "Tank Dress: Simply Minimal." *New York Times,* November 23, 1993.

Mower, Sarah. "Balenciaga, October 2, 2001." Style.com Fashion Shows. www.style.com/fashionshows/review/S2008RTW-BALENCIA (accessed August 19, 2009).

___. "Christian Dior, January 22, 2007." Style.com Fashion Shows. www.style.com/fashionshows/review/S2007CTR-CDIOR (accessed August 16, 2009).

___. "The Kimono with Added Cut and Thrust." *Guardian,* March 6, 1986.

___. "Talking with Rei." *Vogue Nippon* (September 2001): 156–59.

Muir, Robin. "What Katy Did." *Independent,* February 22, 1997.

Petkanas, Christopher. "Comme des Garçons Hits Paris." *Women's Wear Daily,* December 17, 1982.

Reed, Julia. "Calvin's Clean Sweep." *Vogue* (September 1992): 234–37, 240–41.

Reigels Melchior, Marie. "Exhibition Review: Rudi Gernreich: Fashion Will Go Out of Fashion." *Fashion Theory* 7, issue 2 (2003): 223–28.

Rose, Barbara. "ABC Art." *Art in America* (1965): 278.

___. "Looking at American Sculpture." *Artforum* (February 1965): 35.

Rosenblum, Robert. "Frank Stella." *Artforum* (March 1965): 22.

Roux, Caroline. "Reality Bites." *Guardian,* November 2, 1996.

Ryan, Nicky. "Prada and the Art of Patronage." *Fashion Theory* 11, issue 1 (2007): 7–24.

Saunders, Wade. "Talking Objects: Interviews with Ten Younger Sculptors." *Art in America* (November 1985): 128.

Scarzella, Patrizia. "Pleasure Craft." *Surface* 69 (2008): 68–69.

Schjeldahl, Peter. "Systems '66." *Village Voice,* September 29, 1966.

Scott, Felicity. "'Primitive Wisdom' and Modern Architecture." *Journal of Architecture* 3 (Autumn 1998): 241–61.

Smith, Roberta. "Gaining a Voice and an Identity in Minimalism." *New York Times,* November 5, 2009.

___. "60s Minimalism, Looking Handmade." *New York Times,* May 24, 1996.

Smithson, Robert. "Strate: A Geophotographic Fiction." *Aspen* 8 (Fall/Winter 1970–71).

Spindler, Amy M. "Basking in Minimalism as an Antidote to Stress." *New York Times,* March 2, 1994.

___. "Coming Apart." *New York Times,* July 23, 1993.

___. "In Milan, Men in Minimal Suits." *New York Times,* January 18, 1997.

___. "A Mostly Minimal Look in London." *New York Times,* October 20, 1993.

___. "Tracing the Look of Alienation." *New York Times,* March 24, 1998.

___. "When Clothes Become You." *New York Times,* September 22, 1996.

Steele, Valerie. "Anti-Fashion: The 1970s." *Fashion Theory* 1, issue 3 (1997): 279–96.

Steiner, Robert L., and Joseph Weiss. "Veblen Revised in the Light of Counter-Snobbery." *Journal of Aesthetics and Art Criticism* 9, issue 3 (March1951): 263.

Talmey, Allene. "Art Is the Core: The Scull Collection." *Vogue* (July 1964): 118–25.

___. "The Straight and the Narrow." *Vogue* (September 1996): 584.

___. "The X Factor in Art." *Harper's Bazaar* (July 1966): 78–79.

Trotta, Geri. "Not To Be Missed: The American Art Scene." *Harper's Bazaar* (July 1966): 80–85.

Troy, Carol. "Like the Boys." *Village Voice*, February 14, 1984.

Van Meter, Jonathan. "Fast Fashion." *Vogue* (April 1990): 255–59, 279.

Wallerstein, Katharine. "Thinness and Other Refusals in Contemporary Fashion Advertising." *Fashion Theory* 2, issue 2 (1998): 129–50.

Weir, June. "Update on the Japanese." *New York Times*, July 15, 1984.

White, Constance R. "Sexy Minimalism from 2 Perspectives." *New York Times*, March 17, 1997.

Wiegand, Charmion. "Mondrian: A Memoir of His New York Period." *Art Yearbook* 4 (1961): 59–60.

Willard, Charlotte. "The Shape of Things to Come." *New York Post*, May 8, 1966.

Withers, Jane. "Black: The Zero Option." *The Face* (March 1987): 52–53.

Wollheim, Richard. "Minimal Art." *Arts Magazine* (January 1965): 26–32.

Books

Ades, Dawn, Neil Cox, David Hopkins, and Marcel Duchamp. *Marcel Duchamp.* London: Thames & Hudson, 1999.

Agins, Teri. *The End of Fashion: How Marketing Changed the Clothing Business Forever.* New York: Harper Paperbacks, 2000.

Albert, Judith Clavir, and Stewart Edward Albert. *The Sixties Papers: Documents of a Rebellious Decade.* Santa Barbara, CA: Praeger Paperback, 1984.

Arizona Costume Institute of the Phoenix Art Museum, comp. *A New Wave in Fashion: Three Japanese Designers.* Phoenix: Institute, 1983.

Arnold, Rebecca. *Fashion, Desire and Anxiety: Image and Morality in the 20th Century.* New Brunswick, NJ: Rutgers University Press, 2001.

___. "Luxury and Restraint: Minimalism in 1990s Fashion." In *The Fashion Business: Theory, Practice, Image,* edited by Nicola White and Ian Griffiths, 167–81. Oxford: Berg, 2000.

Baker, Kenneth. *Minimalism: Art of Circumstance.* New York: Abbeville Press, 1989.

Ball, Susan L. *Ozenfant and Purism: The Evolution of a Style, 1915–1930.* Ann Arbor, MI: UMI Research Press, 1981.

Barthes, Roland. *Système de la mode.* Paris: Éditions du Seuil, 1967.

Bastian, Heiner. *Andy Warhol: Retrospective.* London: Tate Publishing, 2001.

Battcock, Gregory. *Minimal Art: A Critical Anthology.* San Francisco: University of California Press, 1969.

Bayer, Herbert. "Homage to Gropius." In *Bauhaus and Bauhaus People,* edited by Eckhard Neumann. New York: Van Nostrand Reinhold, 1993.

Benjamin, Walter. *The Arcades Project.* Cambridge, MA: Harvard University Press, 1999.

Birrell, Jan, trans. *Concepts of Cleanliness: Changing Attitudes in France since the Middle Ages* by Georges Vigarello. Cambridge: Cambridge University Press, 1988.

Bolton, Andrew. *Superheroes: Fashion and Fantasy.* New York: Metropolitan Museum of Art, 2008.

Brassaï (Gyula Halász). *Paris de nuit.* Paris: Éditions Arts et Métiers Graphiques, 1933.

Braun, Emily, et al. *Boccioni's Materia: A Futurist Masterpiece and the Avant-garde in Milan and Paris.* New York: Guggenheim Museum, 2004.

Breward, Christopher. *The Hidden Consumer: Masculinities, Fashion, and City Life, 1860–1914.* Manchester, U.K.: Manchester University Press, 1999.

Breward, Christopher, and Caroline Evans, eds. *Fashion and Modernity.* Oxford: Berg, 2005.

Breward, Christopher, and David Gilbert, eds. *Fashion's World Cities.* Oxford: Berg, 2006.

Bright, Susan, ed. *Face of Fashion.* New York: Aperture, 2007.

Bruzzi, Stella, and Pamela Church-Gibson, eds. *Fashion Cultures: Theories, Explorations, and Analysis.* New York: Routledge, 2000.

Bure, Gilles de. *Guy Bourdin (Photofile).* London: Thames & Hudson, 2008.

Buxbaum, Gerda, ed. *Icons of Fashion: The Twentieth Century.* London: Prestel, 1999.

Carnegy, Vicky. *Fashions of a Decade: The 1980s.* New York: Facts on File, 1990.

Cassel, Valerie. *Splat Boom Pow! The Influence of Cartoons in Contemporary Art.* Houston: Contemporary Arts Museum, 2003.

Celant, Germano, Harold Koda, and the Solomon R. Guggenheim Museum. *Giorgio Armani.* New York: Harry N. Abrams, 2000.

Chermayeff, Catherine. *Fashion Photography Now.* New York: Harry N. Abrams, 2000.

Cheviokoff, Sofia, ed. *Minimalism/Minimalist.* Atrium Group, 2003.

Chung, Chuihua Judy, ed. *The Harvard Design School Guide to Shopping/Harvard Design School Project on the City 2.* London: Taschen, 2000.

Church Gibson, Pamela. "New Stars, New Fashions and the Female Audience: Cinema, Consumption and Cities, 1953–1966." In *Fashion's World Cities,* edited by Christopher Breward and David Gilbert, 89–106. Oxford: Berg, 2006.

___. "Redressing the Balance: Patriarchy, Postmodernism, and Feminism." In *Fashion Cultures: Theories, Explorations, and Analysis,* edited by Stella Bruzzi and Pamela Church-Gibson, 347–62. New York: Routledge, 2000.

Clark, Timothy J. "Jackson Pollock's Abstraction." In *Reconstructing Modernism: Art in New York, Paris, and Montreal, 1945–1964,* edited by Serge Guilbaut, 172–243. Cambridge, MA: MIT Press, 1990.

___. *The Painting of Modern Life.* London: Thames and Hudson, 1990.

Colomina, Beatriz, ed. *Sexuality and Space.* New York: Princeton Architectural Press, 1992.

Colpitt, Frances. *Minimal Art: The Critical Perspective.* Seattle: University of Washington Press, 1990.

Cotton, Charlotte. *The Photograph as Contemporary Art.* London: Thames and Hudson, 2004.

Coupland, Douglas. *Generation X: Tales for an Accelerated Culture.* New York: St. Martin's Griffin, 1991.

Crane, Diana. *The Transformation of the Avant-Garde: The New York Art World, 1940–1985.* Chicago: University of Chicago Press, 1989.

Crow, Thomas. *Modern Art in the Common Culture.* New Haven, CT: Yale University Press,1998.

___. *The Rise of the Sixties: American and European Art in the Era of Dissent.* New Haven: Yale University Press, 2005.

Cullerton, Brenda. *Geoffrey Beene: The Anatomy of His Work.* New York: Harry N. Abrams, 1995.

Cuno, James, ed. *Minimalism and Post-Minimalism: Drawing Distinctions.* Hanover, NH: Hood Museum of Art, 1990.

Dachy, Marc. *Dada: The Revolt of Art.* New York: Harry N. Abrams, 2006.

Dahl-Wolfe, Louise. *Louise Dahl-Wolfe: A Photographer's Scrapbook.* New York: St. Marten's Marek, 1984.

Debo, Kaat, and Bob Verhelst, with Martin Margiela. *Maison Martin Margiela 20: The Exhibition.* Antwerp: MoMu-Fashion Museum, 2008.

Debo, Kaat, and Geert Bruloot, eds. *6+: Antwerp Fashion.* Ghent: Ludion, 2007.

Derrick, Robin, and Robin Muir, eds. *People in Vogue: A Century of Portraits.* New York: Little Brown and Company, 2003.

Derycke, Luc, Thimo Teduits, and San Van de Veire. *Belgian Fashion Design.* Antwerp: Ludion, 1999.

Devlin, Polly. *Vogue Book of Fashion Photography: The First Sixty Years.* New York City: Quill/Conde Nast Publishers, 1979.

Dietch, Jeffrey. *Post Human.* Ostfilderm, Germany: Cantz/Deste Foundation for Contemporary Art, 1992.

Duncan, Ronald, trans. *Diary of a Film (La belle et la bête),* by Jean Cocteau. London: D. Dobson, 1950.

Duve, Thierry de. "The Monochrome and the Blank Canvas." In *Reconstructing Modernism: Art in New York, Paris, and Montreal, 1945–1964,* edited by Serge Guilbaut, 244–310. Cambridge: MIT Press, 1990.

Entwhistle, Joanne. "The Dressed Body." In *Body Dressing,* edited by Joanne Entwistle and Elizabeth Wilson, 33–57. Oxford: Berg, 2001.

Entwistle, Joanne, and Elizabeth Wilson, eds. *Body Dressing (Dress, Body, Culture)*. Oxford: Berg, 2001.

Esquevin, Christian. *Adrian: Silver Screen to Custom Label*. New York: Monacelli Press, 2008.

Evans, Caroline. *Fashion at The Edge: Spectacle, Modernity and Deathliness*. New Haven, CT: Yale University Press, 2003.

___. "Multiple, Movement, Model, Mode: The Mannequin Parade, 1900–1929." In *Fashion and Modernity*, edited by Christopher Breward and Caroline Evans, 125–46. Oxford: Berg, 2005.

___. "Yesterday's Emblems and Tomorrow's Commodities: The Return of the Repressed in Fashion Imagery Today." In *Fashion Cultures: Theories, Explorations, and Analysis*, edited by Stella Bruzzi and Pamela Church-Gibson, 93–113. New York: Routledge, 2000.

Evans, Christopher Huw, trans. *Italian Fashion: From Anti-Fashion to Stylism*, by Grazietta Butazzi and Alessandra Mottola Molfino. Milan: Electa, 1987.

Fausch, Deborah, Paulette Singley, Rodolphe El-Khoury, and Zvi Efrat. *Architecture in Fashion*. Princeton, NJ: Princeton University Press, 1996.

Fer, Briony. *On Abstract Art*. New Haven, CT: Yale University Press, 2000.

Fiske, John. *Understanding Popular Culture*. New York: Routledge, 1989.

Foster, Hal, ed. *The Anti-Aesthetic: Essays on Postmodern Culture*. New York: New Press, 2002.

___. *The Return of the Real*. Cambridge, MA: MIT Press, 1996.

Foulkes, Nick. *The Last of the Dandies: The Scandalous Life and Escapades of Count d'Orsay*. London: Thomas Dunne Books, 2005.

___. *The Trench Book*. Paris: Assouline, 2007.

Gaines, Steven. *Halston: The Untold Story*. New York: G. P. Putnam's Sons, 1991.

Galbraith, John Kenneth. *The Affluent Society*. Boston: Mariner Books, 1998.

Gan, Stephen. *Visionaire's Fashion 2000: Designers at the Turn of the Century*. London: Thames & Hudson, 1998.

___. *Visionaire's Fashion 2001: Designers of the New Avant-Garde*. London: Lawrence King Publications, 1999.

Giedion, Sigfried. *The Eternal Present: The Beginnings of Architecture*. Princeton, NJ: Princeton University Press, 1964.

Gingeras, Alison M. *Guy Bourdin*. London: Phaidon, 2006.

Godbold, Brad. "The Chain Store Challenge." In *The Fashion Business: Theory, Practice, Image*, edited by Nicola White and Ian Griffiths, 103–17. Oxford: Berg, 2000.

Golbin, Pamela, and Fabien Baron. *Balenciaga Paris*. London: Thames & Hudson, 2006.

Goldberger, Paul. *Frank Stella: Painting into Architecture*. New York: Metropolitan Museum of Art, 2007.

Greslari, Giuliano. *Le Corbusier viaggio in Orient*. Venice: Marsilio Editori, 1984.

Gropius, Walter. *The New Architecture and the Bauhaus*. Trans. P. Morton Shand. London: Faber and Faber, 1935.

Gross, Elaine, and Fred Rottman. *Halston: An American Original*. New York: HarperCollins, 1999.

Guilbaut, Serge, ed. *Reconstructing Modernism: Art in New York, Paris, and Montreal, 1945–1964*. Cambridge: MIT Press, 1990.

Gundle, Stephen. *Glamour: A History*. Oxford University Press, 2008.

Hall-Duncan, Nancy. *The History of Fashion Photography*. London: Alpine Fine Arts Collection, 1979.

Haraway, Donna J. *Simians, Cyborgs and Women: The Reinvention of Nature*. New York: Routledge, 1990.

Harrison, Martin. *Appearances: Fashion Photography Since 1945*. New York: Rizzoli, 1991.

___. *David Bailey: Archive One, 1957–1969*. London: Thames & Hudson, 1999.

___. *Fashion Faces Up: Photographs and Essays from the World of Fashion*. London: Steidl, 1999.

___. *Outside Fashion: Style and Subversion*. New York: Howard Greenberg Gallery, 1994.

___, ed. *David Bailey: Locations, the 1970s Archive*. New York: Thames & Hudson, 2003.

Haskell, Barbara. *Blam! The Explosion of Pop, Minimalism, and Performance, 1958–1964*. New York: W. W. Norton & Co., 1985.

Heiting, Manfred, ed. *Helmut Newton: Work*. London: Taschen, 2000.

Hillman, David, Harri Peccinotti, and David Gibbs. *Nova, 1965–1975*. London: Trafalgar Square, 1994.

Hirai, Noriko. *Japanese Folk Textiles*. Tokyo: Books Nippan, 1989.

Hobbs, Robert. *Robert Smithson: Sculpture*. Ithaca, NY: Cornell University Press, 1981.

Hodge, Brooke, Patricia Mears, and Susan Sidlaukus. *Skin + Bones: Parallel Practices in Fashion and Architecture*. London: Thames & Hudson, 2006.

Holborn, Mark. *Hiro: Photographs*. Boston: Little Brown & Co., 1999.

Hollander, Anne. *Seeing through Clothes*. New York: Viking Press, 1978.

___. *Sex and Suits: The Evolution of Modern Dress*. New York: Knopf, 1994.

Iribe, Paul. *Défense du luxe*. Montrouge: Draeger Frères, 1932.

Jackson, Lesley. *The Sixties: Decade of Design Revolution*. London: Phaidon, 1998.

Jeanneret, Charles-Édouard (Le Corbusier). *L'art decoratif d'aujourd'hui*. Paris: Éditions G. Crès et Cie, 1925.

Jones, Terry, and Tricia Jones. *Smile i-D: Fashion and Style: The Best from 20 Years of i-D*. London: Taschen, 2001.

Kaprow, Alan. *Essays on the Blurring of Art and Life*. San Francisco: University of California Press, 1993.

Kawamura, Yuniya. *The Japanese Revolution in Paris Fashion*. New York: Berg, 2004.

Khan, Nathalie. "Catwalk Politics." In *Fashion Cultures: Theories, Explorations, and Analysis*, edited by Stella Bruzzi and Pamela Church-Gibson, 114–27. New York: Routledge, 2000.

Kidwell, Claudia, and Valerie Steele. *Men and Women: Dressing the Part*. Washington, DC: Smithsonian Institution Press, 1989.

Kismaric, Susan, and Eva Respini. *Fashioning Fiction in Photography Since 1990*. New York: Museum of Modern Art, 2004.

Koda, Harold, Andrew Bolton, and Nancy J. Troy. *Poiret: King of Fashion*. New York: Metropolitan Museum of Art, 2007.

Koenig, Rene, and Tom Wolfe. *The Restless Image: A Sociology of Fashion*. London: George Allen and Unwin, 1973.

Koren, Leonard. *New Fashion Japan*. New York: Kodansha International, 1984.

Krauss, Rosalind E. *The Originality of the Avant-Garde and Other Modernist Myths*. Cambridge, MA: MIT Press, 1986.

Kuhn, Annette. *The Power of the Image: Essays on Representation and Sexuality*. New York: Routledge, 1985.

Kusama, Yayoi. *Obliteration Manifesto*. New York: Gagosian, 1960.

Kuspit, Donald. "Material as Sculptural Metaphor." In *Individuals: A Selected History of Contemporary Art, 1945–1986*, edited by Howard Singerman, 106–25. New York: Abbeville Press, 1986.

Lawson, Thomas. "The Future Is Certain." In *Individuals: A Selected History of Contemporary Art, 1945–1986*, edited by Howard Singerman, 292–313. New York: Abbeville Press, 1986.

Linker, Kate. "Abstraction: Form as Meaning." In *Individuals: A Selected History of Contemporary Art, 1945–1986*, edited by Howard Singerman, 30–59. New York: Abbeville Press, 1986.

Lipovetsky, Gilles, et al. *Chic Clicks: Creativity and Commerce in Contemporary Fashion Photography*. Hatje Cantz Publishers, 2002.

Loeb, Charlotte I., and Arthur L. Loeb, trans. *De Stijl: The Formative Years, 1917–1922*. Cambridge, MA: MIT Press, 1982.

Loock, Ulrich, ed. *The 80s: A Topology*. Porto, Portugal: Fundaçao de Serralves, 2006.

Loos, Adolf. "Ornament und Verbrechen," 1908 ("Ornament and Crime"), in *The Architecture of Adolf Loos*, edited by Wilfred Wang, 100–103. London: Arts Council, 1985.

Lucie-Smith, Edward. *Late Modern: The Visual Arts Since 1945*. New York: Prager Publishers, 1969.

Maffesoli, Michel. *The Time of the Tribes: The Decline of Individualism in Mass Society*. London: Sage, 1996.

Marsh, Lisa. *The House of Klein: Fashion, Controversy, and a Business Obsession*. New York: Wiley, 2003.

Martin, Richard. *Fashion and Surrealism*. New York: Rizzoli, 1990.

Martin, Richard, and Harold Koda. *Bare Witness*. New York: Metropolitan Museum of Art, 1996.

___. *Infra-Apparel*. New York: Metropolitan Museum of Art, 1993.

McShine, Kynaston. *Andy Warhol: A Retrospective*. New York: Museum of Modern Art, 1989.

Meyer, James. *Minimalism*. London: Phaidon, 2000.

___. *Minimalism: Art and Polemics in the Sixties*. New Haven, CT: Yale University Press, 2001.

Milbank, Caroline Rennolds. *New York Fashion: The Evolution of American Style*. New York: Harry N. Abrams, 1989.

Miller, Dorothy C. *Sixteen Americans: De Feo, Hedrick, Jarvaise, Johns, Kelly, Leslie, Lewitin, Lytle, Mallary, Nevelson, Rauschenberg, Schmidt, Stankiewicz, Stella, Urban and Youngerman*. New York: Museum of Modern Art, 1959.

Mirabella, Grace. *Geoffrey Beene Unbound*. New York: Geoffrey Beene Inc., 1994.

Mitchell, Louise. *The Cutting Edge: Fashion from Japan*. Sydney: Powerhouse Publishing in conjunction with Kyoto Costume Institute, 2005.

Miyake, Issey. *East Meets West*. Tokyo: Heibonsha, 1978.

Moffitt, Peggy, and William Claxton. *The Rudi Gernreich Book*. London: Taschen, 1999.

Montebello, Joseph. *Halston: An American Original*. New York: HarperCollins, 1999.

Newton, Helmut, and Carol Squiers. *Helmut Newton: Portraits*. Munich: Schirmer Art Books, 1990.

Newton, Stella Mary. *Health, Art and Reason*. London: John Murray, 1974.

O'Doherty, Brian, and Thomas McEvilley. *Inside The White Cube: The Ideology of the Gallery Space*. San Francisco: University of California Press, 1986.

Ottinger, Didier, ed. *Futurism*. Milan: 5 Continents Editions, 2009.

Ozenfant, Amédée. *Mémoires, 1886–1962*. Paris: Seghers, 1968.

___. *Foundations of Modern Art*. New York: Brewer, Warren and Putnam, 1931.

Palmer, Alexandra. *Couture & Commerce: The Transatlantic Fashion Trade in the 1950s*. Vancouver: University of British Columbia Press, 2001.

Parkin, Molly. *Moll: Making of Molly Parkin—An Autobiography*. London: Gollancz, 1993.

Patton, Phil. *Made in the U.S.A.: The Secret Histories of the Things That Made America*. New York: Penguin, 1993.

Pawson, John. *Minimum*. London: Phaidon, 1997.

Polhemus, Ted, and Bradley Quinn. *Hussein Chalayan*. Amsterdam: NAi Publishers in conjunction with the Groninger Museum, 2005.

Porter, Catherine, trans. *The Empire of Fashion: Dressing Modern Democracy* by Gilles Lipovetsky. Princeton, NJ: Princeton University Press, 2002.

Quinn, Bradley. *The Fashion of Architecture*. Oxford: Berg, 2004.

Radner, Hilary. "Embodying the Single Girl in the 1960s." In *Body Dressing*, edited by Joanne Entwistle and Elizabeth Wilson, 183–99. Oxford: Berg, 2001.

Rantisi, Norma. "How New York Stole Modern Fashion." In *Fashion's World Cities*, edited by Christopher Breward and David Gilbert, 109–22. Oxford: Berg, 2006.

Richards, J. M. *An Introduction to Modern Architecture*. Harmondsworth, U.K.: Penguin Books, 1940.

Ritts, Herb. *Herb Ritts: Work*. New York: Bulfinch Press, 1996.

Saint-Exupéry, Antoine de. *Terre des hommes*. Paris: Gallimard, 1939.

Sanders, Mark, Phil Poynter, and Robin Derrick. *The Impossible Image: Fashion Photography in the Digital Age*. London: Phaidon, 2000.

Scavullo, Francesco. *Scavullo: Francesco Scavullo Photographs: 1948–1984*. New York: HarperCollins, 1984.

Sennett, Richard. *The Fall of Public Man*. New York: W. W. Norton & Co., 1988.

Serra, Richard. "About Drawing" (1977). In *Richard Serra: Interview, 1970–1980*, edited by Clara Weyergraf, 77. Yonkers, NY: Hudson River Museum, 1980.

Showater, Elaine. *Sexual Anarchy, Gender, and Culture at the Fin de Siècle*. London: Virago, 1992.

Sidlauskas, Susan, ed. *Intimate Architecture: Contemporary Clothing Design*. Cambridge: MIT Committee on the Visual Arts, 1982.

Sieff, Jeanloup. *Jeanloup Sieff, 1950–1990: Time Will Pass Like Rain*. London: Taschen, 1997.

Singerman, Howard, ed. *Individuals: A Selected History of Contemporary Art, 1945–1986*. New York: Abbeville Press, 1986.

Smedley, Elliott. "Escaping to Reality: Fashion Photography in the 1990s." In *Fashion Cultures: Theories, Explorations, and Analysis*, edited by Stella Bruzzi and Pamela Church-Gibson, 143–56. New York: Routledge, 2000.

Sontag, Susan. *On Photography*. New York: Picador, 1977.

Sozzani, Carla, and Yamamoto, Yohji, eds. *Talking to Myself*. Milan: Carla Sozzani Editore; Tokyo: Yohji Yamamoto; and Göttingen: Steidl, 2002.

Sparke, Penny, and Paola Antonelli. *Modern Japanese Design*. New York: Museum of Modern Art, 1987.

Strickland, Edward. *Minimalism: Origins*. Bloomington: Indiana University Press, 2000.

Sudjic, Deyan. *Rei Kawakubo and Comme des Garçons*. New York: Rizzoli, 1990.

Sweetman, Paul. "Shop-Window Dummies? Fashion, the Body, and Emergent Socialities." In *Body Dressing*, edited by Joanne Entwistle and Elizabeth Wilson, 59–77. Oxford: Berg, 2001.

Taylor, Lou. "The Hilfiger Factor and the Flexible Commercial World of Couture." In *The Fashion Business: Theory, Practice, Image*, edited by Nicola White and Ian Griffiths, 121–42. Oxford: Berg, 2000.

Terraroli, Valerio, et al. *The Avant-Garde Movements, 1900–1919: Art of the Twentieth Century*. Milan: Skira, 2006.

Thomas, Dana. *Deluxe: How Luxury Lost Its Luster*. New York: Penguin, 2007.

Troy, Nancy J. *Couture Culture: A Study in Modern Art and Fashion*. Cambridge, MA: MIT Press, 2004.

Tupitsyn, Margarita, ed. *Rodchenko & Popova: Defining Constructivism*. London: Tate Publishing, 2009

Veblen, Thorstein. *The Theory of the Leisure Class: An Economic Study in the Evolution of Institutions*. New York: Macmillan, 1899.

Vinken, Barbara. *Fashion Zeitgeist: Trends and Cycles in the Fashion System*. Oxford: Berg, 2005.

Viscusi, Robert. *Max Beerbohm, or the Dandy Dante, Rereading with Mirrors*. Baltimore, MD: Johns Hopkins University Press, 1986.

Wagstaff, Samuel. *Black, White and Gray*. Exhibition notes. Hartford, CT: Wadsworth Atheneum, 1964.

Wakefield, Neville, and Camilla Nickerson. *Fashion Photography of the Nineties*. Zurich: Scalo, 1996.

Warhol, Andy, and Pat Hackett. *POPism: The Warhol Sixties*. Fort Washington, PA: Harvest Books, 2006.

White, Nicola, and Ian Griffiths. *The Fashion Business: Theory, Practice, Image*. Oxford: Berg, 2000.

Wigley, Mark. *White Walls, Designer Dresses: The Fashioning of Modern Architecture*. Cambridge, MA: MIT Press, 1995.

Wilcox, Claire. *Radical Fashion*. London: V & A Publications, 2001.

Wilson, Elizabeth. *Adorned in Dreams: Fashion and Modernity*. Berkeley: University of California Press, 1985.

Wosk, Julie. *Breaking Frame: Technology and the Visual Arts in the Nineteenth Century*. New Brunswick, NJ: Rutgers University Press, 1992.

Ypma, Herbert. *London Minimum*. London: Thames and Hudson, 1996.

Zelevansky, Lynn. *Sense and Sensibility: Women Artists and Minimalism in the Nineties*. New York: Museum of Modern Art, 1994.

ILLUSTRATION CREDITS

CHAPTER ONE

Page 17: Photograph: Gösta Peterson, "Lunar Whites," *Harper's Bazaar*, August 1966: dress by Georgia Bullock and hat by Mr. John. © Gösta Peterson. **Page 18:** Photograph: Richard Avedon, Dovima, dress by Pauline Trigère, Cape Canaveral, Florida, November 1959. © 2010 The Richard Avedon Foundation. **Page 22:** Collage design for a window display: Liubov Popova; Summer 1924. Photograph courtesy of Galerie Gmurzynska, Zurich. **Page 23:** Photograph: Guy Bourdin, French *Vogue*, July 1966. © Estate of Guy Bourdin/Art + Commerce. **Page 24:** Bathing costume: Sonia Delaunay, 1920s. Photograph courtesy of Luigi Diaz/Getty Images. **Page 25:** Photograph: James Moore, "High Gear," *Harper's Bazaar*, August 1966: ensemble by Robert Sloan and helmet by Paco Rabanne. © James Moore. **Page 26, top:** Photograph: James Moore, "See Paris," *Harper's Bazaar*, March 1966: ensembles by Yves Saint Laurent. © James Moore. **Page 26, bottom:** Drawing: Sol LeWitt, *Wall Drawing*, 1960. © 2010 The LeWitt Estate/Artists' Rights Society (ARS), New York; Photograph © David Lees/CORBIS. **Page 28:** Lithograph, Sheet: Frank Stella (b. 1936), *Tuxedo Park*, 1967, Black Series II. 15 × 21 7/8 inches (38.1 × 55.6cm); Image: 13 3/8 × 8 inches (34 × 20.3cm); Whitney Museum of American Art, New York; Purchase, with funds from Mr. and Mrs. William A. Marsteller 86.8.1. Photography by Geoffrey Clements. © 2010 Frank Stella/Artists Rights Society (ARS), New York. **Page 29:** Photograph: David Bailey, *Queen*, February 1964 (unpublished). Photo David Bailey. **Page 30, left:** Collage on paper: Ellsworth Kelly, *Untitled*, 1960. 10 3/4 × 6 inches (27.3 × 15.2cm); EK D 60.15. © Ellsworth Kelly. **Page 30, right:** Photograph: Edward Steichen; dress by Madeleine Vionnet, *Vogue*, June 1, 1925. Photograph courtesy of Steichen/Condé Nast Archive. Copyright © Condé Nast. **Page 33:** Box: Donald Judd, *Untitled (DSS#41)*,1963. Light cadmium red oil on wood; 19 1/2 × 45 × 30 1/2 inches; collection of Judd Foundation. Art © Judd Foundation. Licensed by VAGA, New York, NY. **Page 34:** Photograph: David Bailey, "Marvels of Form," *Vogue*, July 1967: "Bride" gown by Cristóbal Balenciaga. Photo David Bailey, American *Vogue*. **Page 35, top:** Sculpture: Sol LeWitt, *Complex Form #46*, 1989. Painted wood; 40 × 40 × 80 inches. © 2010 The LeWitt Estate/Artists' Rights Society (ARS), New York; photograph courtesy of Konrad Fischer Galerie, Dusseldorf. **Page 35, bottom:** Chair: Vernor Panton, Panton Chair, 1960. © Panton Office/Foto Hans Hansen. **Page 36:** Dress: Pierre Cardin, 1969. © Christian Simonpietri/Sygma/CORBIS. **Page 37:** Photograph: James Moore, cover for *Harper's Bazaar*, May 1964. © James Moore. **Page 38:** Photographs: Gösta Peterson, "One Minute from Now," *Harper's Bazaar*, May 1966: (left) dress by Oscar de la Renta; (right) dress by John Moore. © Gösta Peterson. **Page 40:** Suit: Yves Saint Laurent, 1967. Photograph courtesy of Reg Lancaster/Getty Images. **Page 41:** Photograph: Brian Duffy; Ursula Andress in a hat by James Wedge; British *Vogue*, April 1966 (unpublished). Brian Duffy/*Vogue* © The Condé Nast Publications Ltd.

CHAPTER TWO

Pages 45 and 46: Model Katharina Sarnitz in the CM Boutique by architect Hans Hollein, 1968. Photograph courtesy of Imagno/Getty Images. **Page 49:** Photograph: David Bailey, "Young Idea Goes West," *Vogue*, April 1962. Photo David Bailey, British *Vogue*. **Page 51:** Photograph: Jerry Schatzberg, 1964; ensemble by Rudi Gernreich, Fall 1964. Photograph by Jerry Schatzberg. **Page 52:** Photograph: David Bailey, "Cape Courrèges," *Vogue*, March 1965: ensemble by André Courrèges. Photo David Bailey, American *Vogue*. **Page 53:** Installation: Carl Andre, *Fall*, 1968, New York. Hot-rolled steel, 21 units; 6 × 28 × 6 feet (1.8 × 0.7 × 1.8m) each, 6 × 49 × 6 feet (1.8 × 14.9 × 1.8m) overall; Solomon R. Guggenheim Museum, New York; Panza Collection, 1991; 91.3670. Art © Carl Andre/Licensed by VAGA, New York, NY; Photograph by David Heald © The Solomon R. Guggenheim Foundation, New York. **Page 54, left:** Photograph: William Klein; suit by Pierre Balmain, *Vogue*, March 1963. © William Klein. **Page 54, right:** Dress: Balenciaga, 1962; worn by Jennifer Connelly, French *Vogue* June/July 2006. Patrick Demarchelier © *Vogue* Paris. **Page 55:** Photograph: Reconstitution of the 1926 "Ford" dress by CHANEL, photographed by Karl Lagerfeld. © CHANEL/Photo Karl Lagerfeld. **Page 56, top:** Object: Dan Flavin, *Icon V (Coran's Broadway Flesh)*, 1962 © 2010 Stephen Flavin/Artists' Rights Society (ARS), New York.

Page 56, bottom: Photograph: Hiro, "Look," extracted from *Harper's Bazaar*, April 1966 © HIRO. **Page 58, left:** Ensemble: Helmut Lang, Spring/Summer 2004. Photograph © MCV Photo. **Page 58, right:** Dress ensemble: Rei Kawakubo for Comme des Garçons, Spring/Summer 2008. Photograph © MCV Photo. **Page 59:** Object: Claes Oldenburg (b. 1929), *Braselette*, 1961. Muslin, plaster, chicken wire, and enamel; Overall: 41 × 30 1/4 × 4 inches (104.1 × 76.8 × 10.2cm); Whitney Museum of American Art, New York; Gift of Howard and Jean Lipman 91.34.5; Photography by Geoffrey Clements © Claes Oldenburg. **Page 60:** Paper dress: Bob Dylan print, 1969. Photo David Bailey. **Page 61:** Silkscreen: Andy Warhol, *Triple Elvis*, 1962. © 2010 The Andy Warhol Foundation for the Visual Arts, Inc./Artists' Rights Society (ARS), New York. **Page 63, left:** Installation: Robert Morris, *Nine Fiberglass Sleeves*, 1967. Fiberglass; 48 1/16 × 24 × 24 inches; 122 × 61 × 61cm. Courtesy Sonnabend Collection. © 2010 Robert Morris/Artists' Rights Society (ARS), New York. **Page 63, right:** Installation: Donald Judd, *Untitled (Stack)*, 1967. Lacquer on galvanized iron, twelve units; each 9 × 40 × 31 inches (22.8 × 101.6 × 8.7cm); installed vertically with 9-inch (22.8cm) intervals; Helen Acheson Bequest (by exchange) and Gift of Joseph Helman; The Museum of Modern Art, U.S.A. Art © Judd Foundation. Licensed by VAGA, New York, NY; Digital image © The Museum of Modern Art/Licensed by SCALA/Art Resource, NY. **Page 64, top:** Advertisement: Costume National, Spring/Summer 1988. Photograph courtesy of Costume National. **Page 64, center:** Photograph: Dancers from the musical *The Dairymaids*, 1906. Photograph courtesy of Hulton Archive/Getty Images. **Page 64, bottom:** Photograph: Guy Bourdin, mid-1960s (unpublished). © Estate of Guy Bourdin/Art + Commerce. **Pages 66–67:** Runway presentation: Hussein Chalayan, Panoramic collection, Fall/Winter 1998–99. Photograph © Chris Moore. **Page 69, top:** Object: Sol LeWitt, *Muybridge I*, 1964. Art © 2010 The LeWitt Estate/Artists' Rights Society (ARS), New York. **Page 69, bottom:** Photographs: Eleanor Antin, *Carving: A Traditional Sculpture*, 1973. Installation View; 148 black-and-white photographs and text; 7 × 5 inches each; Collection of the Art Institute of Chicago. Photograph courtesy of Ronald Feldman Fine Arts, New York.

CHAPTER THREE

Page 73: Bodysuit: Olivier Theyskens, Fall/Winter 1998–99. Photograph courtesy of Olivier Theyskens and Les Cyclopes. **Page 74:** Ensemble: Rei Kawakubo for Comme des Garçons, Spring/Summer 1997. © MCV Photo. **Page 76:** Drawing: Terry Winters, *Untitled*, 1989. Graphite on paper; 12 5/8 × 9 1/2 inches; Collection of Sally and Wynn Kramarsky, New York. Photograph courtesy of the Hood Museum © Terry Winters. **Page 77:** Bodice: Yohji Yamamoto, Fall/Winter 2006-7. © MCV Photo. **Page 78:** *Plastic Body*: Issey Miyake, Body Series, Fall/Winter 1980–81. Fiberglass, synthetic flock lining; 38.5 × 33 × 18.0cm; National Gallery of Australia, Canberra, purchased in 2000. Photograph courtesy of the National Gallery of Australia © The Issey Miyake Foundation. **Page 79:** Dress: Alexander McQueen, Spring/Summer 2007. © MCV Photo. **Page 80, left:** Runway presentation: Issey Miyake, A-POC *Le Feu* finale of Issey Miyake Paris Collection, Spring/Summer 1999. © MCV Photo. **Page 80, right:** Ensemble: Issey Miyake, A-POC *King and Queen* Issey Miyake Paris Collection, Spring/Summer 1999. © MCV Photo. **Page 82, top:** Collage: Michael Roberts, *Sunday Times*, March 1990; "Sphinx" dress by Azzedine Alaïa, 1988. © Michael Roberts/Maconochie Photography. **Page 82, bottom:** Photograph: Alasdair McLellan, "Are You Calling Me Alaïa?" *T Style Magazine*, July 2009: Azzedine Alaïa leather bra and Stella McCartney pink bodysuit, both Fall/Winter 2009–10. © Alasdair McLellan. **Page 83, top:** Photograph: Guzman; jumpsuit with "harness" by Geoffrey Beene, Fall/Winter 1990–91. Photograph courtesy of Geoffrey Beene and Guzman Studio. **Page 83, bottom:** Sculpture: Richard Serra, *House of Cards (One Ton Prop)*, 1969. Lead antimony, four plates, each 48 × 48 × 1 inch (122 × 122 × 2.5cm); The Museum of Modern Art, New York; Gift of the Grinstein Family. © 2010 Richard Serra/Artists' Rights Society (ARS), New York; Digital image © The Museum of Modern Art/Licensed by SCALA/Art Resource, NY. **Pages 84 and 85:** Dress (flat and assembled): Issey Miyake, "Colombe," Spring/Summer 1991. Photograph courtesy of Raymond Meier/trunkarchive.com. **Page 86:** Ensemble: Shamask, jacket by Ronaldus Shamask and sash by Jeffrey Aronoff

for Shamask, Spring/Summer 1981. Photograph courtesy of Murray Moss and Hayden Gallery, MIT. **Page 87:** Dress: Issey Miyake, modeled by Grace Jones, 1994. © Douglas Kirkland/CORBIS. **Page 88:** Photograph: Francesco Scavullo, *Agneta Darin and Paul Craffey, fashion photograph, Southampton, New York, 1966.* Photograph courtesy of Francesco Scavullo /Motion Picture Group, Inc. **Page 89:** Fashion plate: Eduardo Garcia Benito, "L'heure du thé," *La Gazette du bon ton,* 1920. Photograph courtesy of Pratt Institute Libraries—Fashion Plate Collection. **Page 90, top:** Ensemble: Naoki Takizawa for Issey Miyake, Fall/Winter 2000–1. © MCV Photo. **Page 90, bottom:** Dress: Hussein Chalayan, Before Minus Now collection, Spring/Summer 2000. © MCV Photo. **Page 91:** Advertisement: B. H. Wragge, Spring 1964. Photograph courtesy of Sara Wragge and the Sidney and Phyllis Wragge Foundation. **Page 92:** Photograph: Herb Ritts, *Georgina, Back View,* 1996. Photograph courtesy of Herb Ritts/Lime Foto. **Page 93:** Photograph: Guy Bourdin for French *Vogue,* May 1975. © Estate of Guy Bourdin/Art + Commerce. **Page 94:** Photograph: Nathaniel Goldberg, "L'Ombre," *Numéro,* October 2001; cape by Yohji Yamamoto, Fall/Winter 2001–2. © Nathaniel Goldberg /Art + Commerce. **Page 95, clockwise from top left:** Photograph: Nathaniel Goldberg, "L'Ombre," *Numéro,* October 2001. Jacket by Prada, Fall/Winter 2001–2. © Nathaniel Goldberg /Art + Commerce. Photograph: Peter Lindbergh; ensemble by Rei Kawakubo for Comme des Garçons, Fall/Winter 1984–85. Photograph courtesy of Comme des Garçons © Peter Lindbergh. Illustration: Mats Gustafson, *Vogue Italia,* 1997. Silhouette by Rei Kawakubo for Comme des Garçons. © Mats Gustafson/Art + Commerce. **Page 96:** Installation: Dan Flavin, *the nominal three (to William of Ockham),* 1964–69. © 2010 Stephen Flavin /Artists' Rights Society (ARS), New York. **Page 97:** Bodice: Sophia Kokosalaki, Fall/Winter 2002–3. © Nathaniel Goldberg /Art + Commerce. **Page 99:** Silkscreen: Allen Jones, *Cut-A-Way,* 1976. © Allen Jones.

EXPOSITION

Page 103: Dress (detail): Martin Margiela, Fall/Winter 2003–4. Photograph by Bob Verhelst, courtesy of ModeMuseum, Antwerp. **Page 108:** Bodice: Martin Margiela, Fall/Winter 1997–8. Photograph by Ronald Stoops, courtesy of Maison Martin Margiela. **Page 109:** Sculpture: Richard Serra, steel scrap sculpture for LACMA Art and Technology Project, 1969. © 2010 Richard Serra/Artists' Rights Society (ARS), New York. Photograph © Malcolm Lubliner/CORBIS. **Page 110, left and right:** Ensembles: Helmut Lang, Spring/Summer 2003. © MCV Photo. **Page 111:** Sculpture: Sol LeWitt, American (1928–2007), *Incomplete Open Cube* 7/18, 1974. Painted aluminum, 42 × 42 × 42 inches; Museum Purchase with Membership Art Acquisition Funds, 1976.3; Collection University of Virginia Art Museum. © 2010 The LeWitt Estate/Artists' Rights Society (ARS), New York. **Page 112:** Ensemble: Rudi Gernreich, Fall 1964. Photograph by William Claxton/ Courtesy Demont Photo Management, LLC. **Page 113, top:** Dress ensemble: Miu Miu, Spring/Summer 1997. © MCV Photo. **Page 113, bottom:** Trenchcoat: Prada, Fall/Winter 2002–3. © MCV Photo. **Pages 114–115:** Slip dress ensemble (front and back views): Prada, Spring/Summer 1997. © MCV Photo. **Pages 116–117:** Ensembles: Hussein Chalayan, Geotropics collection, Spring/Summer 1999. Photographic image by Marcus Tomlinson. **Page 118:** Installation: Mona Hatoum, *Short Space,* 1992. Nine bed spring meshes, pulley system, and three motors; 70 7/8 (×9) × 142 1/2 × 84 5/8 inches (180 (×9) × 362 × 215cm). © the artist; Photograph Florian Kleinefenn, Courtesy Galerie Chantal Crousel.

CHAPTER FOUR

Pages 123–124: Advertisements: Calvin Klein collection, featuring Christy Turlington, Spring/Summer 1991. Photograph © Bruce Weber. **Page 127, top:** Installation: Andy Warhol, *Silver Clouds,* 1966. Silver mylar balloons, helium; installed at the University Art Museum, Long Beach, CSULB, 1997; courtesy of the Andy Warhol Museum, Pittsburgh, PA. © 2010 The Andy Warhol Foundation for the Visual Arts, Inc./Artists' Rights Society (ARS), New York; Photograph courtesy of the University Art Museum, CSULB. **Page 127, bottom:** Installation: Rachel Lachowicz, *Coma,* 1991. Collection of Bil and Ruth Ehrlich. Photograph courtesy of Shoshana Wayne Gallery. **Page 128:** Photograph: Richard Avedon,

Janice Dickinson, blouse and pants by Issey Miyake, New York, April 1977. © 2010 The Richard Avedon Foundation. **Page 130:** Ensemble: Rudi Gernreich, Resort 1971. Photograph by William Claxton/Courtesy Demont Photo Management, LLC. **Page 132, top:** Photograph: William Klein; Dorothea McGowan wearing a Chanel tweed suit from the 1960 Fall/Winter Haute Couture Collection, *Vogue,* October 15, 1960 and French *Vogue,* October 1960. © William Klein. **Page 132, bottom:** Drawing: Richard Neutra; S. Pauls, Bank Holy Day, London, August 4, 1920. Crayon on paper; 24 × 17.5cm. Permission courtesy Dion Neutra, Architect © and Richard and Dion Neutra Papers, Department of Special Collections, Charles E. Young Research Library, UCLA. **Page 133:** Photograph: Mert Alas and Marcus Piggott, "Boy Kate," *Vanity Fair,* September 2006: featuring Kate Moss in an ensemble by John Galliano for Christian Dior, Fall/Winter 2006–7. © Mert Alas and Marcus Piggott. **Page 135, left:** Photograph: Jean-Paul Goude, *Blue-black in Black on Brown,* 1981. Photograph courtesy of Jean-Paul Goude. **Page 135, right:** Jacket: Giorgio Armani, Fall/ Winter 1996–97; Stella Tennant photographed by Paolo Roversi, Italian *Vogue,* December 1996. Photograph courtesy of Paolo Roversi. **Page 136:** Suit: Giorgio Armani, Spring/Summer 1988. Photographed by Marianne Chemetov, Italian *Vogue,* July 1988. Photograph courtesy of *Vogue Italia.* **Page 137:** Photograph: Deborah Turbeville; ensembles by Jean-Louis Scherrer, Stephen Burrows, André Courrèges, and Emanuel Ungaro, *Vogue,* May 1975. Photograph by Deborah Turbeville /Courtesy Staley-Wise Gallery, New York. **Page 139, top:** Advertisement: The Gap, featuring Veruschka (Countess Vera von Lehndorff), 1989. Photograph by Herb Ritts /Lime Foto. **Page 139, bottom:** Advertisement: CK Jeans; featuring Jamie Dornan and Kate Moss, Fall/Winter 2006–7. Photograph © Mert Alas and Marcus Piggott. **Page 140:** Armchair: Tokujin Yoshioka, *Honey-Pop Chair,* 2000. © Tokujin Yoshioka. **Page 141:** Advertisement: Prada, Spring/Summer 1989. Photograph by Albert Watson. **Pages 142–143:** Photograph: Andreas Gursky, *Untitled IX,* 1998. © 2010 Andreas Gursky/Artists' Rights Society (ARS), New York/VG Bild-Kunst, Bonn. **Page 144:** Sculpture: Tom Sachs, *Prada Toilet,* 1997; cardboard, thermal adhesive 28 × 29 × 22 inches. Photograph courtesy of Tom Sachs. **Page 147, left:** Runway presentation: Calvin Klein, Spring/Summer 1997. © MCV Photo. **Page 147, right:** Slip dress: Marc Jacobs, Fall/Winter 1996–97. © MCV Photo. **Page 148:** Photograph: Corinne Day; featuring Linda Evangelista in a slip dress, British *Vogue,* 1993. © Corinne Day/Maconochie Photography. **Page 149:** Object: Dan Flavin and Sonja Flavin, *The Barbara Roses 3D,* 1962–65. American (Dan, 1933–1997) (Sonja, 1936–); white glazed terracotta flower pot, porcelain light fixture with pull chain containing an Aeroflux Flowerlite light bulb; overall: 8 1/4 × 4 3/4 × 4 3/4 inches; 20.995 × 12.065 × 12.065cm; Smith College Museum of Art, Northampton, Massachusetts; Gift of Philip C. Johnson; SC-1975:36-4. © 2010 Stephen Flavin/Artists' Rights Society (ARS), New York; Photograph courtesy of Smith College Museum of Art, Northampton, Massachusetts. **Page 150:** Photograph: Deborah Turbeville, "American Movers," *Vogue,* February 1975: Halston, Elsa Peretti, and Betsy Theodoracopulos in ensembles by Halston. Photograph by Deborah Turbeville/Courtesy Staley-Wise Gallery, New York. **Page 151:** Photograph: Deborah Turbeville, *Bath House, New York, Vogue,* 1975. Photograph by Deborah Turbeville/Courtesy Staley-Wise Gallery, New York.

CHAPTER FIVE

Page 155: Photographs: Bernd and Hilla Becher, *Water Towers,* 1980. Nine gelatin silver prints; Approx. 61 1/4 × 49 1/4 inches (155.6 x 125.1cm) overall; Solomon R. Guggenheim Museum, New York; Purchased with funds contributed by Mr. and Mrs. Donald Jonas, 1981. Photograph courtesy of Sonnabend Collection. **Page 156:** Photograph: Nan Goldin, *Rebecca at Russian Baths, NYC,* 1985. © Nan Goldin Studio. **Page 159:** Advertisement: Marc Jacobs; featuring Winona Ryder, Spring/Summer 2003. Photography by Juergen Teller. **Page 160, left:** Advertisement: Jil Sander, Fall/Winter 1995–96. © Craig McDean/Art + Commerce. **Page 160, right:** Photograph: Eugène Atget, *Magasin, Avenue de Golbins,* 1925. Gelatin silver printing-out-paper print; 8 1/4 × 6 1/2 inches (21 × 16.7cm); Abbott-Levy Collection; Partial gift of Shirley C. Burden; Museum of Modern Art, New York, NY, U.S.A. Digital image © The Museum of Modern Art/Licensed by SCALA/Art

Resource, NY. **Page 162:** Photograph: Deborah Turbeville, "American Movers," *Vogue*, February 1975: ensembles by Jean Muir. Photograph by Deborah Turbeville/ Courtesy Staley-Wise Gallery, New York. **Pages 164–165:** Photograph: Kayt Jones; featuring Raf Simons, *i-D*, October 1998. Photography courtesy of Kayt Jones/Trish South Management/trunkarchive.com. **Page 166:** Photograph: Philip-Lorca diCorcia, "A Perfect World," *W*, September 1999. Photograph courtesy of Philip-Lorca diCorcia/TheCollectiveShift™/ trunkarchive.com. **Page 167, top:** Photograph: Mark Steinmetz, *Route 316, Barrow County, Georgia*, 2005. Photograph by Mark Steinmetz. **Page 167, bottom:** Photograph: James Moore; ensembles by Geoffrey Beene, *Harper's Bazaar*, July 1967. © James Moore. **Page 168:** Photograph: Cindy Sherman, *Untitled (#133)*, 1984. Color photograph; 71 ¼ × 47 ½ inches; 180.3 × 119.4cm. Photograph courtesy of the Artist and Metro Pictures. **Page 169:** Photograph: Corinne Day; Sarah M in a sweater by Maison Martin Margiela, *i-D*, January 1993. © Corinne Day/Maconochie Photography. **Page 170, left:** Sculpture: Anthony Caro, *Carriage*, 1966. © Anthony Caro. **Page 170, right:** Ensemble: Helmut Lang, Fall/Winter 1997–98. © MCV Photo. **Page 172:** Photograph: Bob Richardson; featuring Anjelica Huston and Jens Lipp, Italian *Vogue*, May 1972. Courtesy of Terry Richardson; Photograph courtesy of *Vogue Italia*. **Page 173:** Photograph: Corinne Day, "Under Exposure": featuring Kate Moss, British *Vogue*, 1993. © Corinne Day/Maconochie Photography. **Page 174, top:** Photograph: Corinne Day, *Tania*, 1995. © Corinne Day/Maconochie Photography. **Page 174, bottom left:** Sculpture: Rachel Whiteread, *Untitled (Double Amber Bed)*, 1991. Rubber and high density foam; 47 × 54 × 41 in. (119.4 × 137.2 × 104.1cm); Collection of Gail and Tony Ganz, Los Angeles. Photo: Robert Wedemeyer. **Page 174, bottom right:** Plate edition: Damien Hirst, *Home Sweet Home*, 1996 © Damien Hirst. All Rights Reserved /ARS, New York /DACS, London. Courtesy of Gagosian Gallery. Photo by Robert McKeever. **Page 176:** Advertisement (in two parts): Jil Sander, Spring/Summer 2008. Photograph by Willy Vanderperre, courtesy of Jil Sander. **Page 177:** Photograph: Inez van Lamsweerde and Vinoodh Matadin, *The Widow (Black)*, 1997. Photograph courtesy of Inez van Lamsweerde and Vinoodh Matadin/trunkarchive.com. **Page 178, top:** Sculpture: Eva Hesse, *Hang-Up*, 1966. Acrylic paint on cloth over wood; acrylic paint on cord over steel tube; 182.9 × 213.4 × 198.1cm; Through prior gifts of Arthur Keating and Mr. and Mrs. Edward Morris, 1988.130; The Art Institute of Chicago. Photography © The Art Institute of Chicago. **Page 178, bottom:** Sculpture: Roni Horn, *Key and Cue, No. 288*, 1994. I'M NOBODY! WHO ARE YOU?; Solid aluminum and black plastic; 5 × 5 × 130cm/2 × 2 × 51 ⅛ inches. © Roni Horn; Courtesy of the artist and Hauser & Wirth. **Page 179:** Runway presentation: Hussein Chalayan, Ventriloquy collection, Spring/Summer 2001. © MCV Photo. **Page 180:** Photograph: Cindy Sherman, *Untitled (#122)*, 1983. Color photograph; 74 ½ × 45 ¾ inches. Photograph courtesy of the Artist and Metro Pictures. **Page 181:** Advertisement: Calvin Klein Collection; featuring Anna Selezneva, Spring/Summer 2009. Photograph © David Sims.

CHAPTER SIX

Page 185: Photograph: *Primary Structures* exhibition at the Jewish Museum, New York, April 27–June 12, 1966. Background: Tim Scott, *Peach Wheels*, 1962; Painted wood and glass; 48 ×60 × 36 inches; the Waddington Galleries, London; the Jewish Museum, New York, NY, U.S.A. Photograph courtesy of the Jewish Museum, New York/Art Resource, NY. **Page 186:** Dress: Shinichiro Arakawa, Fall/Winter 1999–2000. Collection of the Kyoto Costume Institute; photograph by Takashi Hatekeyama. **Page 188:** Dress: Francisco Costa for Calvin Klein, Fall/ Winter 2010–11. © MCV Photo. **Page 189:** Advertisement: Balenciaga; featuring Jennifer Connelly, Spring/Summer 2008. Photograph © David Sims. **Page 190, top left:** Sculpture: Junya Ishigami, *Balloon*, 2007. © junya.ishigami+associates. **Page 190, top right:** Shoe: Nicholas Kirkwood for Nina Ricci, Fall/Winter 2009–10. Photograph courtesy of Nicholas Kirkwood. **Page 190, bottom:** Photograph: David Sims; jacket by Maison Martin Margiela, Fall/Winter 2007–8, French *Vogue*, September 2007. © David Sims. **Page 192, left:** Runway presentation: Hussein Chalayan, After Words collection, Fall/Winter 2000–1. © MCV Photo. **Page 192, right:** Installation: *Richard Serra: The Substance of Time*, the Guggenheim Museum Bilbao, 2005. © 2010 Richard Serra/Artists' Rights Society (ARS), New

York; Photograph © Jose Simal/epa/CORBIS. **Page 193, top:** Photograph: Clare Prentice; "Black Lowry" dress by Brian Kirkby and Zowie Broach for Boudicca, Invisible City collection, Fall/Winter 2006–7. Photograph courtesy of Clare Prentice, www.clareprentice.co.uk. **Page 193, bottom:** Structure: Fernando Romero and Laboratory of Architecture (LAR), *Chinese Bridging Tea House*, 2004. Photograph courtesy of LAR/Fernando Romero. **Page 194, left:** Photograph: Craig McDean, "Superheroes," *Vogue*, May 2008: dress by Armani Privé. © Craig McDean/Art + Commerce. **Page 194, right:** Object: Ron Arad, *MT3*, 2005. Rotation-molded polyethylene, 30; ¹¹/₁₆ × 31 ½ × 40 ¹⁵/₁₆ inches (78 × 80 × 104cm); Manufactured by Driade, S.p.A., Italy; Gift of the manufacturer; The Museum of Modern Art, New York, NY, U.S.A. Digital image © The Museum of Modern Art/Licensed by SCALA/Art Resource, NY. **Page 196:** Sculptures: Zaha Hadid and Patrik Shumacher, *Aura-L* and *Aura-S*, 2008. © Luke Hayes/VIEW. **Page 197:** Dress (two views): Francisco Costa for Calvin Klein collection, Resort 2008. © MCV Photo. **Page 199, top left:** Flagship boutique: Comme des Garçons, New York; designed by Rei Kawakubo and Takao Kawasaki, with an entrance by Future Systems, 1999. Photograph courtesy of Comme des Garçons. **Page 199, top right:** Flagship boutique: Comme des Garçons, Paris; designed by Shona Kitchen, 2001. Courtesy of Shona Kitchen/Photograph by Todd Eberle. **Page 199, bottom:** Flagship boutique: Calvin Klein, New York; designed by John Pawson, 1995. Courtesy of Calvin Klein/Photograph by James Lattanzio. **Page 200:** Photograph, detail: Inez van Lamsweerde and Vinoodh Matadin, "Art & Commerce," *W*, October 2009: suit by Stefano Pilati for Yves Saint Laurent, Fall/Winter 2009–10; Magdalena Abakanowicz, *Abakan Grand Noir*, 1966–67. Photograph courtesy of Inez van Lamsweerde and Vinoodh Matadin/trunkarchive.com. **Page 201:** Sculpture: Jeff Koons, *Balloon Dog (Yellow)*, 1994–2000. High chromium stainless steel with transparent color coating; 121 ×143 × 45 inches; 307.3 × 363.2 × 114.3cm. © Jeff Koons. **Page 203, clockwise from top left:** Painting: Ellsworth Kelly, *Nine Squares*, 1976–77. Screenprint and lithograph on Rives BFK paper; 40 ½ × 40 ½ inches (102.9 × 102.9cm); Edition of 44; EK AX.164. © Ellsworth Kelly; Painting: Damien Hirst, *Diethylene Glycol*, 2006. Household gloss on canvas; 60 × 76 inches; Photo: Prudence Cuming Associates; Courtesy Gagosian Gallery. © 2010 Damien Hirst. All Rights Reserved/ARS, New York/ DACS, London; Dress: Prada, Spring/Summer 2009. *The Spring/Summer 2009 Look Book: An exploration of the collection's domain of inspiration by AMO: divinity, tribalism and primitive symbolism—graphically represented through the dialogue of references between fashion and imagery.* Photograph by Philip Meech/Courtesy of Prada. **Page 205, clockwise from upper left:** Peter Halley, *Prison*, 2006. 40 × 51 inches; Acrylic, Day-Glo acrylic and Roll-a-Tex on canvas. Photograph courtesy of Peter Halley Studio; Painting: Sarah Morris, *Creative Artists Agency (Los Angeles)*, 2005. Synthetic polymer paint on canvas; 7 ¼ × 7 ¼ (213.9 × 213.9cm); Fund for the Twenty-First Century; The Museum of Modern Art, New York, NY, U.S.A. Digital image © The Museum of Modern Art/Licensed by SCALA/Art Resource, NY. Dress: Ohne Titel, Spring/Summer 2010. © MCV Photo. **Page 206, top:** Men's shirt: Prada, Spring/Summer 2009. *The Spring/Summer 2009 Look Book: An exploration of the collection's domain of inspiration by AMO: divinity, tribalism, and primitive symbolism—graphically represented through the dialogue of references between fashion and imagery.* Photograph by Philip Meech/Courtesy of Prada. **Page 206, bottom:** Photographic image: Sølve Sundsbø, *Wired*, 1998. © Sølve Sundsbø/Art + Commerce. **Pages 208–209:** Photograph: Aorta, "Her Serene Highness," *125 Magazine*, Spring/Summer 2009. Thierry Mugler jacket from Rellik. Stylist: Sally O'Sullivan; Set design: Johan Svenson; Model: Hanna R @ Elite Stockholm; Hair: Carina Finnstrom @ Mikas using Redken; Makeup: Oliver Andersson @ Mikas. Photograph courtesy of Aorta. **Page 210, top:** Painting: Marcel Duchamp, American (born France), 1887–1968, *Nude Descending a Staircase (No. 2)*, 1912. Oil on canvas; 57 ⅞ × 35 ⅛ inches (147 × 89.2cm); Philadelphia Museum of Art: The Louise and Walter Arensberg Collection, 1950. © 2010 Artists Rights' Society (ARS), New York/ADAGP, Paris/Succession Marcel Duchamp. **Page 210, bottom:** Advertisement: Jil Sander; featuring Lily Donaldson, Spring/Summer 2005. Photograph © David Sims. **Page 211:** Photograph: Sølve Sundsbø; jacket by Calvin Klein Collection and cuffs by Herve van der Straeten, *Harper's Bazaar*, July 2008. © Sølve Sundsbø /Art + Commerce. **Pages 212–213:** Advertisement: Jil Sander, Spring/Summer 2007. Photograph by Willy Vanderperre/ Courtesy of Jil Sander.

MINIMALISM AND FASHION

Copyright © 2010 Elyssa Dimant

All rights reserved. No part of this book may be used or reproduced
in any manner whatsoever without written permission except in the
case of brief quotations embodied in critical articles and reviews.
For information address Collins Design, 10 East 53rd Street,
New York, NY 10022.

HarperCollins books may be purchased for educational, business, or sales
promotional use. For information please write: Special Markets Department,
HarperCollins*Publishers*, 10 East 53rd Street, New York, NY 10022.

First published in 2010 by
Collins Design
An Imprint of HarperCollins*Publishers*
10 East 53rd Street
New York, NY 10022
Tel: (212) 207-7000
Fax: (212) 207-7654
collinsdesign@harpercollins.com

Distributed throughout the world by
HarperCollins*Publishers*
10 East 53rd Street
New York, NY 10022
Fax: (212) 207-7654

Library of Congress Control Number: 2010926556

ISBN 978-0-06-192599-3

Book design by Christine Heslin

Printed in China
Second Printing, 2011